PHOTOGRAPHY
AND ITS
SHADOW

PHOTOGRAPHY
AND ITS
SHADOW

PHOTOGRAPHY AND ITS SHADOW

HAGI KENAAN

STANFORD UNIVERSITY PRESS ■ STANFORD, CALIFORNIA

STANFORD UNIVERSITY PRESS
Stanford, California

© 2020 by the Board of Trustees of the Leland Stanford Junior University.
All rights reserved.

Frontispiece: William Eggleston, *Glass in Airplane*, c. 1971–1974. Dye transfer print. 30 × 20 1/2 inches. 76.2 × 52.1 cm. © William Eggleston. Courtesy of David Zwirner Gallery.

No part of this book may be reproduced or transmitted in any form or by any means, electronic or mechanical, including photocopying and recording, or in any information storage or retrieval system without the prior written permission of Stanford University Press.

Printed in the United States of America on acid-free, archival-quality paper

Library of Congress Cataloging-in-Publication Data

Names: Kenaan, Hagi, author.
Title: Photography and its shadow / Hagi Kenaan.
Description: Stanford, California : Stanford University Press, 2020. | Includes
 bibliographical references and index.
Identifiers: LCCN 2019040806 (print) | LCCN 2019040807 (ebook) |
 ISBN 9781503606364 (cloth) | ISBN 9781503611375 (paperback) |
 ISBN 9781503611382 (ebook)
Subjects: LCSH: Photography—Psychological aspects.
Classification: LCC TR183 .K65 2020 (print) | LCC TR183 (ebook) |
 DDC 770—dc23
LC record available at https://lccn.loc.gov/2019040806
LC ebook record available at https://lccn.loc.gov/2019040807

Cover photograph: Lee Friedlander, *New York City*, 1966. © Lee Friedlander, courtesy of Fraenkel Gallery, San Francisco.

Designed by Kevin Barrett Kane

Typeset at Stanford University Press in 10.5/15 Arno Pro with display in Mono45 Headline

"Only now do I perceive how rude to you I am, my dear shadow."

—FRIEDRICH NIETZSCHE

CONTENTS

Acknowledgments ix

Introduction 1

I PHOTOGRAPHY'S NATURE: THE PICTURE 15

II THE BUTADES COMPLEX 53

III PHOTOGRAPHY AND THE DEATH OF GOD 117

IV PHOTOGRAPHY'S GOODBYES 175

Notes 195

Bibliography 217

Illustration Credits 225

Index 229

ACKNOWLEDGMENTS

Thanking is integral to a certain kind of thinking, one that remembers that we're not the ultimate source of our thoughts and that other people always play a significant role in the writing we call our own. I thank the graduate students and photographers who participated in my seminars on the philosophy of photography at Tel Aviv University. I thank friends and colleagues who read and commented on the manuscript in its different stages and others who made time to discuss the project with me. I thank Meirav Almog, Martin Berger, Georg Bertram, Sarah Betzer, Mattia Biffis, Eran Dorfman, Assaf Evron, Vered Lev Kenaan, Mor Kadishzon, David Kim, Lilach Lachman, Omer Michaelis, Keith Moxey, Alexander Nemerov, Joel Pearl, Giancarla Periti, Itay Shabtay, Graham Shapiro, Joel Snyder. I also thank the generous support of The Center for Advanced Study in the Visual Arts at the National Gallery of Art, Washington DC, in which, while on fellowship during 2016–2017, the book's main ideas crystalized. I thank CASVA's dean and associate dean, Elizabeth Cropper and Peter Lukehart for their wonderful hospitality. At Stanford University Press, I thank Emily-Jane Cohen for her special way of welcoming the book and the production team for its thoughtful work.

PHOTOGRAPHY
AND ITS
SHADOW

PHOTOGRAPHY
AND ITS
SHADOW

INTRODUCTION

I

In the heated debates over the significance and value of photography that swirled around the medium in the first few decades after its invention, it was already clear to both enthusiasts and detractors that the new image-making process was poised to radically alter human experience. Today, a hundred and eighty years after its inception, photography has established itself as the regulating standard for seeing and picturing, remembering and imagining, and, significantly, for mediating relations between ourselves and others. It is now so intimately intertwined within our ordinary routines that we cannot begin to imagine our everyday lives without it. Photography has become an intrinsic condition of the human, a condition that—with Heidegger in mind—may be termed "an Existential." And yet, photography's rootedness in the ordinary is so deep that its existential dimension also typically hides from us, challenging us to find a vantage point as well as a philosophical language for describing its pervasive presence.

This challenge is further complicated by the fact that photography itself is constantly changing. In recent years photography's dominance as a visual form has been inseparable

from the medium's rapid and ceaseless technological transformations. These transformations are often taken to indicate that photography's ontological grounds have shifted, that a new ontology of images has emerged, which, for lack of a better term, has been called "post-photography." The literature on post-photography tends to identify the new condition of the image with the latest technological forms it has taken after the digital turn, but these innovations cannot in themselves explain the photographic condition. The question concerning technology, to refer to Heidegger again, is not a technological question but is, rather, one rooted in who we are—and who we have become—as human beings. At the same time, however, the fact that photographic theory doesn't offer a satisfying account of post-photography does not necessarily mean that the term, or the intuition behind it, is empty.

In 1839 William Henry Fox Talbot described the invention of photography as the new art of "photogenic drawing." His description of photography came at a time when the medium was still so undetermined—much like post-photography today—that every description of it remained conceptually dependent on the traditional category of visual representation that photography claimed to supersede. It took time for photographers and interpreters of photography to recognize the conceptual autonomy of the photograph and to articulate the nuances of its specificity (as *sui generis*) vis-à-vis the traditional visual arts. This process of retroactively determining the identity of the photographic image constitutes a consequential chapter in the history of photography, which has received a variety of interesting treatments;[1] but, its philosophical significance lies in how it illustrates a general dialectic that is essential to the life of the image: a dialectic between the *possibilities* opened up by new depiction technologies and the *determination* of these possibilities in and through a new pictorial medium with distinctive modalities of meaning.

Understanding the emergence of photography in these terms is fundamental to the project that I propose here, one that lays the groundwork for a philosophical interpretation of the changing condition of photography in the twenty-first century. In this respect, this book should be understood as a prolegomenon—not the kind of

wide-ranging *Prolegomena to Any Future Metaphysics* we know from Kant and the history of philosophy, but one that is more narrowly construed, concentrating on a specific metaphysical problem: an introduction to *a future metaphysics of the image* or to *a future ontology of the visual*. The term "future" applies here, as it does in Kant, to invite further elaborations of a preliminary ontological framework; but, in contrast to Kant, it also serves to acknowledge and address the ever-changing character of the phenomenon under investigation and, specifically, the fact that as the visual changes, it generates new possibilities for the future of the image. Photography, as Hans Belting reminds us, constitutes only "a short episode in the old history of representation."[2] The hegemony of the photographic is a short, and likely, a passing chapter in our relationship with images. Yet, as it is caught between "today and tomorrow," photography also provides an opportune framework for rethinking the condition of the visual image in its movement toward the future, a future for which we are responsible, since its trajectory is determined by our present age.

II

To explain the retroactive dynamics at play in determining the identity of the photographic, we need to recognize the presence of a certain duality—one that was not only operative in the emergence of photography but that reveals itself in the twofold character of photography's present condition. Photography has become a pervasive dimension of the human. It is rooted in ordinary experience, but despite its efficacy and immense impact, it is itself a changing historical condition that might already be passing.

To say that photography is both omnipresent and dead requires further elaboration. And, to explain this tension, I turn to Nietzsche, a philosopher who was born the very same year—1844—that Talbot published *The Pencil of Nature*, the first photographically illustrated book. Nietzsche, I argue, is the father of photophilosophy. His thinking not only developed in a world that had just turned photographic, but it also possessed

the radical potential to articulate photography's new logic of appearance, which, for a long time, photography itself could not accept. This logic of the developing history of photography interestingly coincides with the impending transformation of the human that Nietzsche describes in his philosophy of the future.

The aforementioned duality, the concurrence of omnipresence and death, preoccupies Nietzsche in the context of his thinking on the death of God—a theme that will eventually also become relevant for the discussion of the photographic. For Nietzsche, the death of God—the collapse of an overarching principle on which the possibility of meaning and value relies—is a "tremendous event" that cannot be immediately recognized. This condition "is still on its way, wandering" or, in other words, its actuality is dependent on a structure of a belatedness (or afterward-ness). As Nietzsche's madman runs through the marketplace proclaiming the death of God, his words are senseless to an audience not yet ready to understand him. But, their inability to understand is not a result of their commitment as believers. On the contrary, it is their self-regard as advanced non-believers that bars them from recognizing the extent to which their lives are held under the sway of a god whose death has not yet become part of the network of the real. It is in this sense that the madman arrived too early or, as he puts it: "My time is not yet. . . . This tremendous event . . . has still not reached the ears of men. Lightning and thunder need time; the light of the stars needs time, deeds need time even after they are done, in order to be seen and heard." The death of God needs time to resonate and become part of the network of the real. "The greatest events and thoughts . . . are the last to be comprehended: the generations that are contemporaneous with them do not *experience* such events. . . . Something happens here that is similar to the realm of the stars."[3] Distant stars need time to appear in our human sky. Their appearance seems immediate, but it is, in fact, a belated one. In our human sky, presence is often retrospective. Yet, this star logic has another side to it: The bright presence of a star is often the appearance of light that has traveled from what, in the present, is a dead star. Events and constellations that no longer exist may impact our lives, appearing to take place in the present.

In *Gay Science* #108, Nietzsche articulates this second aspect of the event's belatedness by using a different kind of figure, a shadow—in this case, the shadow of the Buddha:

> After Buddha was dead, his shadow was still shown for centuries in a cave—a tremendous, gruesome shadow. God is dead; but given the way of men, there may still be caves for thousands of years in which his shadow will be shown.—And we—we still have to vanquish his shadow, too.[4]

Making the point that the presence of (an absent) god continues to dominate us long after his death, Nietzsche adverts here to the proverbial Buddhist tale of the shadow cave. In evoking the shadow that the Buddha left in the dragon's cave, Nietzsche is uninterested in the complex resonances of this tale in the development of Chinese theories of the image.[5] For him, the picture of a cave in which a "tremendous, gruesome shadow" is displayed is productive since it offers a succinct way for presenting the *dispositif* by which a dead god continues to exercise his rule. This mechanism is one that creates a spectacle of simulation, and it does so by determining not only what is seen but also the conditions of spectatorship that allow the seen to be seen in a certain determinate way.

The spectacle shown in the enclosed, dark space of the cave is an anomaly: Unlike ordinary shadows, the shadow on display is not a transient phenomenon. Furthermore, it lacks the projective essence of regular shadows whose appearance, as such, is always part of a relationship with the objects that they project. The shadow in the cave is a transmuted shadow, one that is uprooted from the natural matrix of the visible. If shadows belong to the condition of the appearance of whatever is under the sun, then, for Nietzsche, Buddha's shadow in the cave is an allegory of the dramatic transmutation of the condition of the visual that allows the shadow to endure as an independent entity.

With the death of God, the realm of the sensible is no longer upheld by the supersensible. The visible is no longer anchored in the divine. And interestingly, this separation is also what opens up the possibility of a visual manipulation by which the presence of

the divine can be simulated (for Nietzsche, simulated rather than venerated). The ability to fix and control a shadow is, for Nietzsche, a sign of an emerging technology of appearances, which was beginning to develop over and against the kind of human anchorage in the visible that embraces the invisible (the super-sensible) as its horizons and inner lining. In this context, it is remarkable that in evoking the shadow cave, Nietzsche is, in fact, describing a large camera.

III

Indeed, the idea of a dark chamber used for practicing the "art of fixing shadows" was central to the imagination and language of early photography. "A shadow," Talbot proudly declares in his 1839 announcement of the invention, "the most transitory of things . . . the proverbial emblem of all that is fleeting and momentary . . . may be fettered . . . [and] fixed forever . . . so firmly as to be no more capable of change." But, can the proverbial emblem of all that is fleeting ever take on a fixed form? Can the shadow remain a shadow when robbed of its constitutive temporal trademark? In photography, as in Nietzsche, the idea of a fixed shadow resonates with a crucial contradiction. The fixed shadow denotes photography's original sensitivity toward the momentary and ephemeral, but also its strong instrumental determination to transform and control natural appearances by subjugating the fleeting instant.

What's unique here about photography's manner of superseding the shadow is not, however, the durable materiality it lends to the image that it captures. It is, rather, the way in which the "killing" of the shadow radically and irreversibly transforms the relationship between human vision and the image—between the visible and the visual—and consequently brings about a new visual order severed from the claims of nature. What is the significance of this twofold gesture, which both welcomes nature and confiscates nature's self-projection?

Given that shadows belong to the condition of "natural" appearances, does this transmutation of the shadow reflect an epochal change not only in the human relation to the

nature of phenomena but also to the phenomenality of nature? How is the emergence of photography tied, beyond its irreversible transformation of the visual, to a transformation in the subject's relation to what appears in the present, to the appearance of a present? What kind of modality or machine, to use Deleuzian terms, did photography create for welcoming and bidding farewell to the unfolding of phenomena—to that which shows itself and disappears—or, more generally, for negotiating the dimensions of transience and finitude? These questions, which are central for this study, were not, however, subjects that photography could grapple with as long as it was struggling to form and guard its own identity. And, it thus continued to understand, present, and market itself into the twentieth century as the offering—not to mention the offspring—of nature, as a natural process that, like the figure of the shadow, projects itself into the inner drama of human life.

This self-understanding, mixed with self-denial, can be gleaned from different facets of photography's rhetoric in the nineteenth century. A ubiquitous 1840s advertisement for daguerreotypes offers a case in point. The ad reads: "Secure the shadow, ere the substance fade! Let Nature imitate what nature made." Foreshadowing the logic of advertisements in late capitalism, the ad addresses the potential consumer by offering what, in essence, is not a commodity and cannot be bought. Like current ads that present intimacy, friendship, or family values as the achievement of mobile phones, the daguerreotype ad knows how to tap into poignant psychological structures. Its *modus operandi* makes use of sentiments and needs we all have as we face the unavoidable losses that await us in life, presenting the daguerreotype as an answer, a solution, to the human yearning to hold onto the evanescent presence of our departed loved ones.

The ad reminds its reader of what would surely strike a chord. It is important to capture the moment before it is lost forever, before it is too late. And, concomitantly, it offers the daguerreotype as an optimal way to respond to that urgent need. The shadow not only lends itself to "fixing," but it "requires" that it be secured. The securing of the shadow is the prompt and responsible response to the inevitable fading of substance, an answer to the semi-ethical imperative implied by the ad. Substance and shadow both

belong to nature, and they remain nature's creations regardless of the human intervention in securing the shadow.[6] The need is deeply human, but it is nature itself that "oversees" this accommodating process. Making a daguerreotype is not, primarily, a technological production, but only a modest human gesture toward allowing nature to fulfill its own potential. Nature is both productive and imitative, and, as such, the photographic is only a continuation and expansion of nature's inner propensities. Photography "let[s] nature imitate what nature made."

At the same time, however, the ad's call to "secure the shadow" has yet another underpinning, replicating an age-old understanding of what images are: Images are a mode of memorialization that originates in the human need to negotiate the presence of death, to mitigate the imminent experience of loss and protect against the complete breakdown of our forms of attachment to the people, places, and things we love and care about.

Photography, as I show, was attracted to this traditional understanding of the image's essence in which the figure of the shadow had an emblematic standing. The shadow, in this context, was not only a stock figure for evoking human transience, but it furthermore functioned as a metonym for a famous ancient tale on the image's origin that enjoyed great popularity in late eighteenth- and early nineteenth-century culture. This is Pliny's influential myth of the Corinthian maid who creates the first visual image (the first drawing) by tracing, on a wall, the shadow of her departing lover. In assimilating Pliny's tale, early photography could root itself in the long tradition of the visual arts and, specifically, take on drawing's intimate rapport with the realm of the visible—from the vicissitudes of nature to the vicissitudes of love and the vulnerability of the human condition. Furthermore, what Pliny's tale provided was a conceptual-figurative scheme—that continued to be consistently popular in both art and theory at least until Roland Barthes and Victor Burgin—by which photography could ground its mechanical, uprooted images and uphold their meaningfulness as (if they were) continuous evolvements, emanations, traces of an original, if lost, presence.

IV

My interest in photography's changing relation with its self-image is ultimately ontological rather than historical. I use the term "ontology" in its philosophical sense, that is as a *logos* of being, which is different from its prevalent use in contemporary photographic theory. Ontology is not, as it is often understood, "an all-inclusive definition of photography or a list of medium-specific characteristics that would set photography apart from other media."[7] In fact, if photographic theory is a conceptual systematization of the multifaceted aspects of the photographic phenomenon, then ontology is the opposite, or the outside, of theory. Ontology's task is not to systematize but to open up photography to the sense in which its presence can be seen as a "branch of being."[8] Or, as I have previously stated, ontology teaches us to see the photographic as an *Existential*.

And, yet, the ontological approach I take here is inseparable from a historical understanding of photography. We need history in order to properly articulate the question of photography's ontology. It is only through its historical transformations that the being of the photographic can reveal itself as that which is not one with itself. Before I say more about this dynamic ontology, notice that it is structurally different from most ontological renderings of photography. These accounts, regardless of their differing findings and conclusions, typically address "What Photography Is," to cite the title of a book by James Elkins. Photography is what it is—self-same and constant in meaning—and, as such, its essence can and should be articulated in positive terms: "Photography is ABC" or "Photography is XYZ." Here are a few examples of this common tendency, starting with Barthes's canonical *Camera Lucida*.

Barthes opens this influential text by declaring his desire "to learn at all costs what Photography [is] 'in itself,'" "to give a name to Photography's essence,"[9] which he pursues in terms of the photograph's unique ability to allow the past—allow the dead—to

become a real part of the present. This is, for him "the very essence, the *noeme* of Photography." And, since this understanding is based on what he takes to be an undeniable fact about photographs—namely, that they show what was actually in the camera's field of vision—"the name of Photography's *noeme* will therefore be: 'That-has-been,' or again, the Intractable."[10]

Expanding on Barthesian themes, Eduardo Cadava explains the essence of photography by reproducing this common logic of sameness: "Photography is a mode of bereavement. It speaks to us of mortification. . . . This bereavement acknowledges what takes place in any photograph—the return of the departed."[11] For him, "this music of love and death . . . can be called photography."[12]

This inner logic appears again in Elkins's *What Photography Is*, although it takes it in a completely different direction. Elkins provides a straightforward critique of Barthes that deals not only with the key claims in *Camera Lucida* but also with the pathos and mood—"the wounded imagination"—of Barthes's writing that Elkins regards as "an impediment to his project of finding the 'nature' of photography." Elkins "agree[s] with Barthes that at one of its limits, ordinary photography of people has something to do with the viewer's unfocused ideas about her own death." But, he explicitly objects to the fetishization of this blurred idea, which brings reprisals. In locating photography between love and death, Barthes "hides photography's non-humanist, emotionless side," which is precisely where Elkins seeks to uncover the core of the photographic. "Photography is about something harder . . . a duller, less personal kind of pain." For him, what photographs confront us with is the world's own deadness, its inert resistance to whatever it is we may hope or want.[13] Again, despite Elkins's pluralistic approach to what images do, he takes the gist of the photographic image to lie in its ability to "fill our eyes with all the dead and deadening stuff of the world, material we don't want to see or to name." To understand photography is to recognize that it is constantly "at war with our attention."[14]

At first glance, Kaja Silverman's *The Miracle of Analogy* seems to share Elkins's central motivation. Like him, she offers an account of photography that deliberately turns away from the personal and explains the essence of the photograph in terms of its relation to the

world's "authorless and untranscendable" self-disclosure. But, unlike Elkins who empha-sizes photography's "inert resistance" to sense, harmony, and hope, Silverman's account of what photography uncovers is optimistic, and she embraces the meaningfulness of photography's visuality. For her, photography is "the world's primary way of revealing itself to us—of demonstrating that it exists and that it will forever exceed us."[15] In photography, an important dimension of the world's ontological structure becomes manifest. This is what Silverman terms "the analogical structure of Being" whose revelation by photography helps us in assuming our place in the world. Photography "helps us to see that each of us is a node in a vast constellation of analogies." It is the vehicle through which the world discloses itself to us as analogical in essence, "and through which we learn to think analogi-cally" and "assume our place within it because it, too, is analogical."[16]

Silverman's understanding of photography *qua* analogy deserves a separate discus-sion, but what specifically concerns me here is the frame and inner structure of her theoretical discourse. Despite the unique content of her proposal, Silverman's approach exemplifies again a monolithic understanding of the parameters of the ontological ques-tion. Like the aforementioned examples, her response to the question of photography's being also takes the common form of "Photography is XYZ."

What makes the direction I'm taking here methodologically different from those above is—first—its dialectical twist. As suggested, my account begins with the recog-nition that photography has never been one with itself. The history of photography is not a chronology of a given, essentially self-same, pictorial medium; instead, it is an account of a dialectical process that allowed photography to negotiate and sustain an identity. The starting point for the story I tell is the presence of an inner duality that has been both constitutive of and concealed by the process of becoming photography. The photographic image was never one thing or another, but a relational phenomenon that materialized through a constant tension between those parts of its being that it needed to suppress and other, external, foreign aspects of "being an image in general" that it needed to assimilate in order to come into its own and guard its acquired identity as a distinctive pictorial medium.

To complicate the story, I argue that, from its very beginning, photography needed to hide its mechanical birthmark, whose presence created a contradiction that it could not contain. This contradiction was precisely what opened up photography's new visuality, but, at the same time, it seemed to preclude the photographic image from the community of meaningful images. Beyond the general structure of contradictions, "'A is B' and 'A is not-B,'" the contradictory structure of the photograph had a deeper, more troubling, specificity. Its being was torn by an inner opposition: "'The photographic image is some-thing' and 'The photographic image is no-thing.'"

Haunted by a void, photography used different strategies to assert itself as meaningful. I thus argue that its different ways of sense-making should be interpreted in terms of the consistent preoccupation with this inner sense of groundlessness. The need to live with nothing at its core makes the condition of the photographic analogous to the condition of modern subjectivity, which in the nineteenth century finds itself facing the consequences of what Nietzsche called the death of God. This shift away from the optimism of the Enlightenment gives rise to a new mode of attunement, a mood that would become essential to the life of an emerging subjectivity and its new image paradigm. Photographs may appear melancholic, as Susan Sontag described them, but, melancholy is a reactive mood that hides photography's encounter with the primary effect of the nothing. "What effect does nothing have?" Søren Kierkegaard asks. "It begets anxiety," he replies. Anxiety is the primary mood of photography, a mood that photography learned to camouflage and ultimately modify. For Kierkegaard, who published *The Concept of Anxiety* the same year that Talbot published *The Pencil of Nature,* "Anxiety may be compared with dizziness. He whose eye happens to look down into the yawning abyss becomes dizzy.... [A]nxiety is the dizziness of freedom, which emerges when the spirit wants to posit the synthesis and freedom looks down into its own possibility."[17] Indeed, photography has taken hold of its own possibility and has become the ruling image of the human. Today, we are reluctant—we do not know how—to experience what is not intrinsically photographic. Photography provides the most ubiquitous standard for our life with images.

At the same time, however, photography has reached a stage at which its fundamental complex is waning. The intrinsic tensions that constituted its identity have dissolved, and in this sense its dialectical evolvement is coming to a pause. In other words, photography has managed to overcome the historic anxiety regarding the hole that has played a crucial role in the historical process of its self-determination. Photography's mood is no longer anxiety, but dementia. Hence, if there is a sense in which it has moved on to a post-human or post-photographic stage, this is because its mechanisms of negation and inner concealment have gradually ceased to function. Having exhausted its dialectical potential, photography today is merely what it is.

So, where does photography go from here?

PHOTOGRAPHY'S NATURE: THE PICTURE

1. NATURE'S PENCIL

William Henry Fox Talbot's first written account of his invention was read to the Royal Society of Great Britain on January 31, 1839, and subsequently published under the title "Some Account of the Art of Photogenic Drawing, or the Process by Which Natural Objects May Be Made to Delineate Themselves Without the Aid of the Artist's Pencil." As the title suggests, the invention is a natural kind of drawing, a drawing created by light. The new method posits itself as an art vis-à-vis the common understanding of drawing as an activity dependent on the subjectivity, skill, and talent of the artist. Unlike traditional drawing, the process Talbot invented is one that allows nature to "delineate itself" on two-dimensional surfaces independently of the artist's touch.

Talbot's invention was technologically very different from the photographic prototype that his competitor on the other side of the Channel had announced a few weeks earlier, but what Talbot shared with Louis Daguerre was a vision of the new image-making process as one that originates in and takes form through nature itself. For Daguerre—who had already prepared a promotional prospectus for his invention in 1838—the daguerreotype is "a discovery" that "consists of the spontaneous reproduction of the images of nature received in the camera obscura.... [T]he Daguerreotype

is not a tool for drawing nature; it is a chemical and physical process that gives nature the facility to reproduce herself."[1] This understanding continues to be a central theme in Talbot's later account of the invention, which appears in the first photography book he published under the evocative title *The Pencil of Nature* (1844). In the book's introductory remarks, photography is presented as a new form of depiction that no longer requires the traditional work of an artist. The exclusion of the "artist's hand" becomes an emblem of the invention's achievement, one based on a different kind of agent or agency: Photographs are drawn by "Nature's Pencil" and "are impressed by Nature's hand."

Talbot does not explain his similes, but in the context of the agency he ascribes to nature, light—*phos/photos*—is clearly a central protagonist.[2] This is also how François Arago, in his famous report on the daguerreotype, construes the connection between nature and the newly invented images: "images drawn by nature's most subtle pencil, the light ray."[3] In Talbot's second photography book, light's connection to the sun was made explicit in the title he chose—*Sun Pictures*, echoing Nicéphore Niépce's early "Heliographs." Talbot's relation to sunlight was multilayered. As a scientist and botanist, he was well informed about different aspects of the current empirical research on light; furthermore, he understood how his invention tapped into the scientific imagination of the day. When he sent exemplars of his work to the eminent scientist Sir David Brewster, considered the father of modern experimental optics, he received the following enthusiastic response: "I do not believe that a Child ever received a Toy with more pleasure than I do a Sun-Picture. It is a sort of monomania which my dealings with light have inflicted upon me."[4]

At the same time, as a classical philologist, Talbot was well acquainted with the metaphorical and symbolic meanings ascribed to the sun and its light in ancient civilizations and particularly in the Platonic-Christian tradition. Hence, it is not a coincidence that his imagery integrates the traditional attributes of the sun's active agency, its status as a vital and effective force in nature, and even its presence as a godly provider. In this context, what the sun primarily epitomizes, beyond its specific contribution to the photographic process, is the inner connection between nature and the visible. It is the sun that forms

the visible essence of nature. This is an age-old Platonic theme according to which there are two complementary ways by which the sun—symbolizing the form of the good—nourishes the realm of phenomena. While it is responsible for the existence of natural phenomena, giving to nature "birth, growth and sustenance," "the sun [also] gives to what is seen . . . its ability to be seen."[5] It "enables our faculty of sight to see, and the things that are seen to be seen."[6] This also means that "of all the organs of perception . . . the eye is the most sun-*like*," receiving its power "from the sun, as a kind of grant from an overflowing treasury."[7]

The sun enables both nature and human vision; it allows nature to unfold visibly and allows the visible to unfold naturally. For Plato, this mutual unfolding shows itself through a heterogeneous span of nature's visible gradations, which he describes in a famous passage in *The Republic* that recounts how the freed cave-prisoner experiences daylight. As the prisoner, in his upward journey, comes out of the cave and into a sunlit world,

> He'd need to acclimatise himself . . . if he were going to see things up there. To start with, he'd find shadows the easiest thing to look at. After that, reflections—of people and other things—in water. The things themselves would come later, and from those, he would move on to the heavenly bodies and the heavens themselves. He'd find it easier to look at the light of the stars and the moon by night than look at the sun, and the light of the sun, by day. . . . The last thing he'd be able to look at, presumably, would be the sun. Not its image, in water or some location that is not its own, but the sun itself. He'd be able to look at it by itself, at its own place, and see it as it really was. . . . At that point he would work out that it was the sun which caused the seasons and the years, which governed everything in the physical realm, and which was in one way or another responsible for everything they used to see.[8]

Plato reads a hierarchical order into the visible. At the bottom of the hierarchy are the shadows that the freed prisoner sees first—shadows that will come to play a distinctively important role in the imagery of photography—while at its highest point is the sun itself. But, if we momentarily bracket this hierarchy, we see that it is based on a

primary understanding of how, in giving life to nature, the sun also endows it with the power of showing itself in multiple ways to the human eye. What sunlight opens for sight is a domain in which not only the objects of nature—"animals and plants"—are visible but also "their divine reflections in water and the shadows of real things."[9] The sun's illumination of nature implies that nature becomes visible through an intricate and dynamic web of appearances. The photographic act embraces this vision. For the nineteenth-century photographer, the sun not only "gives to what is seen . . . its ability to be seen,"[10] but it also gives to what is seen the ability to become a photograph. The sun is not only the primary condition of nature's visibility; it is also the enabling condition of photographic visuality.

In nineteenth-century photographic literature, nature commonly appears as the origin of the photographic image and its visuality. Gaston Tissandier's popular *History and Handbook of Photography* is a case in point. Tissandier published his "practical guide to photography" in 1877, at a time when "[h]ardly forty years have elapsed and the new invention has spread abroad and become so well known, that it has penetrated everywhere, in every civilised country, into the dwellings of the poor as well as of the rich."[11] For him, photography's history must be understood on the basis of its pre-history—or natural history—that invites us to look back at nature and identify in it the primordial phenomenon that photography ultimately reproduces. "The simple observation of Nature might have led at once to this discovery,"[12] he writes, providing a visual illustration, an etching of the depth of a grove of trees into which the sun's light penetrates—a visual theme that had become popular in the early days of photography and has recurred ever since (see, for example, Gustave Le Gray's studies of the *Forest of Fontainebleau*, 1855–1856).[13]

"The foliage of trees does not entirely intercept the sun's light," Tissandier writes. "[I]t often allows rays of light to pass through the spaces which exist between the leaves, and the images of the ruler of the day appear as luminous discs in the midst of the well-defined shadows on the ground. It is easy to reproduce this phenomenon . . . "[14] Tissandier continues to discuss the historical origins of photography from Giambattista

della Porta to Thomas Wedgwood and Humphry Davy, but these are all subsequent developments and elaborations of what nature has already provided. The photographic is ultimately rooted in "the images of the ruler of the day" or, as Daguerre calls them, "*images de la nature.*"[15]

And yet, Tissandier's example—which, as in Talbot's idiom, appears again and again in the developing tradition of photography handbooks[16]—reveals another important aspect of nature that photography embraces. As in the Platonic passage, the visibility of the shady grove that Tissandier describes does not consist of the objects in the natural surroundings alone. The visible is not only a domain of objects; rather, it shows itself

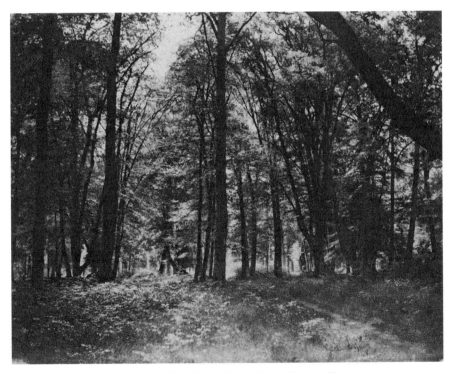

FIGURE 1. Gustave Le Gray, Forest Scene, *Forest of Fontainebleau,* ca. 1855.
Courtesy of the Getty's Open Content Program.

through a dynamic interaction of elements, potentialities, events, and movements within the grove—the foliage, the shades and shadows, negative spaces and perspectival depths, and then, of course, those "luminous discs" that hint at the superfluous and creative ways in which light plays in nature. What the dynamic and reproductive aspects of nature's visibility thus point to is nature's expressivity. The visible is not only a domain in which nature displays its evolving forms of life. It is, rather, an essential dimension of nature's inner movement—its propensity to present itself and make itself shown, its movement toward appearance.

This also means that the visible is never self-enclosed, self-sufficient, or self-identical; rather, it is always open to the eye of a potential viewer. Another way to put this is to say that the visible is not a given but an act of giving, an offering. The visible offers itself to the possibility of becoming visualized. It is an offering of natural proto-images that hold and attest to nature's potential of becoming a picture. Photography embraced the understanding that nature harbors the seed of the visual and rooted itself in that "genetic"—natural—kernel of the image. Its assertion of an intimate connection to nature's inner pictoriality becomes a trademark of photography's rhetoric in the nineteenth century. It underlies the idea that photographs are drawn by "nature's pencil." It also allows photography to present its own history as Francis Wey, for example, does in his 1853 "History of the Daguerreotype and Photography" under the title *Comment le soleil est devenu peintre.*

2. TO LOVE NATURE (AND HUNT WITH A KODAK)

The intimate bond with nature continued to be part of photography's self-image at least until the turn of the twentieth century. The idea that nature is the primary abode of the new picture-making process became deeply entrenched and resonated in various guises and different rhetorical registers. Take, for example, the turn-of-the-century ads for Eastman Kodak cameras. These ads, which rely heavily on visual communication, present (in hand-drawn illustrations) pastoral scenes from nature in which humans (mostly men) engage with their surroundings: They hike, explore, row, fish, and hunt.

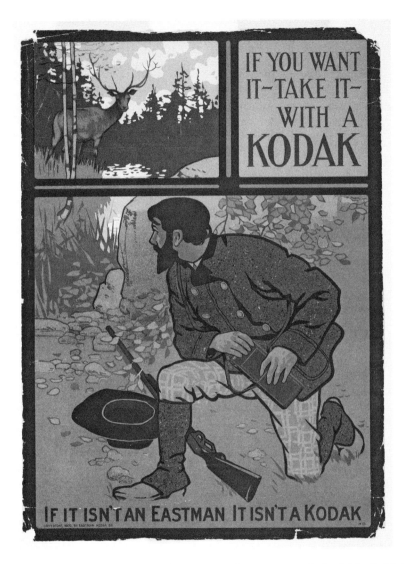

FIGURE 2. Eastman Kodak Company, advertisement, *If You Want It—Take It—With a Kodak. If It Isn't an Eastman, It Isn't a Kodak*, 1900. Courtesy of the George Eastman Museum.

In a stylized Kodak ad from 1901, we see a hunter kneeling. He has spotted a large deer who stares back at him. But, instead of using the shotgun that lies on the ground next to him, the hunter reaches for his camera. The ad reads: "If you want it—take it—with a Kodak."[17] The ad targets a consumer—a man, a potential hunter—who is entitled "to take" what he wants from nature. The fact that nature is available for the man to exploit is assumed. He is only faced with the question of how to "take" that to which he is entitled. In this context, the ad also gives voice to two figures of speech that have become part and parcel of photographic discourse. First, the ad grounds the idiom of "taking pictures" in a basic, literal (more primordial) act of taking. Taking a picture is a sublimated way of taking a wild animal's life, of taking a living creature out of—and away from—nature. This can also be seen in the rectangular "framing" of the deer that occurs through the ad's decorative intersection of lines that separate the animal from the entire scene and create a cropped image (as in photography) above the hunter's head.

The second idiom that is at play here establishes the analogy between "taking a picture" and "shooting" (with a gun). The ad suggests that taking a picture of a beautiful animal can be as satisfying as shooting it. The hunter's rifle is ultimately not used as it is replaced by the workings of a camera. And, the photograph, in this sense, serves as a trophy, analogous to the body of the dead animal. This substitution sublimates the act of killing but remains committed to the logic of shooting.

In Kodak ads from the following years, this rhetoric becomes even more specific: "There are no game laws for those who hunt with a Kodak." Hunting becomes the paradigm and analog for the practice of photography. "The rod or the gun may be left out," the ad continues, "but no nature lover omits a Kodak from his camp outfit." A camera is the mark of hunters who truly love nature. Their love for nature makes hunting unique in that it is released from the restraints of game laws. As a photographer, the lover of nature can shoot and capture whatever he sees and desires. There are no restrictions on what can be hunted with a camera in nature. And nature, too, reveals itself to be an unexhausted repository of photographic images.[18]

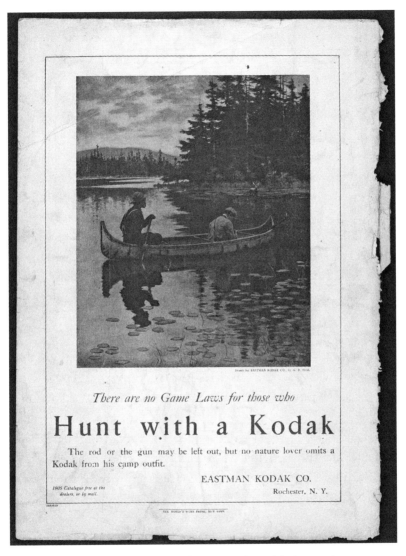

FIGURE 3. Frederick W. Barnes, advertisement for Kodak photography, 1905.
Courtesy of the George Eastman Museum.

But, the phrase "there are no game laws" has yet another connotation, one that evokes the creativity, play, and beauty involved in photography. For the lover of nature, hunting with a camera is, in itself, a creative engagement with nature's beauty. Capturing beauty in a photo is not something that can be done by following a few simple rules because beauty, like a wild animal, never appears as a given and is not something that can simply, procedurally, be "taken" by photographers. There's no recipe for taking a beautiful photo. Kodak's nature-man knows this. He appreciates the singular, elusive, and unexpected ways in which nature's beauty lends itself to—but also escapes—photographic framing. And, in a corollary manner, he also recognizes that capturing beauty requires patience, perseverance, resourcefulness, and creativity that cannot be determined by pre-given laws. Kodak's photographer does not exactly measure up to the Kantian ideal of a genius with "*talent* for producing something for which no determinate rule can be given,"[19] but he can be seen as an amateur-Kantian aesthete for whom "Nature . . . is beautiful [*schön*] if it also looks like art; and art can be called beautiful/fine [*schön*] art . . . [when] it looks to us like nature."[20]

3. A PICTURE OF PICTURES

Kinship with nature was part of the self-image that photography fostered in its early years, cultivating the idea that it was fulfilling nature's expressive essence. What this picture articulated, however, goes beyond photography's relation to nature. It inscribed, more generally, the settings—the constellations—through which photography's origins could become legible. Photography was held captive by this picture of its origins. But, before I begin to elaborate its fuller scope, a word is needed on the terms "picture" and "image," which I use here with Wittgenstein in mind. I'm thinking here of Wittgenstein's "A picture held us captive. And we could not get outside it,"[21] and, more generally, of the Wittgenstein who dedicates his *Philosophical Investigations* to dismantling "a picture of the essence of human language."[22] For him, the point is not to contest a specific theoretical claim, hypothesis, or philosophical position but to take issue with a particular picture or image, *ein bestimmtes Bild,* of essence.[23]

Wittgenstein's decision to take issue with a "picture" rather than with a philosophical theory is a far from obvious move. It is indicative of his insight into the efficacious presence of pre-thematic and pre-theoretical levels that underlie the space of thinking. Thinking is operative prior to the crystallization of specific articulate philosophical positions. An articulate position does not emerge from nothing but develops out of a layered field of pre-thoughts and amorphous concepts, a field that is, nevertheless, not formless but already configured, even if only incompletely. This primary schema—which functions both in closing off ranges of possibilities and in opening paths for the full determination of its embedded potentialities—is what Wittgenstein understands as *Bild*; and, indeed, it is "a particular image," not only because of the specificity of its content, but more importantly because of the unique sense it has as a particular kind of image.

Gilles Deleuze would later call this "the image of thought," and, like Wittgenstein, he ties the dominance of the image to the inability of containing it within the space of reflection.[24] The image affects us; it can assert and continuously reassert itself precisely because we cannot "frame" it as a picture. And we cannot frame it as a picture because we lack sufficient distance from the image. In this sense, our entrapment in a picture is not simply a mistake or a conceptual confusion, but a condition of our attachment to the surroundings—the landscape—from which we begin thinking. Another way to put this is that when an image captivates us, it does so by dominating our imagination rather than our intellect. Finding our freedom in relation to this Ur-*Bild* would call for a *Bildung*. This also explains why Wittgenstein opens the *Philosophical Investigations* by returning to a childhood memory, one he finds in Augustine's *Confessions* that embodies the "picture of language" that continues to preoccupy him throughout his investigation.

In *Confessions* I.8, Augustine recounts an early memory of his passage into language. He "remembers" himself as a child who observes the speaking adults around him in order to decipher what their words mean. The child is still in a prelingual stage, but, interestingly, he is able to identify an intrinsic connection between the objects to which spoken language refers and "the natural language of all people." This natural language consists of the speakers' "gestures . . . facial expression and play of eyes . . . the movements of the

limbs and tone of the voice [which] indicates the affections of the soul when it desires, or clings to, or rejects, or recoils from, something."[25] Recognizing a natural continuity running in between the grownups' souls, bodily movements, spoken words, and the things to which these words refer is a transformative experience for the child who is then able to make the leap into the realm of language. "In this way, little by little, I learnt to understand what things the words, which I heard uttered in their respective places in various sentences, signified. And, once I got my tongue around these signs, I used them to express my wishes."[26]

Citing at length from the *Confessions*, Wittgenstein himself is brief. "These words," he writes, "give us a particular picture of the essence of human language. . . . In this picture of language (*In diesem Bild von der Sprache*) we find the roots of the following idea: Every word has a meaning. This meaning is correlated with the word. It is the object for which the word stands."[27] I shall not discuss here the "idea" that Wittgenstein contests, but only focus on the image, *Bild*, in which that idea is rooted—on *Bild* as the place of roots. In Augustine's Ur-image "we find the roots" from which a full-fledged conception of language develops. The image functions as the origin of an idea, but at the same time, it also presents a scene of origin. It is, in itself, an image *of* origin: the origin of language, Augustine's language. The link between origin and *Bild* is not coincidental here. Origin is always challenging to represent. In harking back to an *arche*, running up against the "immemorial," representation relies on the workings of the imagination and its images.

Photography also needed an image to cover up the rift that its coming into being created in the visual realm. This grounding self-image allowed photography to imagine a birthplace for itself. Without the ability to refer to its own birthplace, photography could neither become a legitimate child of the visual arts nor develop a full sense of its own identity.[28] Without a nativity scene, photography would have remained uprooted and unable to understand itself historically. "Where have you come from? And where are you going?" would have echoed as empty questions. But, ultimately, the gist of an origin image is never only historical. Identity is a metaphysical issue, and photography's self-image was one that provided ontological grounding for the uniqueness of the photographic.

4. THE VISIBLE AND THE VISUAL

Photography was held captive by a picture of origin. In this picture, it could see itself developing continuously out of nature, and, consequently, it could affirm its "natural" rootedness in the visible. Moreover, through this picture, photography could codify the essence of its visuality: It could articulate what it means for the visible to turn into a picture and what was unique in the way it visualized the visible. In this sense, the picture we're interested in is a *picture of pictures*, an *image of images*. As we continue to analyze this picture vis-à-vis what was actually new in the visual experience that the photographic image stimulated, it is crucial to clarify how the terms "visible" and "visual" are used here and how they relate to each other.

"Visible" and "visual" derive from the same Latin word: *videre, visio*—to see, seeing, vision. And vision, as phenomenology has been teaching us for more than a century, is never just a cognitive mechanism for processing information, nor is it only a subjective experience. Seeing is neither the attaining of an external view of the world "outside" us nor is it an internal framing of mental content, as in the back screen of a *camera obscura*. Prior to "re-presenting," vision is a way of being present: being present as situated.

This condition of embodied involvement had already begun to change with the development and integration of virtual technologies. But, historically at least, we may think of "seeing" in terms of the ways seers partake in concrete places and unfolding temporalities—in daily routines but also in dramatic events and moments of crisis—in dynamic, often intersubjective contexts of signification and changing horizons of meaning, in the midst of phenomena. Seeing is an aspect of our dwelling in the world, a processual becoming to which the visible and the visual—and today, also the virtual—are integral. They are essential to the complex matrix of our life-world, and, intertwined, they feed on each other and partake in each other's ongoing transformations. And yet, despite their manifest interconnection, for methodical purposes, let's first consider these terms separately.

The visible, to begin schematically, has historically been the primary correlate of ordinary vision: the experience and achievement of looking at and seeing our surroundings. It is what we are able to see of our world. Opening our eyes, we see things—in meeting the eye, they are (made) visible to us. Having a surrounding world that is visible to us is something we share, on different levels, with various animals. While hiking, for example, we come close to an obstacle obstructing the trail. Like the deer who stood there earlier, we also see—we face—the big rocks that have rolled down the slope and blocked our narrow path. The situation we find ourselves in is visible and thus intelligible to us. Indeed, it is the visibility of our surroundings—the fact that the basic features of the situation show themselves to us—that allows us to cope with the obstacle and surpass it.

The visible is typically the correlate of involved modes of seeing, rather than the more detached form of spectatorship. But, it may also unfold for the impractical—the wandering or wondering—gaze. Tracking his prey, the hunter-gatherer is intensively attentive to the visible. But, the unfolding of the visible, as in the experience of seeing an animal, may also prove significant for the accidental onlooker. "We were riding through frozen fields in a wagon at dawn," Czeslaw Milosz writes in his poem "Encounter" (1936):

A red wing rose in the darkness.
And, suddenly a hare ran across the road.
One of us pointed to it with his hand.

The poem goes on to elaborate on the significance that this long-lost moment retroactively gains. Yet, in describing the moment itself, the initial moment of seeing the movement of a small animal in the middle of a frozen field at dawn, Milosz's succinct phrasing makes it clear how significant an encounter with the visible may be.

The visible is what shows itself to vision. And, when Milosz evokes the memory of seeing a running hare at dawn, his invocation of the "seen world" is done without any reference to the act of seeing, the experience of seeing, or to the framing of this experience by the wagon's window frame. These structural aspects of the viewer's experience

seem unnecessary for describing the visible because what revealed itself to the poet in the moment of dawn was nothing more than the world itself: its frozen fields, a road, a day's first rays of sunlight, the running hare, the pointing hand.

The visual, on the other hand, is commonly understood as connected to a social form of vision; the clearest sign of a visual culture is the actual presence of images. Visuality is a dimension of a culture or a life form that has integrated the image into its daily practices and routines. The relationship between the visibility of things and the visuality of images is never simply oppositional. But, this is not because "the two are not opposed as nature to culture"[29]—of course they are not—but because the visual is not at all a counterpart to the visible. It does not constitute a separate domain of vision opposed to the visibility of the things we see. The visual supervenes on the visible. It is the visible itself taking on a "developed," sublated form. The visual is the visible visualized or, better, the visualizing of the visible.

The enabling condition for this inner transformation is the elasticity of vision, without which vision would remain riveted to what is given to sight. As long as vision is fully dominated by a need to provide accurate information about the surroundings, it does not need to accommodate the visual. The visual emerges from a human vision that has unchained itself, at least partially, from the eye's primary task as a survival sensor and information provider. Another way to put this is to say that the (opening of the) visual depends on the degree of freedom (on the versatility, mobility, playfulness) that seers have in their encounter with the world's visibility. The visual impregnates the visible with a reflexive structure that binds what we see to our abilities and sensibilities as viewers. This schematically means that whereas the visible consists of the objects, aspects, events, and situations we see, the visual is anchored in a second-order relation to what is seen. The visual is not only what meets the eye, but it is what, more specifically, meets the eye *as* that which offers itself to sight. In coming under the visual, the visibility of things is transformed through an accentuation of the very form of their appearance. The shift from visible to visual takes place within human vision itself, which, unlike vision in most animals, knows how to accommodate this change.

One central aspect of this transformation is the insertion of a frame structure into the visible. Unlike the visible—which is primarily a living space and which, as such, is antagonistic to a frame—the visual is an enframed visibility. The frame creates a distance, a separation, between the seer and what is seen, locking the visible into a determined perspective. Moreover, the framing of the visible is what allows it to emerge as autonomously pictorial, as a closed totality in which a relational matrix foregrounds the visuality of specific elements. The elements within a frame are never discrete. They are always already found in a relationship, always part of a whole, and, in this sense, regulated by a grammar and syntax of composition.

To explain the enframing of the visible, consider for example, Camille Corot's *The Meadow, Souvenir of Ville d'Avray* (1869–1872).[30] The painting invites us to look at a woman's absorption—to borrow from Michael Fried—in the sight of a galloping stag. As viewers, we are looking at her viewing. The woman is seated in between two tall trees accompanying the captivating movement of the animal with her gaze. At the specific moment, which we share with her, she has a direct view of the stag, but we know that it is soon bound to exit her field of vision. This is analogous to Milosz's description of the moment of seeing the hare running across the road. The woman is immersed, anchored, in the visible. But, for us, the viewers of the painting, things are different. We are looking at a pictorial world. Our seeing of the stag is different from hers. Unlike the woman, we do not share with the stag the same ground; we are not seated under the same sky or breathing the same air as the stag. We are not in the visible, but we are looking at its visual appearance, which is framed twice: by the painting's frame and by the two trees in the painting, which frame the stag's lightsome galloping in the meadow. For us, the stag is a visual element whose significance is determined within the relational matrix laid out by the painting (e.g., its movement shows itself in relation to the woman's body, her human weight, the turn of her gaze, her stationary position, the firmness of the two large trees, and the touch of sky above).

When vision takes in the visual, it no longer directs our attention to the state of the things we see, but presents us, rather, with their manner of appearing. When I look at

the front of an old Volkswagen and identify in it the features of a smiling face, what I see is not something that is objectively there, but rather an appearance of the car that is determined within the specific context of my viewing. The objects of the visual are thus no longer simply the objects of a world (that happen to be seen) as much as they are the objects of a seeing that relates to and, particularly, shapes the meaning of its surrounding world. The *Aufhebung* of the visible is never selective, however. Its grip never aims only at this or that object, but takes hold of the visible extensively, *en bloc.*

This also means that within the visual, appearances are always already part of a totality, an expanded relational field, a rhizome that both thickens and unfolds through the actualization of potential movements that can be made therein: movements that create

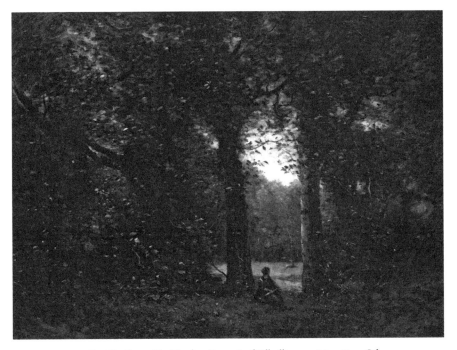

FIGURE 4. Camille Corot, *The Meadow, Souvenir of Ville d'Avray*, 1869–1872. Oil on canvas. Musée d'Orsay, Paris. Art Resource.

connections, links, juxtapositions, differences, comparisons, negations, and analogies that establish themselves as internal to and phenomenologically inseparable from what we see. In this respect, it is only within the horizons of the visual that the visibility—the flight—of a blackbird can be seen, as described, for example, by Wallace Stevens in his "Thirteen Ways of Looking at a Blackbird":

> The blackbird whirled in the autumn winds.
> It was a small part of the pantomime.

Or, in a later stanza,

> When the blackbird flew out of sight
> It marked the edge
> Of one of many circles.[31]

5. PHUSIS, TECHNE, AND PHANTASIA

The transformation of the visible into the visual is most clearly epitomized by the manner in which images, as artifacts, visualize the potentialities opened by natural appearances. Explaining the character of this transformation is crucial for understanding what was unique in the visuality that photography created and, specifically, for recognizing how photography ruptured the traditional process of becoming visual. But, in order to explain this, we need first to say more about the traditional features of an image's visualization of the visible. This will not only allow us to come to terms with the manner in which photography radically and irreversibly altered the relationship between the visible and the visual but also to see how the development of photography depended on the denial and concealment of this radical transformation.

When photography was invented, the idea that nature was the cradle of the pictorial arts was not only fully operational in the imagery of romanticism, but it already reverberated with a long history of its own. The conceptualization of the visual image as evolving from nature was articulated in explicit and comprehensive ways in the

Renaissance, but partial versions of this idea can be traced back to antiquity, from Aristotle to Pliny to Philostratus. When photography appropriates this idea, it does so through a particular understanding of the conditions that determine the process of visualization as essentially continuous. As suggested, photography understands its images as growing out of the continuous evolution of nature: both imitating and developing nature's work. But, although it presented itself as the child of and heir to the traditional visual arts, photography moved to erase the specific conditions that were traditionally associated with the artist's ability to create images out of nature's imagistic potential.

First, the visualization of natural appearances depends on a *techne* of image-making. The conception of *techne* as continuing nature's inner movement goes back to Aristotle's ontology of nature. According to Aristotle, intelligent human productivity shares with nature's processes the inner structure of being directed toward an end. Nature's purposiveness "is most obvious in animals ... [that] make things neither by art nor after inquiry or deliberation," but it can also easily be seen in plants: "[T]he swallow makes its nest and the spider its web, and plants grow leaves for the sake of the fruit and send their roots down (not up) for the sake of nourishment." For Aristotle, the inner connection between nature and human *techne* is so strong that "if a house ... had been a thing made by nature, it would have been made in the same way as it is now by art; and if things made by nature were made also by art, they would come to be in the same way as by nature." Like nature, "Art does not deliberate. If the ship-building art were in the wood, it would produce the same results *by nature*. If, therefore, purpose is present in art, it is present also in nature."[32]

And, yet, Aristotle's linking of nature and art is not only a matter of drawing an analogy between two parallel or separate domains. The point is, rather, that productions of nature and *techne* are homologous. And, this means that, according to Aristotle, the deep affinity between nature and *techne* makes *techne* the natural candidate to complete the incomplete workings of nature: "[G]enerally, art partly completes what nature cannot bring to a finish, and partly imitates her."[33]

Techne has the ability to continue what nature started by developing and elaborating processes that began in nature. *Techne*'s productivity is indeed a *pro*-duction, a bringing forth, a bringing further. But, this idea has another side to it, one that was only fully articulated in the nineteenth century.[34] *Techne*'s "continuation" of nature not only marks its grounding in nature, but also nature's incompleteness. In this sense, *The Pencil of Nature* cannot really remain within the bounds of the strictly natural. Nature needs *techne* in order to function as a pencil and to be able to "draw" photogenic drawings, which testify to a *telos* that is ultimately external to nature. Nature's apparent dependence on the ends of human ingenuity, however, is not only an abstract idea as much as it is a concrete reality: the reality of an ongoing technological exploitation of nature whose tragic consequences have resulted in nature's gradual destruction.

In creating an identity for itself, however, photography not only bracketed the question of how technology fits into the picture of its continuity with nature, but it also obscured the dependence of *techne* on human agency. More specifically, what photography systematically underplayed in the visual models that it borrowed from the tradition were two significant conditions that have historically grounded the *techne* of image-making: (1) the dependence of image-making on an embodied form of human agency; and (2) the dependence of image-making on a specific kind of human intentionality—a modality of "seeing-as"—that makes the experience of images possible. Traditional presentations of these dimension of image-making typically revolve around one of two different focal points that only occasionally are brought into congruence. One of these two foci has to do with the human capacity to produce images, while the other, more primary one is concerned with the ability to see images. One deals with *mimesis* as *techne* or art (which typically presupposes the involvement of the hand) while the other underlines the structures of consciousness that ground the appearance of images in the material world. The human eye, in this context, has traditionally occupied an intermediary, often oscillating, position between mind and hand, subjectivity and world.

Hence, whereas photography starts off by appropriating the age-old idea of the image's evolvement from nature, it does so by obscuring the traditional core of this idea: the triangulation of nature, eye, and hand. What photography, more specifically, passed over—wanting to know nothing about—is the hinge that allows the visible to open onto the visual: the dependence of an image's being on the unique human ability to experience images *as* images. In asserting itself as a direct imprint of nature, photography paradoxically detached itself from a primal stream of human vision—of being in the visible—whose openness to images is grounded in vision's elasticity and free play or, as philosophy would have it, in the imagination.

The power of the imagination is evoked to explain how a vision that is immersed in the world can nevertheless suspend the weight, pressure, and the materiality of the real so as to uphold the appearance of an autonomous, or semi-autonomous, image. Another way to put this is to say that the experience of images requires an imaginative eye. Appearances can become images only for an eye whose imagination is activated. Traditionally, vision has been known to modulate, or change, the perceptually given in accordance with extenuating circumstances. Aristotle, for example, describes the case of "persons in the delirium of fever [who] think they see animals on their chamber walls because of the faint resemblance to animals of the markings thereon."[35] In the tradition reflecting on art, this "delirium of fever" is not very different, in its effects, from the poetic delirium, which would become the attribute of the artist. Indeed, as Shakespeare puts it, "The lunatic, the lover and the poet/Are of imagination all compact."[36] But, in the act of enhancing illusion, these outstanding artists only corroborate the basic imaginative potential of ordinary human vision that occasionally chances upon figures and living forms in the uninhabited surfaces that form the field of vision.

Nature, according to the visual tradition, invites us to see a plethora of surprising forms in its surfaces and silhouettes. We see faces in trees, landscapes in rocks, and animals, angels, and monsters in clouds. In all these cases, the object form of these appearances—the appearing face, animal, monster—is never a given but meets us as a potentiality whose determination requires suitable viewing conditions and a proper way

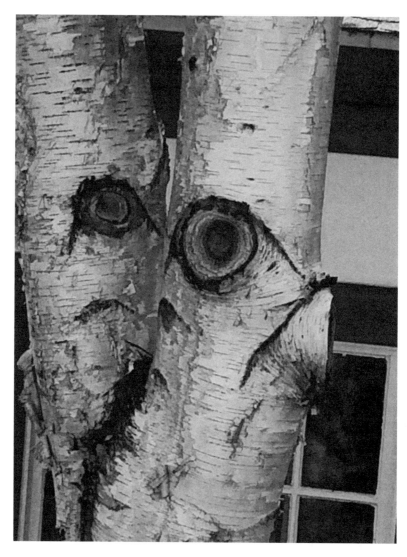

FIGURE 5. Hagi Kenaan, *Face in a Tree*, Pennsylvania 2017.

of looking. Seeing a face in a tree, for example, requires that we look at the tree from a specific angle and that we frame and synthesize what we see in a certain way, one that allows a facet of the tree's surface to be seen—to show itself—*as* a face.

But, the experience of seeing images has yet another important dimension to it. It requires a double-tier intentionality that, in addition to identifying form, can also recognize the visual autonomy of that form and thus distinguish between image and objective presence. This relation consists of, first, a synthetic apprehension that organizes the sensible multiplicity that meets the eye into patterns, forms, and meanings; and, second, an "as if" mechanism that suspends the question of the immediate objectivity of what appears to the eye while granting autonomy to a framed field of appearance that is upheld by a material surface of sorts.[37]

When photography came on stage, it insisted on situating itself in a pictorial tradition that already had a long and variegated history of articulating the underlying conditions by which the experience of images and the making of images are made possible. But, as it sought to assimilate itself into the tradition of the visual arts, photography was unable to come to terms with a fundamental lesson of that tradition's history: Images, in their visualization of the visible, are products of a human endeavor that depends on a gift given to humans by nature. This is nature's offering of potential images, Ur-images, and, more generally, of the potentiality of becoming an image. Humans, according to this traditional view, are able to receive nature's gift and make it integral to their own creative existence, precisely because being human means being part of nature. Whereas photography's early rhetoric adopted this predominant understanding, the invention could not continue to uphold the vision of humanity's connectedness to nature. As I'll show, photography's inception announces a separation from, rather than immersion in, the natural world. It is the (incidental) mark of a daunting change in the human condition, one that needed gradual digestion and that in the digital age has become coherent: Humans have become uprooted creatures. The world is no longer a home for them.

FIGURE 6. Eugène Atget, *Saint-Cloud*, 1915–1919.
Courtesy of the Getty's Open Content Program.

6. "SEEING-AS" AND THE PHOTOGRAPHIC IMAGINATION

Alberti—the Renaissance humanist, architect, and artist—famously opens his treatise *On Sculpture* (1464) with the following account of the origin of image-making:

> The art of those who tried to produce in their works the image and likeness of bodies created by nature came about . . . in the following way. By examining a tree trunk, a clump of earth and other similar objects, they must one day have noticed certain features which, slightly transformed, could be made to resemble completely real natural shapes. After observing this, they then made attempts, with the necessary care, to see if they could complete, by addition or removal, what seemed to be lacking for the true likeness of particular shape. So, insofar as the object itself indicated, by correcting and perfecting its lines and surfaces, they arrived, at their aim, and not without pleasure.[38]

For Alberti, image-making originates in the human encounter—described as a collaboration—with nature's visibility. Nature offers its imagistic potential to the artist who appreciates and knows how to embrace nature's offering. This primary reciprocity is an important link in the continuous translation of nature's expressivity into human-made images. The continuum is based on a chain of interlocking intentionalities. The ability of artists to recognize nature's imagistic potential is the key to their creativity in making new, independent images. Alberti's account underlines the transformative moment in which nature's visual potential is discovered by the human eye, which, in principle, can also remain inattentive—blind—to nature's gift.

The human production of images depends—conceptually and, according to Alberti, also historically—on a prior (nontrivial) ability to see and recognize images in nature's surfaces. The condition for allowing images into our life-world requires, in other words, a specific kind of intentionality, one that allows a viewer to recognize the presence of a visual form in—or, to lend an imagistic form to—the givenness of a material object. It allows the artist to frame and exclusively attend to "appearances" and, in this sense, to

look at the world in ways that are different from the standard way of viewing objects. The basic difference here is that these Ur-images are never simply given facets of objects that happen to occupy our field of vision. They are not perceptible as given objects are, but evolve in relation to the creative play—the imagination, the freedom—of a human eye that is able to bracket and hold in abeyance the facticity—the objective presence, the reality *qua* object—of what it sees. Nature's images—a Gigantomachia in a cloud, a horse in a rock—are never there as given contents that imprint themselves on the eye, but appear as an ongoing synthesis created by an eye that is free—that unknowingly knows how—to transcend the factual.

The first artists were those whose attentiveness toward natural objects led to the revelation that "a tree trunk, a clump of earth and other similar objects" are visually pregnant with the potential appearance of other "completely real natural shapes." Hence, in attending to what "the object itself indicate[s]," the artist could elaborate and determine its visual potential "by correcting and perfecting its lines and surfaces." Becoming an artist is thus dependent on an imaginative, nonliteral vision that awaits to be further developed. This is the distinctive mark of a potential image-making artist.

Alberti's short account of origin has interestingly proved appealing to Ernst Gombrich who, in his influential *Art and Illusion*, embraces Alberti as a precursor of his own theory of projection. "Today," he writes, "we lack Alberti's boldness in speculating about origins. Nobody was present when 'the first image was made.' And yet I think Alberti's theory about the role of projection in the origins of art deserves to be taken seriously."[39] Unlike Gombrich, I don't think that Alberti's insight is about projection as much as it is about a dynamic, reciprocal relationship with the visible. But, without opening this discussion here, what I find specifically interesting in Gombrich's articulation of the matter is the way in which it continues to carry that humanistic heritage of art's rootedness in nature into the second half of the twentieth century.

There is only one area at least where we can check and confirm the importance which the discovery of accidental similarity has for the mind of primitive man: the images

which all people project onto the night sky. I need hardly enlarge on the spell these discoveries cast over the mind of man. To find the image of an animal in the scattered pattern of luminous points in heaven was to imagine it ruling over that part of the sky and over all creatures which came under its influence . . . not only the night sky but anything that could not be classified otherwise may have offered such shapes . . . includ[ing] strange rock formations and cracks and veins in the walls of caves. Could it be that bulls and horses were first "discovered" by man in these mysterious haunts before they were fixed and made visible to others by means of colored earth?[40]

Triggered by "Alberti's boldness in speculating about origins," Gombrich returns to the setting of prehistoric cave art in which he identifies the primal intertwining of nature and art, the visible and the visual. In this primary setting, he reveres the first artists who were not only able to "discover" the potential figures of bulls and horses in rock formations but who also knew how to "fix" these potentialities, extract them from nature and present them to a community, by lending them a determined form. As we've seen, photography—the "art of fixing shadows"—appropriated the intimate relation between images and nature as its essential trademark. And yet, as a modality of seeing-as, does the photographic really consist of an ongoing negotiation of its potentialities for vision? Or, is the unprecedented autonomy—the role, the rule—of the machine in the constitution of the photographic indicative of a new phase in the history of the visual? Given that the photographic apparatus is primarily passive in relation to the visible—and based on the separation of the artist's vision from her touching—can photography generate and accommodate the reciprocal free play between the visible and the visual, the collaboration with nature, that Alberti and Gombrich praise?

The question here pertains to the relationship between an image's potentiality and its determination or, in Kantian terms, the relationship of an image to the synthesis by which it becomes (legible as) an image: its relation to the imagination. Following Kant, who revolutionized the concept of the imagination at a time in which the first experimentations with photography took place, we are invited to evaluate the photographic

image by shifting attention from its givenness (as an object or a cultural product) to its dynamic constitution. How is it, then, with photography?

In the pages that follow, I discuss in detail the dialectic relationship among human embodiment, the imagination, and the machine structure, with the aim of showing that the photographic is already caught between two options: Photography can struggle to draw its visual identity from the precarious openness of the imagination (which in the Kantian and phenomenological traditions is a figure of human freedom), but it can more easily take on an uprooted image-form through which a new kind of reification would gradually prevail over the sphere of the visual.

At this point, however, let's notice that the anomalies of photography may also have a positive lesson to teach us, one that unexpectedly resonates and may already be gleaned from Gombrich's description of the prehistoric artist. "Could it not be," he rhetorically asks, "that bulls and horses were first 'discovered' by man in these mysterious haunts before they were fixed and made visible to others by means of colored earth"?[41] His answer is this: "Perhaps a photograph of the sculpted horse from Cap Blanc gives a better idea of the way these man-made shapes rose from the irregular rock."[42] Why does Gombrich need to allude to the photograph in order to affirm his thesis of man's primordial "seeing-as"? What is it in the photograph that makes it so pertinent for understanding the life and development of images?

7. FOSSILS AND THE CONTINUUM CONCEPT

Photography "discovered" its roots in nature and conceived of its visuality as the natural maturation of nature's visibility. Daguerre's 1839 *Fossils and Shells* is a visual statement that reaffirms this self-image. Fossils are imprints of plants or animals that lived in a past geologic age. And Daguerre's image, which depicts an arranged display of these natural formations (from the collection of the Conservatoire des Arts et Métiers), not only addresses nature's ability to preserve and present the beauty of organic forms from a bygone era, but it also evokes the formal affinity between fossils and photographs. Like fossilization, photography is a natural process that grants an afterlife to the living by creating a

continuous and consistent imprint of an original presence. Daguerre juxtaposes the two forms to demonstrate that photography is, at its heart, a process of fossilization.[43]

The resonance of this idea of fossilization has accompanied the history of photography and can still be heard in contemporary photographic discourse. A photographic statement that continues to elaborate this early understanding of the essence of photography is found, for example, in Hiroshi Sugimoto's "Pre-Photography Time-Recording Device" series (2008). Sugimoto explains his attraction to fossils (of which he holds a collection) as follows:

> Even before the invention of photography in the early nineteenth century, there already existed a wonderful medium capable of recording the past with great

FIGURE 7. Louis Daguerre, *Fossils and Shells*. Daguerreotype, ca. 1839.
Musée des Arts et Métiers, Paris.

precision. This pre-photography time-recording device was the fossil. If we allow the technology of the fossil to be an art, then fossils can be characterized justifiably as the world's oldest art form. Indeed, fossils have been around for aeons and long predate the human race and its ability to appreciate art.

Fossils are the result of natural cataclysms. They are created when something vibrantly alive is instantaneously extinguished and entombed by an earthquake, landslide, subsea volcanic eruption, or meteor impact. The earth and ash heaped on top of the thing stamp out the impression of its shape like a carved seal; then, over the course of tens of hundreds of millions of years, that shape becomes embedded in sedimentary layers and turns to stone. When you split the strata, the layer on top is the negative image, while the fossilized life form appears as the positive image. . . .

Taking a photograph, I realize, is to fossilize the present day.[44]

Sugimoto's understanding of the fossil-like essence of photography is in no way popular today. Although the fossil model is mostly obsolete, what remains of that model has consistently played a central role in twentieth-century photographic theory. This is the idea that the photograph is connected to its source, its reference, through an unbroken physical link. In contrast to Daguerre or to Sugimoto's statement, modernist theoretical positions have not been particularly concerned with the process by which nature transforms itself into a picture. But, they have been preoccupied with the implications of the causal and physical continuity that exists between the object and its photograph. The most common way of discussing the causal continuum underlying photography has been in terms of the photograph's indexicality, its presence as a trace, which was typically used to highlight the medium's independence from human intentionality and cultural codification, its automatism, and also its veracity.

In *On Photography* (1977), for example, Susan Sontag develops her view on the autonomy of the photographic by elaborating on a journal entry in which Delacroix makes an analogy between the photographic process and the delayed rays of a star (the stars again! remember Nietzsche?). What Sontag gleans from the analogy between the

FIGURE 8. Hiroshi Sugimoto, *PPTRD 028*, 2008. © Hiroshi Sugimoto, courtesy Fraenkel Gallery, San Francisco.

photograph and nature is, in the spirit of Talbot, the fact that "Photography has powers that no other image-system has ever enjoyed because, unlike the earlier ones, it is *not* dependent on an image maker."[45]

Unlike Sontag, for whom nature's causal chain is ultimately a mark of photography's mechanistic and automatic character, Roland Barthes interprets the process of the transmission of light as a sign of the photograph's impregnation with the transcendent. "The photograph," he writes,

> is literally an emanation of the referent. From the real body, which was actually there, proceed radiations which ultimately touch me, who am here . . . the photograph of the missing being . . . will touch me like the delayed rays of a star. A sort of umbilical cord links the body of the photographed to my gaze.[46]

Barthes ultimately separates himself from Sontag as his terminology weaves itself into the Christian imagery of the *acheiropoietos*: "Photography has something to do with resurrection: might we not say of it what the Byzantines said of the image of Christ which impregnated St. Veronica's veil: that it was not made by the hand of man, *acheiropoietos*?"[47] Yet, despite their clear differences, both Sontag and Barthes embrace the "unbroken" physical process as the key to deciphering the photograph's essence. Furthermore, while they both evoke the analogy between photography and the delayed rays of a star, the two thinkers ultimately sever the photographic from nature's constellations. Unlike nineteenth-century photographic theorists, they no longer have any interest in nature or in the role it plays in this analogy.

As representatives of the then-emerging, turned canonical, theoretical positions of the 1970s, Barthes and Sontag were not alone here. Rosalind Krauss's influential "Notes on the Index" exemplified this tendency in a manner that was even more nuanced. Following Barthes and André Bazin, Krauss articulated photography's index in a manner that became crucial for the more general theoretical discourse on American art of the 1970s, as a prism for reevaluating itself vis-à-vis the trajectory of twentieth-century modernism. The gist of Krauss's engagement with the index had to do with her attempt

to uncover in the artwork a physical/material/gestural mode of signification—of sense-giving—that could not be reduced to the predominant symbolic or semiotic interpretative frameworks of the day. The clearest example of such a modality was, for her, the photographic index. "As distinct from symbols, indexes establish their meaning along the axis of a physical relationship to their referents." The sense of the photographic lies outside the symbolic order that emerges "through the human consciousness operating behind the representation."[48] In the photograph one finds "the mute presence of an uncoded event," a meaning that is anchored in "the absoluteness of its physical genesis."[49]

Since the advent of digital photography, the index's popularity as a theoretical principle has diminished considerably.[50] But, this theoretical construct is nevertheless a helpful reminder of important continuities in photography's understanding of its visuality. Photography has altogether distanced itself from its initial fixation on nature as its birthplace. Twentieth- century photographic theory has ultimately forgotten nature. But, while *physis* is ignored, "the physical" has continued to serve as the mark of photography's connected visuality. The term "world" replaced "nature," and the term "object" took the place of "tree" and "leaf," but photography has consistently held on to an underlying principle of visuality that, at least until recently, has proved fundamental to its self-understanding. I term this the *continuity principle* or *the continuum concept*, which establishes that photographs have meaning because they are ontologically grounded: "The connective tissue binding the objects contained by the photograph is that of the world itself."[51]

8. AUTUMN LEAVES ON THE TATSUTA RIVER

When the artist Katsushika Hokusai (1760–1849) was 45, his reputation caught the attention of the Shogun, the military governor of Japan. To test Hokusai's standing, the Shogun arranged a competition between Hokusai and the leading painter of the day, Tani Buncho. Tani Buncho commenced the competition by painting a breathtaking landscape that depicted mountains, beautiful birds, and animals. Hokusai followed by spreading out a long sheet of paper. Next, he took a pot of blue ink and painted it across the length of the paper. He then opened a basket containing a rooster. He dipped the

FIGURE 9. W. H. F. Talbot, *A Peony Leaf Above Leaves of a Species of Chestnut.*
Courtesy of the Met's Public Access Initiative.

rooster's feet in red ink, held it close to his cheek, whispered something to the bird, and then bent over and carefully placed it on the blue paper. The Shogun and the audience watched in silence. Then Hokusai brought his hands together and clapped. The rooster's feet raced across the length of the blue strip and into the audience. Everyone was in awe. Hokusai bowed to the painting and then to the Shogun. Finally he said, "That's autumn leaves on the Tatsuta River."

<p style="text-align:center">* * *</p>

Fossils and fossilization are only one kind of trope for imagining the continuum that enables nature to become a photograph. Its counterpart is another primordial figuration of nature's uninterrupted chain of transmission: the organic imprint. "A leaf of a plant," Talbot writes in *The Pencil of Nature*,

> is laid flat upon a sheet of prepared paper which is moderately sensitive. It is then covered with a glass, which is pressed down tight upon it by means of screws.
>
> This done, it is placed in the sunshine for a few minutes, until the exposed parts of the paper have turned dark brown or nearly black. It is then removed into a shady place, and when the leaf is taken up, it is found to have left its impression or picture on the paper. This image is of a pale brown tint if the leaf is semi-transparent, or it is quite white if the leaf is opaque.[52]

- Did you say this book is about photography?

- I did.

- But, weren't you also saying that it's about the question of saying goodbye?

- Yes. Photography's goodbyes *are* the book's subject.

PART II
THE BUTADES COMPLEX

1. WERTHER (ON NOT BEING ABLE TO DRAW)

What is our world like without love? Like a magic lantern without a light. The moment you bring the little lamp into it, the brightest pictures shine on your white wall. And if it were no more than that, only passing phantoms, still it always makes us happy when we stand there like innocent boys enraptured by the wondrous visions. I couldn't visit Lotte today . . . [1]

Young Werther is intensely in love. And, being a painter, he describes the power of love in visual terms. Love is the light that transforms an inert—ostensibly useless—mechanical device into an active "magic lantern," one that, through the projection of bright pictures, brings to life "wondrous visions." Whereas Werther speaks in (and to) a world that is pre-photographic,[2] the magic lantern, like its twin the solar microscope, continued to be popular into the nineteenth century and served both Daguerre and Talbot as tools for their early experimentations with the "natural magic" of photography. Like Werther, Talbot too is taken by the "curious and wonderful" images presented by the solar microscope, which allows him to create, for example, the surprising

photomicrograph of insect wings. But let's remain with Werther and his world.

Werther has fallen in love with Lotte. Although he has not yet sensed the tragic fate that awaits them, the letters he writes to his friend Wilhelm reveal that he is already deeply affected and even tantalized by the complicated future—the apparent impasse—toward which their relationship advances. Still, there are days in which he is able to bracket love's dark sorrows, forget its complications, and embrace only its "brightest pictures."

"I shall see her," I say aloud in the morning when I wake and with all cheerfulness look towards the lovely sun, "I shall see her!" And for the whole day then I have no further wish. Everything, everything is consumed in this one prospect.[3]

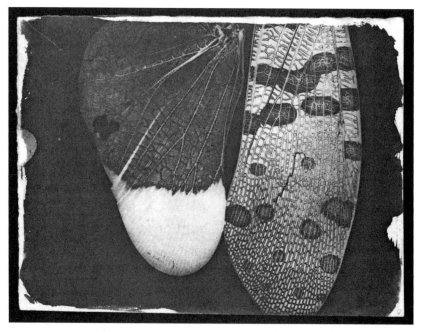

FIGURE 10. W. H. F. Talbot, *Photomicrograph of Insect Wings*, ca. 1840.
Public domain. Courtesy of the National Science and Media Museum, Bradford.

On one such optimistic day (July 24 to be precise), Werther feels fit to respond to Wilhelm's worry that he might be neglecting his art. He writes,

> Since you are so concerned that I shouldn't neglect my drawing I'd rather pass over the whole subject in silence than tell you that for some time now I have done very little.
>
> I've never been so happy, never was my feeling for nature, down to the smallest stone or blade of grass, so full and heartfelt, and yet—I don't know how to express myself, my powers of representation are so weak, everything drifts and wavers so before my soul, I can't grasp hold of any outline. . . .
>
> Three times I've begun Lotte's portrait and three times the result was a disgrace. I am all the more aggrieved by this since a while ago I was very lucky in my like-nesses. Now I have done a silhouette of her and I'll have to be content with that.[4]

Werther's response is straightforward. Something did change, and his powers of representation have indeed diminished. He is now unable to produce "likenesses" with the success that he once had. But, while he is struggling with his artistic performance, what really matters to Werther lies in a different dimension of life: the fact that he has "never been so happy" as he is at present. Furthermore, Werther's happiness has to do with his ability to immerse himself *in* the present. Being-in-the-present not only allows him to embrace the joy of love, but also the beauty of nature. Werther is at the center of an essential triangulation of being-in-the-present, being-in-love, and being-in-nature. And in this fundamental existential triangle, visual representation seems secondary and inessential. In the experience of plenitude, drawing loses its necessity, if not its *raison d'être*.

This feeling is not new to Werther. In a letter he writes on May 10, he links his happy immersion in nature to his inability to draw.

> My dear friend, I am so happy and have sunk so deep into the feeling of calm exis-tence that my art suffers under it. I couldn't do a drawing now, not a line of one, and yet was never a greater artist than I am in these moments. When the moisture rises

in a mist in the sweet valley all around me and the high sun rests on the surface of the forest's impenetrable darkness and only occasional beams find their way into the inner sanctum and I lie in the tall grass by the tumbling stream and, thus close to the earth, become aware of the myriad varieties of grasses, and when I feel . . . against my heart the countless unfathomable shapes and forms of the tiny creatures that flit and crawl . . . I feel the presence of the Almighty who created us in his image, the wafting breath of the Love that encompasses all.[5]

Werther is intimately connected—sensitively open and responsive—to the plethora of ways that nature reveals itself: The play of the sun's rays, the darkness of a forest, the varied blades of grass, the murmuring brook, the shapes of tiny insects are, for him, manifestations of immanent transcendence. Werther's spiritual connection with the fullness of nature satisfies his artistic aspirations, supplanting his inspiration to draw. From within this harmonious wholeness, the option of drawing appears superfluous. And, interestingly, love is also already part of this experience. At this stage, Werther has yet to meet Lotte, and the love that he experiences is still not "preferential" (in the erotic sense). In nature, he comes to embrace love as a metaphysical condition that "encompasses all" and that upholds the beauty and harmony of nature, in which he is delighted to take part.

When Werther falls in love with Lotte, things change. Human love ineluctably ruptures the sense of fullness and bliss associated with nature. Under the constant threat of disillusionment, Eros is, in itself, grounded in lack. This is an ancient Platonic idea that takes on new formulations in romanticism and, then, in existentialism. "Desire is a lack of Being . . . [that] bears witness to the existence of a lack in the being of human reality."[6] Lack, or absence, is a constitutive dimension of being human, a dimension that love both conceals and makes manifest.

Werther's changing moods attest to this duality as his joy, for example, gives way to pain and sorrow. But, the ambiguity of love can also be detected at the heart of moments of happiness, moments during which he experiences an apparent affinity to

nature, such as the one connected to his attempts and inability to paint Lotte's portrait. "I've never been so happy, never was my feeling for nature, down to the smallest stone or blade of grass, so full and heartfelt, and yet—." And yet, Werther's happiness, his intimacy with nature, is anchored now in a more complicated relation to time and the plenitude of the present. Although not fully aware of what has taken place, Werther has gradually become riveted to the map of impasses that marred his love to Lotte; as a result, he has lost the kind of saturated being-in-the-present that trivializes the need for re-presentation. In terms of his art, this means a renewal of his professed attachment to drawing. By loving, Werther is wanting, and what he specifically wants is to re-present the object of his love.

Werther's world appears to him through the prism of the absence that makes his love so intense. When happy, he can disregard the intrinsic lack—the impossibility of wholeness, the imminent disillusionment and loss—that are intrinsic to his present love. At the same time, his urge to "hold an outline" speaks to his implicit understanding of the slippage of the present. His urge to draw is directed at the person he loves, a person whose presence he on some level knows is volatile and gradually becoming elusive. Unlike the sense of sinking deep "into the feeling of calm existence," Werther is latently experiencing the constraints of finitude, the transience of beauty, and the tearing pain of an approaching separation. All he is able to do is draw his lover's silhouette.

2. THE MAID OF CORINTH

When photography first came on the scene, it presented itself as a new form of drawing. This is a commonplace that is captured by early terminology such as "photogenic drawing" and, of course, the term "photo-graphy." Indeed, while it was clearly important for the first photographers to distinguish their modern depiction-technology from the traditional practice of drawing, their understanding of the new image continued to depend, as the invention's name tells us, on the very paradigm that it opposed. In its very attempt to detach itself from drawing, the photographic still relied on the idea of drawing to define itself.

And yet, what early photography ultimately borrowed from drawing was something quite different from a technical vision of image-making. At the end of the eighteenth century and the beginning of the nineteenth, the image of drawing's origin came to function as a central trope within a much wider worldview—one that embraced the traditional visual arts as central to the cultivation of human nature and that was specifically nuanced about the setting, the conditions, and the *Bildung* necessary for becoming an artist or a creative self. In this context, the picture of origins that photography assimilated did more than articulate the rootedness of the photographic image in nature and the naturally visible. It was a picture that defined the existential horizons within which drawing unfolds, tying the essence of the image—which was already connected to nature—to the core of the drama known as human life.

Evoked in a variety of media and genres—directly and indirectly, subtly and ostentatiously—the clearest, if somewhat limited and often sentimental, manifestation of this *Ur-Bild* can be found in depictions of a mythical scene of origin that enjoyed great popularity in late eighteenth-century culture. This was the myth described as the origin of drawing—at times as the origin of painting or even as the origin of art—a myth that was typically associated with its feminine protagonist: Dibutades—sometimes Butades or Boutades—and primarily known as the Corinthian maid. "If ever a legend deserves our belief," Henry Fuseli asserts in his *Lectures on Painting* to the Royal Academy of 1801, "the amorous tale of the Corinthian maid who traced the shade of her departing lover by the secret lamp appeals to our sympathy, to grant it."[7]

The tale of the maid of Corinth first appears in Pliny's *Natural History*, where we find two etiological references to drawing's origin. Previously having mentioned that the drawing of pictures began with "tracing an outline round a man's shadow,"[8] Pliny returns to elaborate on this theme precisely at the moment he moves away from painting to a discussion of a different art form, modeling of clay:

> Enough and more than enough has now been said about painting. It may be suitable to append to these remarks something about the plastic art. It was through the

service of that same earth that modelling portraits from clay was first invented by Butades, a potter of Sicyon, at Corinth. He did this owing to his daughter, who was in love with a young man; and she, when he was going abroad, drew in outline on the wall the shadow of his face thrown by a lamp. Her father pressed clay on this and made a relief, which he hardened by exposure to fire with the rest of his pottery; and it is said that this likeness was preserved in the Shrine of the Nymphs.[9]

What has become known as the tale of the Corinthian maid was originally condensed into a single sentence. And yet, despite its succinctness, Pliny's line nevertheless provides a basic schema that has been used repeatedly in subsequent elaborations and articulations of the concrete setting of the legendary birth of image-making.

In this setting the allegedly technical act of tracing a shadow is integrated into the particularity of a painful and dramatic moment. The Corinthian maid becomes an image-maker through a gesture that responds to her lover's imminent departure, as well as to her own predicament of being abandoned. In Pliny, the moment of the birth of drawing is subsumed under the larger scheme of explaining the invention of clay portraits. And thus, just as the *logos* of drawing needs to be released here from the *telos* of the more tangible, technologically advanced craft of the potter, the protagonist-daughter, who appears nameless, must be released from the law of her father.

In the reception of Pliny's tale, the daughter only seldom has a name of her own, as she does, for example, in Amelia Opie's poem "The Maid of Corinth" (1801), in which she is called Eudora. In most references to her, she either remains a nameless young maiden or appears under a variant of her father's name. Occasionally, she also takes on the exact name of her father, Butades, a name that I shall continue to call her here.

The influence of Pliny's tale on eighteenth-century visual culture turned into a field of scholarly research through the unique work Robert Rosenblum in the 1950s. In "The Origin of Painting: A Problem in the Iconography of Romantic Classicism," Rosenblum was concerned with the considerable popularity that Pliny's tale had enjoyed and, specifically, with its prevalence as a pictorial theme between the 1770s and the

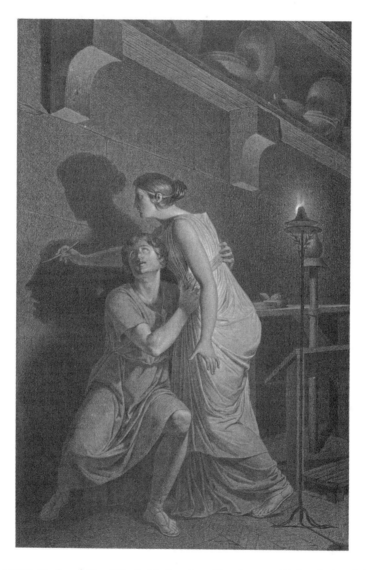

FIGURE 11. Joseph-Benoît Suvée, *The Invention of Drawing*, 1791. Black and white chalk on brown paper. Courtesy of the Getty's Open Content Program.

1820s, after which it fell out of fashion.[10] He ties the popularity of this pictorial theme to two contemporaneous developments that took place in the last third of the eighteenth century: the growing prominence of women painters as well as the invention of "automatic" portrait technologies, such as the silhouette and the physionotrace, in which the shadow figured centrally.[11]

Rosenblum's proto-explanations were subsequently developed in more nuanced ways that accommodated more critical questions on the relationship among gender, class, and artistic identity, specifically, on the "relation between women and certain forms of artistic production to the fine arts."[12] But, whereas Rosenblum left the social history of the "Corinthian maid" undeveloped, the cogency of his study lay elsewhere, particularly, in its ability to recognize and articulate an iconography that grounded the prevalence of the theme of the Corinthian maid. For Rosenblum this iconography, inseparable from the complicated history of the reception of Pliny's tale—from Quintilian to Alberti to Leonardo and Vasari, to Rousseau—provides an important visual backdrop for deciphering the imagination of romantic classicism.

Rosenblum ends his study with the waning of Butades's cultural popularity in the 1820s. But, what remained outside the scope of Rosenblum's work, and is of particular importance to the present inquiry, is that the last decades in which this iconographical matrix was in vogue were particularly crucial years for the development of photography's imagination. Ann Bermingham puts this succinctly in the coda to her insightful study of Wright of Derby's *Corinthian Maid* in which she situates the painting in the context of eighteenth-century British visual culture. "The legend's popularity in the eighteenth century's revival of classicism," she writes "did not coincidently anticipate the dawn of a new relationship between image, object, and beholder that was photographic. Rather, it virtually establishes this relationship by setting the terms in advance by which photography would be discovered, understood, and assimilated."[13]

Hence, when Oscar Gustav Rejlander, the father of art photography and a professed disciple of William Henry Fox Talbot, presented *The First Negative* in the second annual exhibition of the *Société française de photographie* in 1857, he knew that the staged dramatic

scene depicted in his photograph would be familiar to many of the visitors at the exhibition. In *The First Negative* [fig. 15], Rejlander offers a photographic version of the tale of the Corinthian maid that concomitantly functions as a statement about the new art of photography, one that continues his commentary on the relationship between painting and photography that appears in his *Infant Photography Giving the Painter an Additional Brush* (1856). Setting photography's "first negative" within the mythical scene of drawing's origin, Rejlander is making the point that, despite its status as an "infant art," photography developed from the same root and has the same origin as the traditional art of drawing.

What Rejlander's photograph underscores, in other words, is that photography has deep affinities to—and rootedness in—the traditional visual arts. Moreover, it insists that photography plays an equal role in the dramatic life of visual images.[14] For him, the photographic image is essentially isomorphic with the images of drawing and painting since it shares their inner form. Although it bears unique material and technical features, the photograph is, first of all, a visual image, one that emerges from the imagistic potential found in the living shadow and that comes into being through the same primordial *modus operandi* that has given civilization its most ancient visual forms.

3. BUTADES AND THE ART OF SAYING GOODBYE

The immediate imprint of Pliny's origin myth in neoclassical romanticism has to do with its evocation of a shadow as the constitutive root of the visual image. The centrality of the shadow in Pliny's picture is clarified by a historical contextualization of the tale, suggesting—as Jean-Pierre Vernant, Victor Stoichita, Gerhard Wolf, and Hans Belting each do—that the "story should be read within an anthropology of the shadow in the classical world . . . where the insubstantial *eidola* of the dead were called 'shadows.'"[15] For the Greeks, the semantic extension of the term *eidolon* bound together images, shadows, phantom phenomena, apparitions of the dead, and dreams. As Belting notes, for example, "A Greek understood his shadow as a premonition of his shadowy existence in the underworld, when he would no longer be able to cast a shadow but would himself *be* a mere shadow."[16]

Analyzing the shadow in similar terms, Stoichita explains the making of the shadow image in Pliny's tale as a creation of "a 'living' double, a surrogate figure difficult to understand without visualizing the ritual actions we exert over it." For him, the tale fuses different aspects of the surrogate figure, which serves first as a memory token, then as an exorcizing medium, and ultimately, as a cult object in "a cult of the 'clay semblance' that reproduces, includes and accommodates the 'shadow' of the young man, who in all probability is forever absent."[17] Furthermore, as these archaic conceptions find their way into Platonic metaphysics, the shadow is incorporated into an ontological hierarchy by which it is not only relegated to the ontologically insubstantial domain of mere appearance (as a kind of image, or in analogy to images) but also becomes, according to Stoichita, a figure that "is charged with a fundamental negativity that, in the history of Western representation, was never to be abandoned altogether."[18]

Against this backdrop, interpretations of Pliny's image of origin often place the act of drawing within the bounds of the classical Platonic oppositions between being and appearance, the conceptual and the sensible, the spiritual and the bodily, and ultimately between the mimetic arts and higher forms of knowledge. Indeed, with its emphasis on the shadow, bodily gesture, and the feminine, Pliny's depiction of the birth of drawing seems to consist of the very elements that traditionally mark the inferiority of the mimetic arts in relation to the ideal of a genuine quest for truth: While truth calls for a spiritual path that transcends our all-too-human temporal and corporal situatedness, drawing is understood as a form of mimesis that can only respond and correspond to what shows itself to the eye. As such, Pliny's origin of painting has often suggested itself as a complementary image to a more famous ancient image of origin in which the presence of shadows is also central: the origin of philosophy as depicted by Plato in his allegory of the cave in *The Republic*, Book VII.

Plato's description of human prisoners "dwelling in a sort of subterranean cavern"[19] has lent the tradition one of its most vivid and influential pictures of both the human immersion in the world of appearances and of the possibility of transcending worldly appearances via a philosophical journey in the pursuit of truth. Plato's prisoners have

"their legs and necks fettered from childhood, so that they remain in the same spot, able to look forward only, and prevented by the fetters from turning their heads."[20] The prisoners are not only radically severed from the world outside the cave, but they are also barred from relating to their near surroundings in the cave since their gaze is fixed on a screen of shadow appearances. The prisoners, like us, cannot see "anything of themselves or of one another, except the shadows cast from the fire on the wall of the cave that fronted them."[21]

For Plato, the prisoners' attachment to the realm of shadows marks the distance that separates them from the light of truth and thus serves as the starting point for articulating the possibility of human enlightenment and emancipation. Yet, in itself, this unenlightened human condition is described in a way that may invite an analogy with Butades's indissoluble attachment to a shadow. That is, her preoccupation with the shadow may be read as signifying a surrender to the power of illusion, an endorsement of a substitution, a replica, a conflation of the real and the virtual. This kind of reading is offered, for example, by Stoichita who, in his *Short History of the Shadow*, presents the apparent affinities between the shadow in Pliny and Plato as indicative of the rootedness of Pliny's tale in the Platonic conception of the image. For him, "the first painting was nothing more than a copy of a copy."[22]

Should such a Platonic rendering of the tale dominate our understanding of Butades's action? Can the significance of her gesture—which produced the first image—be released from the Platonic grip? In particular, can it be read in a way that subverts the Platonic field of oppositions, suggesting, for example, that it is not "the ancient quarrel between philosophy and poetry" that echoes in the story but the intimacy that is intrinsic to the relationship of philosophy and *poiesis*, thinking and seeing, truth and the image? The key to my non-Platonic reading of Butades is phenomenological: It lies in Pliny's claim—and, specifically, its reformulation in the neoclassical romantic imagination— that the constitutive root of the visual image is a shadow. "Shadow" and "image" are not technical terms, but they appear in the tale as components of a human drama from which a lesson is to be gleaned. The first lesson of Pliny's tale is that drawing originates

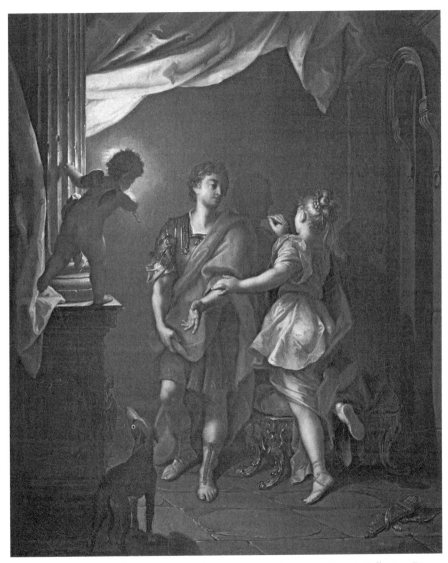

FIGURE 12. Jean Raoux, *The Origin of Painting*, 1714–1717. Oil on canvas. Private Collection, Paris.

at an intersection: It takes place at the crossroad of desire and the experience of loss, of wanting to hold on to what one loves and of having to let go. Drawing is born, in other words, at the intersection of Eros and Thanatos or, even more specifically, it emerges at the moment in which Eros inevitably needs to face Thanatos. The image comes to life, and becomes part of life, when the shadow calls for articulation, when death or finitude open up the question of how to bid farewell and say goodbye.

In Jean Raoux's early eighteenth-century depiction of the myth, for example, Butades's lover stands upright, his shadow cast on the wall behind him, his body language indicating his readiness to take leave. While Butades, Cupid, and the dog (recurrent figures in the pictoriality of the tale) are seen from the back, the lover is the only figure facing the viewer who, by definition, marks the outside of the depicted interior. Butades draws her lover's shadow with her right hand, while her other hand is gently placed on her lover's forearm, holding him from moving so as to allow for a successful depiction of the shadow but also a suspension, a prolongation of the moment of his departure.

In Joseph Wright of Derby's *Corinthian Maid* (1782–85), Butades' lover is asleep. Wright has modeled his figure, as Rosenblum showed, after a Roman relief of Endymion, a beautiful youth to whom Zeus granted the option of everlasting sleep, which would allow him to remain youthful and handsome forever. In this painting, sleep evokes the imminent separation that awaits the two lovers; and, more specifically, it evokes the presence of (its mythical brother) death.

But, sleep is, of course, only one of the ways in which pictures of the Corinthian maid foreground the presence of death whose primary appearance is created through the kind of *negativité* that the shadow inscribes into the pictorial field. Being the unlit projection of the human figure, the shadow epitomizes the dark absence that is about to become part of Butades's world and that ultimately triggers her painterly response. The first drawing emerges from Butades's mode of attending to this imminent absence, one that ultimately saves the desired—lost—object from complete oblivion. The first image not only addresses the lover's imminent departure, but it becomes fully significant through its ability to bear witness to the lover's presence *after* his departure. While

generalized as an essential feature of the image, the bearing of this futural dimension will become a paradigmatic aspect of the tradition of portraiture in which the very idea of creating a person's "faithful likeness" is inseparable from the need and thus the intent to remember the depicted person after his or her eventual death. And, more generally, the tale articulates the coordinates of the emerging image as the triangulation of three dimensions of subjectivity: desire, loss, and memory or, more abstractly, of presence, absence, and re-presentation.

Hence, while Pliny's tale does indeed bear traces of ancient ritualistic conceptions of images as well as of a metaphysics underlying cults of the dead, the idea of

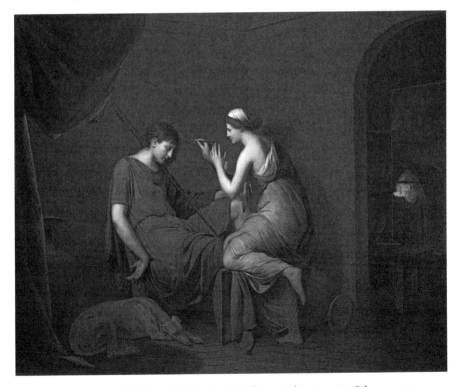

FIGURE 13. Joseph Wright of Derby, *The Corinthian Maid*, 1782–1785. Oil on canvas. Courtesy of the National Gallery of Art, Washington, D.C.

image-as-substitution veils the existential significance that Butades's act of drawing carried for the Romantic imagination. I am particularly thinking here of the disposition and orientation, the kind of response and responsibility, that are embodied in the young woman's act. In Pliny's tale, drawing is ultimately articulated as a gesture that negotiates the presence of death and, specifically, the death of another (loved) person. In drawing, Butades gestures toward her lover's shadow. Unlike Plato's prisoners, she is not under the spell of the shadow; her eyes are not lost in it. On the contrary, her gesture ensues from her ability to recognize the shadow *as* a shadow, and, in tracing its outline, she makes the shadow's form explicit. She responds to the shadow by determining its boundary.

Butades is a young woman who knows she has been abandoned. Yet, while experiencing a great loss, she does not allow the lost object of her desire to cast its shadow on her. If melancholy, to use Freud, is a state in which the shadow of the object falls upon the ego, then the young woman's gesture is a way of avoiding melancholy. What Butades does, rather, is to come to terms with the presence of the object's shadow, her lover's absence. Butades allows herself to experience the pain of being separated from the object of her desire, but at the same time, she does not surrender to the pain of that separation.

In giving form to the shadow of the desired lover, the Corinthian maid takes the essential step of resisting the domination of the shadow. In paintings that depict the tale, Butades is typically presented in a manner that explicitly demonstrates where her attention lies. Her gaze wanders beyond her lover and is intensely directed at the shadow, whose outline she traces. In her involvement in this new act, she creatively positions herself vis-à-vis the absence that the shadow bespeaks: While acknowledging the continual presence of both desire and the pain of loss, she creates a place that is dominated by neither. In this respect, the line she draws around the shadow is creative rather than reproductive. It embodies the event of her freedom and, as such, allows her to reorient herself in relation to a time of loving that has come to an end. Butades's drawing is a mode of working through the painful separation she is facing.

The act of drawing permits her to say goodbye but also to face the future and, as such, welcome and say hello.

But, the tale further implies a more general issue. Drawing is a form of responding to an irresolvable tension that is intrinsic to human existence. This is the tension between the character of the world as a domain of meaningful things that we care about and love and the character of the world as a place in which we also inevitably find ourselves separated and cut off from the things and people we love and care about.

Once we recognize that desire and loss are at the root of the act of drawing, it becomes clear that the predominant way of speaking about the first painting as a form of "replacement" or "substitution" cannot suffice. For the eighteenth century, Butades does not create a substitute because she has no need for a substitute. Her love is real, and she cannot sell it short. The young woman is in love, just as the young Werther is in love. She wants to love and she wants one specific love, but she also knows she has been abandoned. She faces the object of her love as a desiring subject. Yet, she also faces the impossibility of fulfilling that love. Butades faces her limits and limitations, her finitude—herself. In other words, the first painter is a woman who experiences the world without collapsing the experience of desire and loss into one another, without replacing one with the other.

In this sense, her act of painting is not a means for construing a stand-in for her lover, a surrogate or a substitution. To use the common rhetoric of "presence" and "absence" (of which I am not a fan), we should notice that the issue here is not the alternation between these two poles. Butades is not concerned with filling up and eliminating the absence created by her vanishing lover. Her act is not an attempt to replace absence with a new form of presence, but, on the contrary, it reflects an attempt to create a new place for herself in between the opposite poles of absence and presence. Indeed, the notion of an "in between" is helpful.

It is precisely a domain of "in between-ness" that the act of the Corinthian maid opens up. As she faces her situation, Butades could have responded in a variety of ways. A field of options, characteristically arranged in pairs of oppositions, is available to her. Yet,

in her response, she resists the appeal of the "either-or." She neither tries to prevent her lover from leaving nor does she insist on joining him. She neither holds onto her object of love nor does she renounce or turn her back on it. She is neither active—practical, goal-oriented—nor passive. Or, more precisely put, she is active within the passivity that the situation forces on her. She opts for an option that has no significant objective consequence, no real effect in the world, but she clearly does act instead of retreating into the privacy of the purely subjective. The act of the Corinthian maid is neither a something nor a nothing. It is, to use Vladimir Jankélévitch's expression, a *presque rien*. And it is in this location of infinitesimality that drawing originates. This is where the image opens up.[23]

4. WHY BUTADES MATTERS TO PHENOMENOLOGY

Among twentieth-century philosophical approaches to the image, it is phenomenology that has most clearly internalized the lessons of Butades. Although the great phenomenologists of the twentieth century have not explicitly dealt with Butades, she has been there for them in understated ways, and her presence can clearly be detected in between the lines of Maurice Merleau-Ponty or, in a different way, in Roland Barthes. Butades embodies an existential stance, a position in life, a creative understanding of phenomena from within phenomena, which, for phenomenology, is exemplary. Her figure is a model, a lens through which the intersection of key phenomenological themes—embodiment, temporality, alterity, sexual difference, the visible and the invisible—comes into view. Furthermore, Butades interestingly stands as an emblem of both painting and photography. In Merleau-Ponty her figure may be read as an emblem of phenomenology's primary and deep attachment to painting and, specifically, of its initial privileging of painting over and against the photograph, whereas in Barthes her story becomes the backdrop for his novel understanding of the essence of the photograph.

In the context of phenomenology's reflection on the nature of images, the promise of Pliny's picture of origin primarily lies in its figuration of the need to think of the image

in terms of the dynamics of its coming into being. This is what phenomenology terms "the problem of constitution." The image is not something that is simply there, present as a given, but is a phenomenon that constantly becomes what it is while upholding what it has become. And, this becoming is the key, for phenomenology, to address the image's unique presence. The image, in other words, is a *dynamis* whose vitality cannot be framed in terms of its givenness as a re-presentation, an object, or a cultural product. Becoming-image is, rather, a phenomenon that develops through—and thus requires an attentiveness to—the ongoing negotiation between the potentialities of vision and their determination, between the visible and its visualization.

This negotiation cannot be discussed, however, solely in terms of what the image is, in and of itself. In order to reckon with the processual dimension of becoming an image, attention must be given to the configuration of the space that enables the image to appear, a space whose basic coordinates are corporeality, temporality, and intersubjectivity, as well as history. It is only within such a relational constellation that an image can show itself as an image. This is one of the lessons of Pliny's picture of origin. The making of an image always occurs in a space of interaction in which different practices, forces, and agents are operative: love and the interruption of death, loss, abandonment; father, daughter, and lover; a creative image-maker, a subject of representation—an agent whose agency is only implied—and a spectator who, being himself an acclaimed artisan, transposes the drawn image into a more tangible medium, turning it into an object that is brought into and presented in the public sphere.

The regard that the Butades tale has for the question of the image's becoming—or, the image *as* becoming—is primarily apparent in the tale's focus on the gesture that creates the first image. In Pliny, the drawing of the Corinthian maid is first and foremost an *act*. The image that Butades makes receives no autonomous treatment; there is no specification of its visual contents or features as an image-object beyond the prism of her agency: "she ... drew in outline on the wall the shadow of his face thrown by a lamp." This is a reminder of the fact that—unlike the term "photography," the words "drawing" and "painting" operate on two levels. They denote both the work created by the artist (an

image or object that can be handled, moved, and displayed) and an action, the process of working (that articulates the visual). It is this second level that is phenomenologically crucial for deciphering Pliny's tale with its invitation to dwell on the intentionality of an act that was once new to the world.

But Butades's contribution to phenomenology extends further to a precise view of how visuality evolves out of drawing's primal setting. This can be seen in basic elements of the Pliny scene that phenomenology picks up on and develops.

MEDIUM/TOUCH: Butades's drawing is a response to the visible. She sees her lover's shadow and moves to touch it (ineluctably touching the wall on which it appears). Touching is central to her act of image-making. Drawing involves a tactility whose resonance is visual and a vision whose inner impulse is the desire to touch. "These distinctions between touch and sight are unknown in primordial perception."[24]

In drawing, the eye can never forget—it is bound to bear witness to—its condition of embodiment. The form of the eye's relationship to the image is that of an intertwining—a "chiasmus" as Merleau-Ponty calls it—of vision and the body, the eye and the hand. "It is by lending his body to the world that the artist changes the world into paintings. To understand these transubstantiations," he writes, "we must go back to the working, actual body—not the body as a chunk of space or a bundle of functions but that body which is an intertwining of vision and movement."[25] For him, painting is an extended invitation to reevaluate the conditions of human vision and to recognize the lived body as the gravitational center of vision and visuality. The visuality of drawing is intrinsically corporeal, and as I shall show in the next section, this is why, for Merleau-Ponty, it also differs significantly from photography.

Butades's mythical drawing is primordial also in the sense that it makes no use of an autonomous, self-sufficient means of representation. Butades does not draw on a predetermined surface designated for her creation, but operates with what shows itself as part of her ordinary environment. She responds to a shadow she sees on the wall and creates an image that shares the very same surface with the shadow to which it is related.

Tracing, in this context, means that the transformation of the visible (shadow) into the visual (image) takes place on the same physical grounds where the visible was originally perceived. In tracing a line, Butades at once touches what she sees and what she wants to render visual. She draws *in situ*. As in prehistoric cave paintings that accentuate the latent form of a rock—or, as in hand imprints—Butades's image is intertwined not only with the materiality but also with the "here and now" of the phenomenon that appears to her. One cannot look at the image she creates without returning to the actual scene where that image was made, to the singularity of the interior, to the texture of that specific wall. And, yet, being there on the wall, the presence of Butades's image extends beyond the texture of that wall, just as "the animals painted on the walls of Lascaux are not there in the same way as the fissures and limestone formations." They are not completely there, "[b]ut they are not *elsewhere*."[26]

LINE: Butades traces a line, touching simultaneously what she sees and what she wants to articulate visually. But what exactly does she see? The term "trace," which would become important to the theory of photography, suggests that Butades simply passes over a line that is there or given, already registered on the wall. But is this really the case? Can we speak of a line that delimits the lover's shadow prior to the act of the first painter? Are contours, outlines, objectively present in the things we see?[27]

In "Eye and Mind"—a text in which the spectral presence of Butades can be strongly felt—Merleau-Ponty challenges what he calls "a prosaic conception of the line" according to which the line is "a positive attribute and property of the object in itself." In considering "the outer contour of the apple or the border between the plowed field and the meadow . . . as present in the world," this conception turns drawing into the work of tracing the contours that are already given in the field of vision, as if "the pencil or brush would only have to pass over them."[28] For Merleau-Ponty, this positivistic attitude toward vision and the visual is most successfully contested by attending to the work of painters. It is the painter—rather than the scientist, philosopher, or, on another level, photographer—who can teach us a new metaphysics of the line. Painters are those who best know that

there are no lines visible in themselves, that neither the contour of the apple nor the border between field and meadow is this place or that, that they [the lines] are always between or behind whatever we fix our eyes upon; they are indicated, implicated, and even very imperiously demanded by things, but they themselves are not things.[29]

This understanding is characteristic of painters, whose poetic, markedly embodied, ways of seeing put them in touch with the dynamic nature of the visible that remains inconspicuous for ordinary—and specifically, scientific—optics.

The painter's vision is not a view upon the *outside*, a merely "physical-optical" relation with the world. The world no longer stands before him through representation; rather, it is the painter to whom the things of the world give birth by a sort of concentration or coming-to-itself of the visible.[30]

In this respect, it is only by releasing the human gaze from its common objectifying structures that one learns to see lines.

not in a "physical-optical" way but rather as structural filaments, as the axes of a corporeal system of activity and passivity. Figurative or not, the line is no longer a thing or an imitation of a thing. It is a certain disequilibrium kept up within the indifference of the white paper; it is a certain process . . . [that] upholds the pretended positivity of things.[31]

Butades is just the kind of painter who can teach us the lesson of the line. In her primordial act of drawing, she responds to a path that was opened by what she sees on the wall. But what she sees is latent. The possibility of a line is not something that appears as a positive element in her field of vision. As Merleau-Ponty argues, the latent line can be seen, but it is not given. It has no objective presence but is only there as a potentiality that Butades's act foregrounds. In other words, Butades is able to see the latent trajectory of a line, and by intervening in what she sees, she prompts the line to take on an explicit form.

THE INVISIBLE: Butades's line attests to her ability to recognize and mark an incon-
spicuous potentiality within the visible. But, surprisingly, this inconsequential mark
on a wall was the crux of a transformative event. By tracing a line, Butades unlocks a
crucial dimension of the visible that had previously remained hidden. After the first
drawing, the visible could no longer be equated with that which simply meets the eye.
It could no longer uphold its self-identity as a form of "presentness"—wholly manifest
as Michael Fried calls it. The first drawing revealed an internal rift in the visible that the
history of painting continued to negotiate at least until Frank Stella's "what you see is
what you see."

In bringing forth the visibility of the line, Butades not only develops a specific po-
tentiality, but she uncovers a life of visual potentiality that throbs at the heart of our
seeing. What we see is always more—and, in an implied sense, less—than what we see.
Transcendence is an integral part of the visible, but its transcendence is paradoxically
immanent, belonging to the visible itself. The visible, in other words, is neither self-
identical nor fully positive but is essentially pervaded, to return to Merleau-Ponty, by
a dimension of invisibility. "With transcendence I show that the visible is invisible," he
writes in his late working notes. To see this, one should "start from an analysis of the total
philosophical error which is to think that the visible is an *objective* presence."[32] Seeing
through the positivity of the visible—releasing vision from the hegemony of the object-
structure—is the key to encountering the invisible. "The invisible is *there* without being
an *object*."[33] It does not reside beyond the scope of the visible but belongs, in its unique
heterogeneous forms, to a non-objective presence, to the very core of the visible. And
as such, it is also termed by Merleau-Ponty, "the invisible of the visible."

In a famous working note from November 1959, Merleau-Ponty, who in his later
writings was incessantly preoccupied with the invisible, articulates its enigmatic pres-
ence in the following way:

> The invisible is not the contradictory of the visible: the visible itself has an invisible
> inner framework (*membrure*), and the in-visible is the secret counterpart of the

visible, it appears only within it, it is the *Nichturpräsentierbar* which is presented to me as such within the world—one cannot see it there and every effort to *see it there* makes it disappear, but it is *in the line* of the visible, it is its virtual focus, it is inscribed within it (in filigree)— —[34]

Merleau-Ponty's "filigree," with its traditionally feminine connotations, takes us back to Butades whose act of drawing not only creates a "line [that] is no longer a thing or an imitation of a thing," but also brings into view the difference between the positive and immanently transcendent aspects of the visible. Butades's line marks, first and foremost, the fact that the visible and visual are never simply and fully there. Seeing is not just the act of grasping a given content. What we see always pulsates with the absence of what we cannot see, which in turn means that genuine seeing is structured around a possibility, an event, a mode, an unfolding. We already have argued that the first act of painting is neither representational nor mimetic. And we can now take the argument further by adding that Butades's drawing is, in fact, an act of uncovering. Butades's act reveals the depth of the visible. More precisely, it uncovers depth at the very heart of the visible and shows depth to be the inner frame—the *membrure* as Merleau-Ponty would call it—of what we see.

But, Butades does more still. In tracing a shadow's contour, she forever changes the form of our human encounter with the visible. Before the birth of drawing, the visibility of the world was encountered as that which simply imposes itself on the eye. The visual appearance of things was cast on the human eye as a shadow. We only needed to face or look at the world for it to appear. And it appeared through the medium of sight. That is, before the birth of the image, seeing was no more than a lens, a way of accessing and processing the world. And the visible accordingly appeared as a manifestation of the world itself, of those things, qualities, events, and facts that appeared in one's field of vision. Butades, with her inventive action, opens a new possibility, the possibility of not just seeing the world but of seeing it *as that which is seen*.

Butades, the first painter, should be remembered as the person who allowed the

visible to become visual. Her primordial line marks the human possibility of overcoming our fundamental thrownness—to use a Heideggerian term—into the realm of visibility. With the mythical first painting—and this applies also to painting's actual beginnings in such places as Chauvet, Lascaux, and Altamira—the human condition of being in a perceived world changes. In the presence of images, the world is no longer simply there. Rather, it is there in the form of what shows itself to the viewer.

What is celebrated in the tale of the first painting, then, is the impregnation of the field of visibility with the seed of human reflection. The stroke of a line—the line of Butades or that made more than thirty thousand years ago by a human hand moving in the light-spotted darkness of a cavern—is a second beginning. It coincides with the birth of the human look, a liberated gaze that has released itself from the shadow of brute existence by learning to see the world as a reflection of its own image. Butades's act of drawing uncovers within the visible a structure of relationality from which the history of visuality can develop and take on new forms, including, of course, that of photography.

A NOTE ON DERRIDA'S READING OF THE ORIGIN OF DRAWING: In *Memoirs of the Blind*, Derrida argues that it is not vision but blindness that is the constitutive condition of Butades's drawing. His reading of the tale of the Corinthian maid—a reading with which I disagree but is pertinent here because it interestingly links Pliny's tale to Merleau-Ponty's phenomenology—takes its lead from the pictorial convention of highlighting Butades's focus on her lover's shadow rather than on the lover himself. "Butades does not see her lover," he writes:

> It is as if seeing was forbidden in order to draw, as if one drew only on the condition of not seeing.... Whether Butades follows the *traits* of a shadow or a silhouette—her hand sometimes guided by Cupid— ... or whether she draws on the surface of a wall, ... a *skiagraphia* or shadow writing in each case inaugurates an art of blindness.[35]

This "art of blindness" which, for Derrida, is synonymic with the "narrative [that] relates the origin of graphic representation to the absence or invisibility of the model,"

ultimately suggests that the tradition is "attributing the origin of drawing to memory rather than to perception."[36]

Derrida's point about the need to integrate memory into the primal scene of drawing is, in itself, poignant and will be addressed when I discuss the temporal structure of the image. But the reason I mention his interpretation of Butades is that he couples his deconstruction of the primacy of vision (which resonates with his ongoing, more general critique of "the metaphysics of presence") with an evocation of Merleau-Ponty's phenomenology. He sees in Pliny's Butades "an entire program for rereading the later Merleau-Ponty" and, specifically, for understanding the latter's notion of the invisible. In other words, the question of the origin of drawing leads Derrida back to phenomenology, which, in many ways, marks the origin of his own philosophical career. As he writes in his 1990 text for the Louvre exhibition, it is a beginning that belongs to a distant past.

Derrida, who began writing around the time of Merleau-Ponty's death, was well aware that a "rereading" of Merleau-Ponty's notion of the invisible in which vision is replaced by memory was quite distant from the phenomenologist's own agenda. His devaluation of the place of vision in Pliny's story not only ignores Merleau-Ponty's core motivations—especially the non-positivity of the visible—but also fails to recognize the significance of drawing's relation to the shadow. Derrida's insistence on the shadow as an absence synonymous with invisibility, and thus with blindness, misses a fundamental dimension of the shadow's essence. The shadow, when taken phenomenologically, reveals itself to be an intrinsic part of the object's space of appearance and, as such, belongs to the core of the object's visibility. To use Merleau-Ponty's terminology, the shadow is one of the crucial premises of the visible. Shadows are constitutive of the appearance of objects; yet in making an object visible, they must be inconspicuous: "To see the object, it was necessary *not* to see the play of shadows and light around it. The visible in the profane sense forgets its premises."[37] But, this is precisely where the painter comes into the picture, with his quest "to unveil the means, visible and not otherwise" by which the object—Mont Sainte-Victoire, for example—"makes itself a mountain before our eyes."[38] The painter interrogates the existence of shadows

at the threshold of profane vision. . . . The painter's gaze asks them what they do to suddenly cause something to be and to be *this* thing, what they do to compose a talisman of a world, to make us see the visible. The hand pointing toward us in *The Nightwatch* is truly there only when we see that its shadow on the captain's body simultaneously presents it in profile.[39]

Similarly, Butades's attendance to the shadow of her lover rather than to the lover himself is indicative of her unique sensitivity toward the visible, of her painterly vision, and not, as Derrida suggests, of her blindness.

5. MY FATHER'S PROFILE

In his memoirs, the painter Giorgio de Chirico returns to his childhood, paying particular attention to the times and events surrounding the death of his father. In his description of that period clouded by death, there are two particular episodes that invite us to draw a connection between de Chirico's experience of loss and mourning and his developing sense of his vocation as an artist. The first episode took place a few weeks before the death of Giorgio's father.

> My father felt that his end was not far away. One day towards evening, a fine evening near the end of April, I was going along a street in Athens with my father. Between me and my father, despite the deep affection that linked us, there was a certain aloofness, an apparent coldness or rather a kind of reserve . . . we walked in silence and the shadows of the evening came down in silence. I was on my father's left. At a certain moment he took hold of me by the shoulders and I felt the weight of his large arm. I was upset and embarrassed and tried to understand the reason for this unexpected gesture or affection. Then my father spoke to me: "My life is ending. But yours is hardly beginning." We returned home without saying anything more, my father keeping his arm over my shoulder.[40]

De Chirico's language remains close to the visual. The dramatic scene of which he speaks can easily be framed as a picture, one that naturally belongs to the corpus

of de Chirico's own metaphysical paintings. The urban setting consists of a long, perhaps even empty, street. The light is sufficient for viewing the scene, but darkness is just about to settle in, and there's a strong presence of the shadows coming "down in silence." Against this backdrop, we see two figures walking—again, in silence—connected by the invisible threads of a completely private world.

This childhood picture shares the basic features of such paintings as de Chirico's *Nostalgia of the Infinite* or *The Anguish of Departure*; but, at the same time, it stands out as unique due to the sudden disruption of the serenity so typical of de Chirico's paintings of that period. The stillness of the framed memory is broken by an event, a surprising twofold gesture. De Chirico's father puts his arm over his son's shoulder and begins to speak: The physical distance so central to the relationship between the two figures collapses at once, and the silence enveloping father and son is suddenly fractured. For Giorgio, the boy, his father's words cannot be contained within the ordinary. The moment is described as an epiphany, one that continues to resist explanation in the eyes of the adult de Chirico who is writing his memoir.

De Chirico makes no attempt to explain or elaborate further the meaning of his father's words. But, this is not because he thinks these words cannot be understood. On the contrary, it is because the only way to access their meaning is to recognize how they have become embedded in the personal span of a life. The significance of his father's words lies in the manner in which they echo throughout de Chirico's autobiography. "My life is ending. But yours is hardly beginning." Ending and beginning. The relation between father and son is articulated in terms of an opposition: The man and the boy occupy asymmetrical positions with regard to time. The father's time is running out. For him, time is already past, but for his son time is the open future, the possibility of a life that is to be lived through. The father speaks of the inescapable structure of human temporality. And yet, what he relates to his son is not the mere fact of human finitude. In the voice of the father, the fact of mortality resonates as a request. What de Chirico's father bequeaths to his son is an imperative: Live your life!

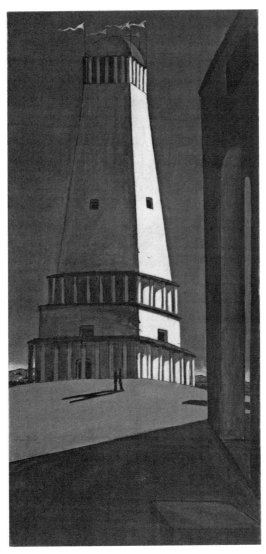

FIGURE 14. Giorgio de Chirico, *Nostalgia of the Infinite*, 1911. Oil on canvas.
The Museum of Modern Art, New York. Art Resource and Artists Rights Society.

De Chirico's father does not succeed in overcoming his illness; he dies within a few weeks. In the memoir, there is no mention of any further conversation between father and son. The second episode that concerns us takes place a few hours after de Chirico's father has died.

> In the evening when everyone left and the servants had gone to bed, my mother, my brother and I stayed up to keep vigil over my father. It was a beautiful mid-spring night, the full moon lit up the city that was sunk in sleep. The song of amorous nightingales rose from the surrounding gardens and from time to time came distant chords of a guitar and songs sung in chorus by groups of young men accompanying a friend singing serenades beneath the window of the girl they loved. Midnight struck. Beneath the weight of the fatigue and sorrow my mother and my brother had fallen asleep and I remained alone to keep vigil over my father. I looked at him and then I looked outside through the open window, at a beautiful moonlit May night. Then, I tiptoed into my bedroom, took some paper and pencil, and returned to draw by candlelight my father's profile as he lay in the sleep of kindly death. My mother always kept this drawing and I believe that my brother still has it.[41]

The scene, again, is not so much an actual narrative as an evocation of an elaborate image. The space of the scene is construed through the opposition between the closed interior of the father's private room and an indefinitely open "beyond," a backdrop consisting of a big city at night. Whereas the father's room is the place of death, sleep, sorrow, and silence, the "outside" appears as the realm of desire, spring, song, and beauty. De Chirico's mother and brother are under "the weight of the fatigue and sorrow" and thus surrender to sleep, as if temporarily joining the dead father. De Chirico, on the other hand, is caught in between Eros and Thanatos, embodying the irresolvable tension between them that is the very tension that holds the scene together.

Here again, as in the previous episode, the general setting is suddenly lit up by an unexpected event: in between Eros and Thanatos, the artist finds the possibility of creativity. De Chirico is neither tempted by the call of desire that reverberates through

the open window, nor does he surrender to the sorrow that dominates the silent room. Instead, he acts creatively, drawing his dead father's profile in pencil, by candlelight.

De Chirico's act is spontaneous; yet its immediacy is neither isolated nor cut off from the narrative's overall logic, one that, as we already understand, is not only singular but also representative of the general picture we have called "Butades." The drawing of the dead father is not an arbitrary act, but one that allows de Chirico to respond in a personal manner to his father's last request. In drawing this profile, de Chirico is taking the first step on a path evoked by his father's words: Your life is hardly beginning! In this respect, his youthful drawing should be understood as an act of self-determination. The sketch of his father is his first work as a painter. That is to say, the above scene commemorates not only the death of de Chirico's father but also the moment of de Chirico's individuation as a creative self, his birth as an artist. At the heart of this picture of a child parting from his father, we find an image of origins: the origins of de Chirico's painting, his first work of art. This unique moment of beginning had not been forgotten by the adult, the famous painter who is writing his memoir. De Chirico does not explicitly articulate his attachment to that place of beginning, yet he clearly alludes to its continual intimate presence in his life by referring to that first artwork's whereabouts: "My mother always kept this drawing and I believe that my brother still has it."

6. MERLEAU-PONTY AND THE PHOTOGRAPHIC

Announcing his phenomenological credo in the "Preface" to the *Phenomenology of Perception* (1945), Merleau-Ponty offers an explanation of phenomenology that underscores the close affinity between this radical form of philosophical reflection and the arts, especially, literature and the visual arts. "Philosophy," according to him, "is not the reflection of a pre-existing truth but, like art, the act of bringing truth into being." Like drawing and painting, "true philosophy consists in relearning to see the world." Phenomenology is as painstaking as these arts; it requires "the same kind of attentiveness and wonder, the same demand for awareness, the same will to grasp the sense of the world or of history in its nascent state." Interestingly, for Merleau-Ponty, this shared radical pursuit of truth "merges with the effort of modern thought."[42] And, perhaps

even more interesting is the fact that photography does not seem to have any part in this painstaking modernist enterprise.

In Merleau-Ponty's subsequent phenomenological writings that explore the connection between the visual and the embodied dimensions of human subjectivity, the arts of drawing and painting are embraced as fundamental coordinates. In this context, too, his admiration for the visual does not include a discussion of photography, toward which he seems to remain indifferent if not distrustful. Unlike drawing or painting, photography is not a medium to which Merleau-Ponty dedicates any considerable thinking.[43] And, in reconstructing his view on this medium, one must carefully parse the few passages in his oeuvre for mentions of photography or photographs that provide clues to his position. In "Cézanne's Doubt," published in the same year as *Phenomenology of Perception*, for example, photography is only mentioned in passing and appears as a negative example in the context of a claim about the significance of Cézanne's defiance of geometrical perspective:

> By remaining faithful to the phenomena in his investigations of perspective, Cézanne discovered what recent psychologists have come to formulate: the lived perspective, that of our perception, is not a geometrical or photographic one.[44]

To explain the place of photography here, we must first notice that it is presented as part of an opposition—important to Merleau-Ponty in this period—between the inflected spaces of "lived experience" to which embodied perception belongs and the homogeneous, objectively constructed spaces that are the outcome of an instrumental, technological, or scientific rationality that posits impoverished forms of experience as the standard of human everydayness. Hence, whereas photography, together with visual representations that comply with the rules of geometrical perspective, belongs to a space that flattens experience, Merleau-Ponty sees Cézanne's painting as exemplifying the kind of visual work that embraces the heterogeneity and richness of lived experience.

The uniqueness of Cézanne's work lies in its commitment to the life of primary phenomena that all too easily disappear when digested and packaged by the instrumental

eye and, specifically, when subjected to the objectifying scheme of geometrical or photographic perspective. The question of perspective arises from an understanding that the visual appearance of the world is always anchored in and opens up through a relation to a point of view.

But what objective perspectival models too often tend to eliminate is the embodied condition of the seeing-eye, which, according to Merleau-Ponty, cannot be integrated into a mathematical calculation of positive relations within a homogenous geometrical space. Unlike virtual and photographic reconstructions of the real, Cézanne makes raw perspective visible and, more generally, he "make[s] visible how the world touches us."[45] In order to do so, Cézanne must first "forget all he ha[s] ever learned from science," and it is this "forgetting" that allows him "to recapture the structure of the landscape as an emerging organism."[46] As a painter, Cézanne thus "recaptures, and converts into visible objects what would, without him, remain walled up" and inconspicuous: "the vibration of appearances which is the cradle of things."[47]

In Merleau-Ponty's later writings, painting's ability to reveal "the metamorphosis of Being . . . [into] vision"[48] is more closely associated with the painter's concrete knowledge of the invisible. The painter, like the philosopher, uncovers the continual inception of the world's visibility that remains invisible within the framework of ordinary object-oriented perception. This is one sense in which paintings offer a "figured philosophy of vision." What's unique in the painter's work, however, is that its means of uncovering the invisible depth of the visible are themselves wholly visual. Like Butades's first drawing, painting embodies a way of seeing that not only penetrates the positive determinations of everyday perception but expresses itself by "giving visible existence to what profane vision believes to be invisible."[49] The corollary of this is photography's implicit relegation to the domain of representations that, unlike drawing and painting, lack a genuine connection to the pulsating heart of the visible and, specifically, a sensibility toward the presence of the invisible.

A more nuanced version of Merleau-Ponty's position appears later in "Eye and Mind," in a passage that immediately follows the section on the ontology of the line in

the arts of drawing and painting. Having argued that the line needs to be understood as a *dynamis*, Merleau-Ponty takes up the question of how movement appears in painting:

> Just as painting has created the latent line, it has made for itself a movement without displacement, a movement by vibration or radiation. . . . [Although] painting is an art of space . . . the immobile canvas can suggest a change of place in the same way that a shooting star's track on my retina suggests a transition, a motion not contained in it.[50]

This leads him to offer his most detailed remarks on photography, which appear in a reflection on the difference between it and painting. Unlike painting, which can make movement vibrate on an immobile canvas,

> photography's instantaneous glimpses . . . petrify movement as is shown by so many photographs in which an athlete in motion is forever frozen. We could not thaw him out by multiplying the glimpses. Marey's photographs . . . do not move. They give a Zenonian reverie on movement. We see a rigid body as if it were a piece of armor going through its motions. It is here and it is there, magically, but it does not *go* from here to there.[51]

Merleau-Ponty's dismissal of photography as incapable of upholding movement is not completely clear, especially as he uses an image—of a shooting star on the retina—that evokes the idea of a trace, which, as we've seen, is so typically associated with photography. But, again, Merleau-Ponty does not seem to be interested here in photography's essence; rather, he uses the example of photography to make a point about the power of painting. His explanation of how painting succeeds in embracing movement elaborates on statements on the subject that he borrows from Rodin:

> Movement is given . . . by an image in which the arms, the legs, the trunk, and the head, are each take at a different instance, an image which therefore portrays the body in an attitude which it never in any instant really held. . . . The picture makes

movement visible by its internal discordance. Each member's position, precisely in virtue of its incompatibility with that of the others (according to the body's logic), is dated differently or is not "in time" with the others. And since all of them remain visibly within the unity of one body, it is the body which comes to bestride duration. . . . When a horse is photographed at that instant that it is completely off ground, with his legs almost folded under him—an instant therefore when he must be moving—why does he look as if he were leaping in place? And, why, by contrast, do Gericault's horses really *run* on canvas, at a posture impossible for a real horse at a gallop? It is because the horses in *Epsom Derby* bring me to see the body grip upon the ground and that, according to a logic of body and world I know well, these "grips" upon space are also ways of taking hold of duration. . . . Photography keeps open the instances which the onrush of time closes forthwith. It destroys the overtaking, the overlapping, the "metamorphosis" of time. This is what painting, in contrast, makes visible. . . . Painting searches not for the outside of movement but for its secret ciphers. . . . [T]he art of painting is never altogether outside time, because it is always within the carnal.[52]

Following Rodin, Merleau-Ponty explains painting's ability to make movement vibrant through its own carnality. By definition, movement is never in one place but always already relational. Whereas photography's "frozen" instances kill—by breaking apart—this essential relationality, painting knows how to keep it alive, although it does so in a manner that, for the positivist's eye, appears as an "internal discordance." Merleau-Ponty compares here the galloping of horses in Géricault's *Derby at Epsom* (1821) with Muybridge's galloping horse photographs (1878), which not only provide a more adequate representation but reveal that Géricault's depiction is factually and visually inaccurate (real galloping horses are never in a position in which their front and hind legs all extend outwards). Yet this is also precisely why Muybridge's horse "looks as if it were leaping in place" while Géricault's "horses really *run* on canvas."

But the point of the discussion is ultimately not the effects of painting so much as the intimacy that painting shares with the inner logic of the moving body. For Merleau-Ponty, this intimacy has to do with the painter's primal intertwining with what it makes visible and, in corollary fashion, with movement, change, and temporality, which are essential coordinates of the visible. "The painter's vision is not a view upon the *outside*, a merely 'physical-optical' relation with the world,"[53] because the painter is always already "caught within the fabric of the world," a "world made of the very stuff of the [painter's] body."[54] Painting works from within vision and expands it. It is a "mirror phenomenon" that emerges in a material world that is "an extension of my relation with my body."[55] Unlike photography, then, "painting searches not for the outside of movement but for its secret ciphers" whose unveiling is made possible because "the art of painting is never altogether outside time, because it is always within the carnal."[56]

Being within the carnal: This is why painting is utterly different from photography. Merleau-Ponty concedes that the photographic image is "magical" and in this sense continues to reference a positive attribute that has accompanied photography from its very inception. But for him, photography's magical quality does not qualify it to participate in the mystery of incarnation. In the dichotomy of magic versus mystery, photography ultimately remains foreign to the "transubstantiations"—and Merleau-Ponty reverts here to the language of his Catholic upbringing[57]—whereby, in "lending his body to the world, the artist changes the world into paintings."[58]

Yet, here again, we are confronted with the lesson of Butades: Painting (unlike photography) emerges as a unique gesture of touching the world viewed, while viewing the world touched. It is an active aspect of the passivity of an embodied subject who is always living in a world in which she herself is already being touched and viewed. The gesture foregrounds the presence of the invisible within the visible by articulating the artist's primal intertwining with the flesh of the world and her power to transform the dynamics of this intertwining by drawing out of the visible new forms of invisibility.

7. IMAGE AND MOURNING: BUTADES AND BARTHES

Barthes's reflections on photography and Merleau-Ponty's reflections on painting mirror each other in interesting ways. Barthes is attached to photography, Merleau-Ponty loves painting, and each of them moves to ground the uniqueness of his chosen art in an ontology of the image that he expounds phenomenologically. Yet, in spite of their respective preferences for photography or painting, they ground these preferences in phenomenologies that—somewhat surprisingly—have much in common. There is quite a bit of overlap between the conceptual-figurative schemes each thinker uses to ponder the question of the image in his own way. I've already given a name to the shared core of these schemes: What they both embrace, albeit unknowingly, is the figure of Butades. Butades is the mirror in which Barthes's photographs become the reflection of Merleau-Ponty's paintings.

* * *

Barthes's mother, Henriette, died in October of 1977. On August 18, 1978, a few months before he began working on *Camera Lucida*, he wrote the following entry in what would become known as his *Mourning Diary*.

> The locality of the room where she was sick, where she died, and where I now live, the wall against which the head of her bed rested where I have placed an icon—not out of faith—and still put flowers on a table next to it. I have reached the point of no longer wanting to travel in order to be here, so that the flowers here will always be fresh.[59]

Barthes describes the "locality" in which his separation from his beloved mother had taken place. In this room, he had taken care of his dying mother, while knowing that her imminent death would mark the end of the life they shared under the same roof.[60] When he writes the above passage, Barthes is already looking back. His mother's death is already a fact—"*maman* is dead *forever, completely*"—yet Barthes cannot but continue to embrace the strong presence of her absence. He describes the difficulty of saying goodbye, of

letting go of the person he loved so much and of coming to terms with the gaping hole her death left in his life. Having moved into his mother's room—preserving the continuity of life in the space that she used to inhabit—Barthes is scrupulous about keeping up the supply of fresh flowers that he puts on the table next to her deathbed. Barthes seems uninterested in distancing himself from the "locality" of love, death, and grief; rather—in not wanting to travel anymore—he remains within its confines.

Barthes's state of mourning is commonly addressed in interpretations of the unique tonality of *Camera Lucida*; it is also considered in more critical responses that regard Barthes's frame of mind—his "wounded imagination" as Elkins calls it—as "an impediment to his project of finding the 'nature' of photography."[61] The question of how Barthes's personal grief influenced his reflections on photography is not, however, something I wish to discuss here. I am interested in his *Mourning Diary* because I think that the condition of mourning—or what he, more specifically, terms "amorous mourning"—is itself central to Barthes's thinking about images and, in particular, of the photographic. The triangular relationship among desire, absence, and memory is a recurring *topos* in Barthes's writing (from *On Racine* to *S/Z* to *Barthes by Barthes* to *A Lover's Discourse*). When he declares his intention, in *Camera Lucida*, to "interrogate the evidence of Photography . . . in relation to what we romantically call love and death," the way he frames the question of the photographic image is hardly circumstantial or coincidental. While he may indeed have accentuated these themes as a result of the personal loss that he was processing even as he wrote, Barthes's reflections on photography should be read as further developments of the notion of the image that he had already begun to formulate in his earlier texts.

In *A Lover's Discourse*, for example, the triangulation of love, absence, and the image is posited as a structural feature of a lover's experience. Being in love is, on the one hand, inseparable from—what Barthes terms—an "image-repertoire," and on the other hand, in its dependence on the image, love is an experience that always already has absence built into it. In this context, mourning can only accentuate the already existing inner form of the erotic phenomenon. Hence, indeed, "in amorous mourning . . . it is I who decide that the image must die." And consequently, "as long as this

strange mourning lasts, I . . . undergo two contrary miseries: to suffer from the fact that the other is present (continuing, in spite of himself, to wound me) and to suffer from the fact that the other is dead (dead at least as I loved him)."[62] Yet, on the other hand, "the true act of mourning is not to suffer from the loss of the loved object; it is to discern one day, on the skin of the relationship, a certain tiny stain, appearing there as the symptom of a certain death."[63]

Being upheld by the image, love has death inscribed in it from its very inception. And, in this sense, "love at first sight is always spoken in the past tense. . . . The image is perfectly adapted to this temporal deception: distinct, abrupt, framed, it is already (again, always) a memory."[64] It is also on this note that Barthes adds a comment on the nature of photography that foreshadows one of *Camera Lucida*'s famous motifs: "[T]he nature of the photograph," he writes, "is not to represent but to memorialize."[65]

Let's return here to the passage from *Mourning Diary*. Barthes presents himself as living in his dead mother's room. In addition to making sure that there are fresh flowers at her bedside, he does one more thing: He places an icon on the wall above her bed. The icon brings an image into the room, albeit a religious one, whose location on the very wall onto which her body had cast its shadow each night is meant to uphold, perhaps to uplift, her absent presence. The icon takes the place of Henriette's living shadow, and Barthes, in his introduction of the image into the scene of mourning, is enacting here the Butades story. More specifically, Barthes takes on Butades's role, just as he does in *Camera Lucida*, when, in seeing that his "mother's [photographed] face is vague, faded," he exclaims "I want to outline the loved face by thought."[66] In embodying Butades, Barthes is well aware of traditional gender implications. "Historically," he writes, "the discourse of absence is carried on by the Woman. . . . It is Woman who gives shape to absence," and consequently, it also "follows that in any man who utters the other's absence *something feminine* is declared; this man who waits and who suffers from his waiting is miraculously feminized."[67]

Anthropological interpretations of Pliny's Butades typically highlight, as suggested, its implied allusions to ancient rituals of the dead. Barthes's decision to place both an

icon and fresh flowers in his mother's room also appears as a form of veneration, a gesture that belongs to a liturgical lexicon, albeit a private one. But, the presence of the icon in the space in which Barthes mourns the loss of his mother has an even deeper connection to his conceptualization of images.

"Icon" is derived from the Greek *eikon* = likeness = image. Yet, as the history of the word *eikon* shows, the identity of *eikon* and image in ancient Greece cannot be taken for granted. The common notion of the image that we have inherited from antiquity is, itself, a historical category whose emergence depended on a crucial paradigm shift that occurred in the fourth century, with Plato as its central proponent. Jean-Pierre Vernant's work on the ancient anthropology of images and, specifically, his key essay "The Birth of Images" explains this shift in a telling manner.[68] According to Vernant, "The image, properly speaking: that is, the image conceived as an imitative artifice reproducing in the form of a counterfeit the external appearance of real things,"[69] is a construction of the classical period. Archaic man, in contrast, did not have a distinct category for mimetic representations of the visible world. He embraced a wider and more amorphous notion—*eidolon*—that denoted a spectrum of image presences. The core of this spectrum, which included a variety of natural and human-made forms of "likeness," was not mimetic or representational (in the Platonic sense). Rather, it primarily consisted of "super-sensible" phenomena such as transcendent visions, dreams, divine messages, spirits—the appearances of the dead to the living—and phantoms.

Vernant thus suggests that the new prominence of the term *eikon* as a philosophical and cultural concept can be best understood in the context of the terminological shift that is stipulated by Plato's philosophy in its attempt to redefine the ontological significance of images. According to Vernant, Platonic philosophy inaugurated a new terminology for speaking about images, and it concomitantly simplified and ultimately obliterated the traditional, and more complicated, semantic field within which the different senses of being-an-image resonated as meaningful. In instituting the concept of *eikon* to denote a figurative representation, Plato replaced the archaic word *eidolon*, which was not only more common but also broader and murkier, as well as transcendent and thus spiritually

and existentially more intense. Trimming this heterogeneous spectrum of being was essential, according to Vernant, to the Platonic project. And, Plato's ontology should thus be read in light of its deliberate effort to purge twilight entities that are rationally incongruent from the domain of the real. In this respect, image-as-*eikon* not only supersedes *eidolon* but establishes itself as a concept that downgrades the meaningfulness of an image to an empty appearance, redefining its visuality in clear opposition to what genuinely *is*.

A glimpse of the subjectivity of the image that was silenced by the new Platonic order is provided by the following encounter between Odysseus and the *eidolon* of his dead mother.

> I waited steadily where I was standing, until my mother
> came and drank the dark-clouding blood, and at once she knew me,
> and full of lamentation she spoke to me in winged words:
> "My child, how did you come here beneath the fog and the darkness
> and still alive? All this is hard for the living to look on,
> for in between lie the great rivers and terrible waters
> that flow, Ocean first of all, which there is no means of crossing
> on foot, not unless one has a well-made ship. Are you
> come now to this place from Troy, with your ship and your companions,
> after wandering a long time, and have you not yet come
> to Ithaka, and there seen your wife in your palace?"
> So she spoke, and I in turn said to her in answer:
> "Mother, a duty brought me here to the house of Hades."[70]

The intense conversation that develops between Odysseus and the *eidolon* of his mother makes clear why Antikleia's "image" is neither an empty apparition nor a kind of second-order representation of the real. Antikleia's *eidolon* is itself real and completely present even if the condition of its being is pervaded by absence. "The *eidolon* of Antikleia, Odysseus' mother" Vernant writes,

and that of Patroklos, Achilles' friend, are not only "wholly similar" and "entirely like" these two beings. In their voices, words, gestures, and thoughts, these *eidola* incarnate an actual presence that stands before the particular hero, who addresses them and converses heart to heart with one or the other, as though speaking to a real mother or friend.[71]

The *eidolon*, Vernant shows, manifests an unresolved synthesis between a real presence and an irremediable absence that archaic ontology could embrace.[72] In this respect, the enigma or logical incongruity at the heart of the conception of the image-qua-*eidolon* neither renders the image less genuine nor excludes it from the domain of the real. On the contrary, these peculiar dimensions of the *eidolon* only accentuate its fundamental rootedness in the spiritual depths of human experience.

Being upheld by an irresolvable tension between genuine presence and disconcerting absence, the acceptance and confirmation of the *eidolon*'s anomalous constitution by the archaic mind is well illustrated by the painful scene in which Odysseus's dead mother explains why, as an *eidolon*, she cannot be hugged:

> . . . I, pondering it in my heart . . . wished
> to take the soul of my dead mother in my arms. Three times
> I started toward her, and my heart was urgent to hold her,
> and three times she fluttered out of my hands like a shadow
> or a dream, and the sorrow sharpened at the heart within me, and so I spoke to her
> and addressed her in winged words, saying:
> "Mother, why will you not wait for me, when I am trying to hold you, so that even
> in Hades with our arms embracing we can both take the satisfaction of dismal
> mourning? Or are you nothing but an image that proud Persephone sent my way,
> to make me grieve all the more for sorrow?"
> So I spoke, and my queenly mother answered me quickly:
> "Oh my child, ill-fated beyond all other mortals,
> this is not Persephone, daughter of Zeus, beguiling you,

but it is only what happens, when they die, to all mortals.
The sinews no longer hold the flesh and the bones together,
and once the spirit has left the white bones, all the rest
of the body is made subject to the fire's strong fury,
but the soul flitters out like a dream and flies away. Therefore you must strive back
toward the light again with all speed; but remember these things for your wife, so
you may tell her hereafter."[73]

Barthes does not descend to Hades to meet his mother face to face. But, he does look through many photographs until he finally "discover[s] her *as into herself.*"

> The Greeks entered into Death backward. . . . In the same way I worked back through a life . . . of someone I love. Starting from her latest image, taken the summer before her death . . . I arrived, traversing three quarters of a century, at the image of a child . . . of the mother-as-child.[74]

In *Camera Lucida*, Barthes describes his incessant preoccupation with finding a photograph that would embody his mother's true being. At first, "none seemed . . . really 'right': neither as a photographic performance nor as a living resurrection of the beloved face."[75] In those photographs, he was only able to recognize different fragmented aspects of his mother's appearance, different "masks," which made it clear to him that he "missed her *being* . . . missed her altogether" and that he was thus compelled "to perform a painful labor; straining toward the essence of her identity . . . struggling among images partially true, and therefore totally false."[76] This "Sisyphean labor"—as he calls it, thereby alluding to Hades—ultimately brings its rewards.

> There I was, alone in the apartment where she had died, looking at these pictures of my mother, one by one, under the lamp, gradually moving back in time with her, looking for the truth of the face I had loved. And I found it.
>
> The photograph was very old. The corners were blunted from having been pasted into an album, the sepia print had faded, and the picture just managed

to show two children standing together at the end of a little wooden bridge in a glassed-in conservatory, what was called a Winter Garden in those days. My mother was five at the time (1898), her brother seven.[77]

Barthes's reflections on his mother's appearance in the Winter Garden photograph is one of the most discussed episodes in the scholarship on *Camera Lucida*, and this allows me to forgo an analysis of my own. But I mention the Winter Garden photograph because, for Barthes, "something like an essence of the Photograph floated in this particular picture."[78] As he returns again and again to the "Winter Garden," it becomes his measure of a genuine photographic image and, interestingly, his articulation of the essence of that "Veracious" and "Just"[79] image clearly evokes the Homeric *eidolon* even as it parts ways with the traditional Platonic conception of the *eikon*.

The first lesson that Barthes draws from the Winter Garden photograph is a negative one: Likeness—adequate representation—cannot provide a sufficient condition for genuinely encountering one's beloved in a photograph (likeness "only gave me her crudest identity, her legal status," etc.) As likenesses—and they are always also likenesses—photographs are lifeless death masks, disjointed surfaces that remain entirely separate from what they make visible. But, the photograph (and it's unclear whether Barthes really thinks this about all photographs) may relate to the real in yet another unexpected way, one that ultimately leads Barthes "to that cry . . . There she is!"[80] What the Winter Garden photograph teaches Barthes is to bracket the common understanding of the photographic as a mere likeness of something that appeared in time (and, as such, is no longer present). Photographs can indeed serve as copies of a lover's lost presence, but they can also do something else: They can make the beloved herself present. Instead of substituting or making up for an absence with a copy, photography can uphold and protect the beloved's actual presence with a vibrancy that bears the mark of her absence:

> In this veracious photograph, the being I love, whom I have loved, is not separated from itself: at last it coincides. And, mysteriously, this coincidence is a kind of metamorphosis. All the photographs of my mother which I was looking through

were a little like so many masks; at the last, suddenly the mask vanished: there remained a soul, ageless but not timeless.[81]

What shows itself in the image of the beloved is not a mask but the actuality of the soul that Barthes also names in the diminutive, *animula*.[82] But, as in the case of Odysseus's mother, this spirit, this *eidolon*, is in the present only by virtue of the past. This is also a way to access Barthe's famous claim that "the very essence, the *noeme* of Photography" takes the form of "That-has-been." Photography creates "a superimposition . . . of reality and of the past."[83] The now of looking at a photograph accesses visual content that always belongs to a moment in the past. I look now—and I concomitantly look back—at what comes to meet me from the past. The photographic presence of the "being I love" is always also a presence of "whom I have loved," and yet, in the photograph, the person I love is *"without future."*[84] The beloved's appearance is harshly severed from the future, but it is inseparable from the past, from the resonance of a movement toward the present that can only be embraced by the viewer's retroactive gaze that collects into itself time that was lost. "The Winter Garden Photograph, however pale, is . . . the treasury of rays which emanated from my mother as a child, from her hair, her skin, her dress, her gaze, *on that day.*"[85]

Barthes describes himself as being awakened by the Winter Garden photograph. His personal experience with the photograph coincides with a transformation of his generally indifferent attitude toward "the daily flood of photographs . . . the thousand forms of interest they seem to provoke." Looking at this specific photograph, he feels "the effect of a new experience, that of intensity," triggered by the photograph's "paradoxical order," which opens for him "the truth of the image, the reality of its origin."

I had identified truth and reality in a unique emotion, in which I henceforth placed the nature—the *genius*—of Photography.[86]

By putting things this way, Barthes alludes to the initial framing of his philosophical project at the opening of *Camera Lucida* and, specifically, to that emerging "ontological

desire" that sent him on the quest of finding "what photography was 'in itself.'" It is also in that same opening passage of *Camera Lucida* that Barthes first mentions his search for the "genius" of photography. This term alludes to the Roman idea of a "tutelary spirit" that is born with a person, guiding the individual throughout life. For Barthes, it is the scene of mourning in which the living spirit—the *eidolon*—of the photographic image shows itself; or, in other words, the photographic takes on its form (unknowingly perhaps) under the sign of Butades. In what follows, I explain this further by considering Barthes's methodology and, specifically, what he presents as his "ontological" approach to the photographic image.

8. ONTOLOGY, RELATIONALITY, AND LOVE: SAYING GOODBYE TO BARTHES (PROPERLY)

It took me years to realize that there was a problem with the bold proposal that I had admired so much in Barthes: to think of photography in an ontological manner. I have only recently come to see that what was so innovative in Barthes's ontological turn is ultimately related to a narrow image of photography and, specifically, to what I call the Butades picture. But, in order to explain this, let me first say a few words about what it was in Barthes that captured my philosophical imagination.

At the outset of *Camera Lucida*, Barthes announces his ontological turn, which he frames as a philosophical change of heart. He tells his readers that he was overcome by an "'ontological' desire," a philosophical mood that transformed his "interest in photography," distancing it from the "cultural turn" that marked his previous work. This move from a cultural to an ontological understanding of photography also represents an affective shift, one that leads him from a theoretical mode of thinking motivated by an *interest* in photography to a mode of thinking permeated by *desire* with its reverberation of philosophy's originary—all too often forgotten—Eros.

Barthes's emerging "ontological desire" is the other side of what he describes as his "ultimate dissatisfaction" with "the discourses of sociology, of semiology, and of psychoanalysis," a dissatisfaction tied to his "desperate resistance to any reductive system." For

Barthes, the need for an ontological turn implied the insufficiency of cultural analysis for understanding photography. The point was not that photography is ever independent of a cultural matrix—the kind of matrix mastered by Barthes—but that the language, codes, and operations of that matrix are ultimately insufficient for capturing the unique essence of the photographic image. The photographic image cannot be understood as long as we frame it only (in terms of its features) as an artifact, a given kind of image within "the community of images."

Barthes' evocation of ontology is not, however, just a call for a supplementary theoretical discourse that would illuminate previously unexplored dimensions of the photographic. Ontology is not just another given—readymade—perspective of investigation (or domain of inquiry) but a fundamental mode of questioning that requires a distinctive form of sensibility: an attunement to the *logos* of the ὄν. To speak of the ontological is to evoke the question of being, a question that, as Barthes knew, does not relate to those theoretical discourses that hold "an object"—a "some-thing"—at their center. This question can only be asked in light of what Heidegger termed the "ontological difference": the difference between the objecthood of an object—its contextual determination *qua* object—and the being of that object. In a corollary manner, we may understand Barthes's declared ontological turn as a reframing of the question of photography by bracketing the photograph's object-related, culturally embedded parameters and focusing instead on its unique mode of presence: that is, on the being of the photographic image, its modality as a photographic-being. In other words, Barthes is inviting his readers to listen anew to the question posed to and by photography. "What *is* photography?" is a question that needs to be asked while shifting the emphasis away from the familiar *what* category to the verb *is* ("to be") whose blandness hides an enigma that must be articulated.

Seen in this Heideggerian light, the first step toward articulating the condition of being-an-image is to make room for the dynamism, for the becoming, which is always already part of being. If Heidegger is the philosopher who taught us—as Emmanual Levinas puts it[87]—how to hear the resonance of the *verb* "to be" in the concept "being," then Barthes is a thinker who teaches us how to recognize the active presence of that

verb in the photographic image. Another way of putting this is to say that for Barthes, the question of the image's being is one that must be answered in terms of the image's inner vitalism, its mode of becoming. This is apparent in his evocations of the spirited essence of the photographic image, which he repeatedly refers to as the "genius" of photography. In this respect, just as Barthes is known for his attempt to recover the forgotten form of the *middle-voice*[88] for writing, he should also be valued for his effort to recover the spirited form—the subjectivity—of the archaic *eidolon* for image theory.

Barthes's ontological turn should be understood, in this context, as paving the way for a new theorization of images, one that explores the intermediate ground between two paradigmatic and oppositional approaches to the image. First, Barthes turns his back on a traditional—call it Platonic—framework in which the conceptualization of the image is grounded in the opposition between being and appearance. In this tradition—as we've seen with the *eikon*—the image is understood as a likeness or representation that draws its significance from that which it represents without in any way being part of the real. When construed in this way, the image gives itself to thought only in terms of what it is not: that is, in terms of a more basic kind of entity—an object, an event, a state of affairs—whose presence is re-presented. In this case, the image is naturally relegated to a secondary, derivative domain of existence: It is a copy, a double, a substitute.

In contemporary theory, Platonic criticism of the image's ontological inferiority—its implied ethical and political dangers and the corollary moral admonition that it calls for—seems to no longer resonate. And yet the common tendency to think of images— say, in the discipline of art history—in terms of what they represent and the historical, social world that they depict is still quite common. This, of course, no longer provokes ambivalence or even hostility, but it nevertheless continues to reproduce the structure that underlies the image's ancient inferiority complex.

In opposition to the Platonic framework, the twentieth century has offered us a whole family of positions that resist the idea of image-as-representation while empha-sizing the image's autonomy. One of the most common ways of understanding the au-tonomy of images is in terms of their objecthood: Rather than focusing on the ways in

which images can be said to be *about* the world, they are addressed primarily via the manner in which, as objects, they take part *in* that world. Indeed, the framing of the image in terms of the place it occupies or the role it plays in the world that it depicts often succeeds in granting it new forms of autonomy. Yet, this autonomy typically remains grounded in the same traditional opposition between the object (with the fullness of its being) and that which lacks genuine rootedness in the world of objects. In this respect, the positing of the object as a model for the image obscures the (ontological) question of what it is to be an image, of what is unique about an image's being.

Following this Heideggerian impulse, Barthes is thus also reluctant to embrace the anti-Platonic interpretation of the image as object. For him, the being of an image can neither be reduced to the place that the image occupies *in* nor to the effects it exercises *on* the world. Ontology calls for thinking about the image's being in a way that goes beyond the question of its content or functionality. Barthes, we should underscore, uses scare quotes to introduce the term "ontological" just as he dubs the phenomenological vocabulary he uses—a vocabulary so central to his work—as a "casual, even cynical phenomenology." But, in spite of these distancing gestures, something has nevertheless changed in Barthes's theoretical temperament by the late 1970s. And *Camera Lucida*, in particular, brings him closer to phenomenology and perhaps even closer to Heidegger, whose "heavyweight"—abstract, somber, slow, root-searching, modernity-hating—style of philosophizing had previously been antithetical to Barthes's position as a thinker and writer.

Barthes dedicates *Camera Lucida* to Sartre's *The Imaginary*, and it is indeed Sartre with his *Essay on Phenomenological Ontology* who, in the most immediate way, exemplifies for Barthes what a phenomenological approach to ontology might look like. Heidegger's influence seems to be a much later development, whose extent becomes apparent when we attend to the references to Heidegger in Barthes's posthumously published texts of the same period (such as his 1979–80 lectures at the Collège de France).[89]

Barthes's posthumous publications confirm the presence of ontological concerns and ontological sensitivity in his later writings. But my point is neither to reconstruct

these concerns nor to corroborate their specific ties to Heidegger's *Seinsfrage*. What is at stake here, in other words, is not the roots of Barthes's ontology of the photograph but the afterlife of that ontology. It is, in my view, only through *Camera Lucida*'s evolving afterlife that Barthes's photo-ontological turn acquires its significance. To be more precise, the ontological motivations in *Camera Lucida* deepen when we read them through the prism of central developments in image theory—specifically through "the pictorial turn" that took place in the decades following Barthes's death.

I'm thinking here of a spectrum of very different thinkers and theoretical approaches—from philosophy to *Bildwissenschaft* to art history; from Deleuze, Rancière, and Jean-Luc Nancy to Belting, Didi-Huberman, Mitchell, Whitney Davis, and Michael Fried—all of whom, in different ways, have made ontological thinking central to the study of images. What these thinkers share is an anti-Platonic approach that is aware of the need to articulate a modality of presence that uniquely belongs to images *qua* images (and not as objects or functions). And here, the subsequent formulations offered by theory to the image's dynamics, efficacy, desire, vitalism, and even the image's subjectivity may be placed on a trajectory that continues Barthes's preoccupation with photography's phantasmagoric life.

At the same time, what these more recent theoretical developments illuminate through their successes and failures is not only the originality and potential of Barthes's ontological vision of the photographic, but also the limits and limitations of his particular manner of undertaking this ontological turn. And in this context, there is a specific set of methodological presuppositions that regulate his photo-ontology with which I want to take issue. Barthes lays out his ontological path in terms of a desire to "learn/know at all costs what photography was 'in itself,' by what essential feature it was to be distinguished from the community of images."[90] This formulation is reminiscent of Sartre's way of introducing his own turn to the image in *The Imaginary*: "It is therefore necessary," Sartre writes, "since we want to talk of images . . . —that the image, taken in itself, contains in its inner nature an element of radical distinction."[91] But, despite an apparent family resemblance, Barthes's language ultimately suggests a different understanding of

the ontological. The core of this difference lies in Barthes's desire to determine what photography is "in itself," "*en soi.*" In so doing, Barthes forgets the Sartrean lesson of the "*pour soi,*" that is, the understanding that the "inner nature" of the image is what it is due to its grounding in the relationality of human consciousness.

For Barthes, ontology not only provides an explanation of what photography is and what constitutes its uniqueness, but it does so under the implicit assumption that photography "in itself" can ground this uniqueness and that the essence of the photographic can thus be comprehended only by looking at photographs. Barthes is, of course, extremely mindful of the plurality of image types—the "community of images"—that make up the domain of the visual in modern culture. But this plurality is, for him, only secondary to and derivative of the independent identity that given types of images such as the photograph have.

My point is that, on a methodological level, Barthes's search for the "genius" of photography remains tied to a more traditional and static conception of essence, one that is anchored in the object's intrinsic features and that, as such, occludes discussion of a few critical dimensions of the photographic that resonate, in fact, in the idea of "genius." These are: the continual evolution—the becoming, the transformation—that is part of photography's ongoing life and, in a corollary manner, the dimensions of difference and relationality that are immanent to photography's being. In searching for photography's essence in the isolated "in itself" of photographs, Barthes prevents himself from seeing that photography acquires its unique identity only through participation in the intricate relational matrix of a "community of images."

Relationality is a crucial methodological lacuna in Barthes's ontology. The effects of this lacuna are consequential and appear as blind spots on four different levels of his thinking about the being of the photographic.

1. Photography's inner plurality, the relation between different modalities of being-a-photograph, that comprises the heterogeneous field of the photographic: Barthes operates under the implicit assumption that the variegated field of the photographic has a cohesive, self-identical, inner structure/core.

2. Photography's dynamic relation to and relational position within "the community of images"; the interaction, within an evolving relational network, of the photographic and the non-photographic: Barthes operates under the implicit assumption that a photograph is what it is independently of the position it occupies in, and the evolving relationship it has with, the global domain of images.

3. The relation between the photographic image and the more general constitution of the image *as* image; the relation between being-a-photograph and being-an-image.

4. The relation between photography's synchronic and diachronic dimensions; the relation between the ontology and the history of photography, between the "what is?" and its historical development.

Barthes's photographic turn was novel, but it had its revenges. The very gesture that opened the photographic to ontology also narrowed the topography of the ontological in such a way as to blur the potential that the question of being had for the study of photography. This predicament is not unique to Barthes, however. Barthes serves here to exemplify a misuse of ontology that is prevalent in photographic theory. Ontology is not, as it is often understood, "an all-inclusive definition of photography or a list of medium-specific characteristics that would set photography apart from other media."[92]

Indeed, if photographic theory is a conceptual systematization of the multifaceted aspects of the photographic phenomenon, then ontology is the opposite, or the outside, of theory. What ontology—and, we can also just say, philosophy—brings to the theory of photography is an open question, one that requires us to be responsive to the *logos* of being within a system of objects, objectives, and objectivities that, by definition, cannot allow such nonsense. Ontology's task is not to systematize but to open photography to the way in which its presence can be seen as a branch of being. Or, as I have previously stated, ontology teaches us to see the photographic as an Existential. I think that Barthes's core motivations in *Camera Lucida* were not very different.

And, yet, he couldn't attain this goal, while holding onto a notion of essence that could only lead to a self-enclosed, monolithic picture of the photographic. What primarily eluded Barthes was a crucial dimension of difference that is integral to the space in which photography's being becomes legible. Barthes had a clear ontological desire. He was unable to fulfill it because his exclusive way of focusing on the desired object could not accommodate the supplemental presence of an ontological difference. He could not see that the photographic object is never self-identical or self-contained but always relational (ontological difference primarily means the non-identity of the object's being and its object-form). Without a notion of ontological difference, the philosophy of photography would remain a pure abstraction and the history of photography a mere positivistic rendering of facts. In photographic theory, ontological difference is hardly addressed. This goes hand in hand with a common tendency to avoid a crucial question: How should we understand the relationship between the ontological conditions—the being—of the photographic image and the historical space within which it singularizes itself?

Avoidance of this question is analogously symptomatic of a tendency to construe the photographic image in one of two opposing ways—either by embracing a closed visual identity for the photograph (with respect to other genres of images or with respect to its own technological developments) or by locating the photograph's *modus operandi*, its pulsing heart, in a more basic, general notion of *the image*.[93] The latter is what happens in Barthes, who searches for the ontological specificity of the photographic image but does so while making irrelevant the more general question of what an image is and of how, from a historical perspective, it acquired the specificity of its photographic form. In shelving these questions, Barthes is unable to consider the identity of the photographic within its relational, dynamic, and historical setting. And, thus, in spite of his best intentions, he ends up interpreting the photograph's uniqueness in terms of general, preexisting ideas of what an image is. In other words, photography inadvertently becomes an illustration of a preexisting independent notion of *the image*—a notion specifically extracted from Pliny's tale. We've called this notion—with its triangulation of love, loss, and mournful memory—Butades.[94]

9. THE FIRST NEGATIVE

Reflecting on the Butades paradigm, I think that Rejlander's *First Negative* deserves a second look, one that searches beyond the apparently obvious interpretation that regulates its reception by historians of photography. Indeed, in creating a photographic version of the Butades tale, Rejlander seems to be making an explicit statement about photography's origin: Nature is the cradle of the photographic image. The photograph, like drawing and painting, develops from a natural negative—a shadow that belongs, in both the literal and figurative sense, to the core of human life in which absence and death are always imminent.

And, yet, while the photo's visual proclamation, enhanced by its two titles, seems clear, there is something about *The First Negative* that does not allow the eye to happily plunge into what it sees. Bluntly speaking, the photo is visually boring, especially in comparison to the dramatic and erotic (even the merely sentimental) depictions of the Corinthian maid in the tradition of painting. When I first became interested in Rejlander's photograph and started to spend time with it, I had to write off this deadening affect as irrelevant. I ignored the fact that the photograph did not appeal to me in any aesthetic sense by contextualizing the work and focusing on its iconography. But, with time, it dawned on me that the photograph's affect is very much relevant and that what it reveals, once one notices its oddities, is something that is incongruent with its thematic core.

The key to what's unique in Rejlander's articulation of the Butades story (in contrast to the way the theme is handled by Romantic classicism) is the picture's visual literalness. The photograph presents the basic elements of Pliny's tale (a man, a woman, a shadow, an act of tracing), but it seems to make no room for the dramatic resonance of the situation within which the mythical act of drawing transpires. Desire and loss, love and death, these are not evoked in the photograph's visual presentation: There is neither affection nor suffering in the relation between Butades and her lover. And, no effort seems to be made to tie Butades's gesture to her lover's imminent

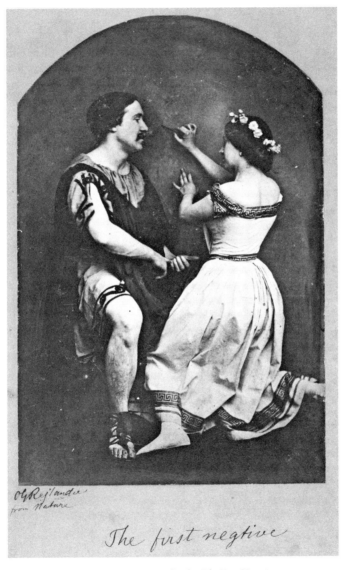

FIGURE 15. Oscar Gustav Rejlander, *The First Negative*, 1857.
Musée d'Orsay, Paris. Art Resource.

departure or to her experience of abandonment. Her act of drawing bears no trace of its rootedness in an amorous relation or, more specifically, to the crisis of separation that threatens the lovers' relationship. On the contrary, the man appears to be deliberately posing for Butades and authoritatively surveying her deeds as if he has commissioned her to work for him. Butades, for her part, appears to be carrying out a technical task, one she has been trained to do and in which she engages in a neutral and controlled manner.

But, the dramatically impoverished—sometimes I think grotesque—way in which the photograph stages the Butades tale has to do with yet another aspect of the photograph that typically escapes attention. *The First Negative* is not only emotionally flat; it is also—and this becomes clearer the longer one looks at it—peculiar in its arrangement of the bodily positions of its protagonists. Butades and her lover are presented as collected, even self-possessed, but their bodies seem to lack weight; they give the impression that they are floating. A closer look at the photograph reveals that, in fact, the two figures do not have their feet on the ground; rather, they are standing on blackened supporting props that are meant to remain inconspicuous.

This at once illuminates and can be explained by the staging that went into the photograph's composition. (We know, for instance, that the figure of the man was played by the head of an acting company, the British tragedian John Coleman.) But, staging the Butades scene for a camera turns out to be a harder task than one might imagine. Finding a point of view that fully displays the story is something with which the painter Joseph Wright of Derby also struggled. In his correspondence with Josiah Wedgwood, who commissioned his *Corinthian Maid*, he speaks of how he must twist Butades's body while also changing its "natural" proportions in order to allow for the shadow and the act of tracing to become simultaneously visible in his painting. Rejlander's props serve similar purposes. They allow the figures of Butades and her lover to be positioned in such a way as to maximize the visibility of the tale's basic elements.

But they have another effect as well. At this early stage in the development of photography, events could only be captured if they were motionless; this means that the

photographed figures must have strenuously held their positions. The need to find a position that would allow the models to remain in balance, to keep from moving, may explain why Butades is touching the wall with both of her hands or why the man is holding his hands together. From this perspective, what we see in Rejlander's picture is not the playing out of the mythical scene of Butades—not a representation of an action—but a depiction of a motionless *tableau vivant*.

Yet, a problem arises here: The gist of the Butades scene is an action, and an action essentially defies the motionless condition of being photographed. In negotiating this problem, we better understand the effect of Rejlander's concealed props. By lifting the figures above the ground, the props are intended to create the appearance of movement in otherwise stationary bodies. Rejlander staged a *tableau vivant*, but he was also concerned with creating an illusion of movement for the potential viewer. His solution was to rely on a covert mechanism of presentation that upholds the photographic as a form of contrived appearances.

The feigned character of this photograph becomes especially interesting when we recall the inscriptions that Rejlander wrote on the *passepartout* that frames his photograph. In addition to the centrally positioned title *The First Negative* (in which the word "negative" is interestingly misspelled as "negtive") the work also bears, on its lower left side, Rejlander's signature with another inscription: "from nature." Both "first" and "from nature" are terms that seek to establish photography's primordial and autochthonous standing. The underlying claim, as we've seen, is that photography is rooted in nature and that it naturally develops nature's visibility into a form of a picture. This statement about the essence of photography is, of course, self-referential. In referring to the essence of the mythical scene of Butades, the inscriptions "The first negative" and "from nature" also relate to Rejlander's photograph itself, which, according to the same logic, is also rooted in the continuous unfolding of nature's visibility. This expectation is confirmed by the juxtaposition of the inscription "from nature" with Rejlander's signature, suggesting that it functions as an adverbial qualifier of the photographer's act: "Rejlander makes pictures from nature"—a claim that, like the concealed props,

disguises the artificial construction that makes possible the appearance of the natural—or the natural look of appearances.

What we see in *The First Negative*, in other words, is the photograph's determination to appear (to create an appearance of itself) as intimately rooted in the natural. But such efforts, in concealing themselves, only accentuate the fact that the photograph's identity lies elsewhere. In this respect, Rejlander's visual statement can be seen as foreshadowing the kind of advice one gets today on the internet on how to take the perfect selfie: When taking a selfie, the most important thing is to appear authentic.

10. BUTADES AND *THE PENCIL OF NATURE*

My interest in photography's relation to Pliny's tale was initially triggered by a photograph. It emerged when I was spending time looking at Karen Knorr's *The Pencil of Nature* (1994), which is part of her *Academies* series and which was taken in a corridor of the Swedish Royal Academy of Arts in Stockholm. Between a large neoclassical statue of a nude man on a pedestal (whose torso alone is visible) and a medallion relief that depicts a man's head in profile (which is hanging on the wall and can be seen through a glass partition), the photograph stages a scene that evokes the anecdote or myth immediately familiar to the art historian. At the very center of the picture, two women are intensely engaged in a joint endeavor: One traces the shadow of the other's face as it falls on a wall.

My reflection on Knorr's *The Pencil of Nature* began with a point that may seem obvious: The work opens up to its viewer through an intertwining, a doubling, of two originary moments in the life of images. While its title alludes to the origin of photography, the image itself evokes the more primordial origins of drawing. Knorr's *The Pencil of Nature* is a nod to the title of Talbot's first photographically illustrated book (1844), a title—and trope—used by the British inventor of photography to introduce to the general public the principles involved in producing a new kind of image. At the same time, what we see *in* Knorr's picture—its visual theme, so to speak—is a nonstandard feminized variation on Pliny's influential myth of the origin of drawing (or painting).

Given the consistent popularity of the tale of the Corinthian maid, the connection Knorr draws between Talbot and Pliny is, at first sight, hardly surprising. And indeed, Knorr's *The Pencil of Nature* may easily lend itself to a reading that underscores the rootedness of photography in the same primal setting from which the tradition of

FIGURE 16. Karen Knorr, *The Pencil of Nature*, 1994. Courtesy of the artist.

visual representation emerges.[95] But thematizing the photograph in this way would immediately distract us from a crucial complexity in the manner in which it addresses its viewers.

Knorr's *The Pencil of Nature* pictures (articulates in a pictorial way) the origin of drawing. It deals with the origin of the image by presenting an image of origin. This image *on* origin is, itself, a photograph whose photographic being is alluded to in the work's title. But, in bearing a title that invokes Talbot's invention, Knorr's work also seems to be saying something about photography's origin and the way that story of origin is apposite to an understanding of the image that it photographically presents. If that's the case, then we cannot take for granted the connection between the title and the picture's content, and indeed, how the latter complicates the former. The apparent tension between what we're told *of* and what we see *in* the photograph should be understood as an invitation to ponder a question that is, in fact, addressed to the viewer: What is the significance of the way in which saying and showing are brought together here? And why tie the origins of photography to the much older origins of drawing? Should the simultaneous reference to these two distinct origin stories be understood as but two variations on a theme, or is the work making its way (as it dawned on me) toward dividing the image of origins from within, presenting non-identity as integral to the question of the image's origins?

Knorr's photograph was made at the very end of photography's analog era. Soon after, the artist would begin to work with digital technology, and I cannot but ask myself whether the work's entanglement with the origins of the image—and particularly with photography's origin—has to do with (latent) concerns over photography's changing condition, the gradual disappearance of a spectrum of visual options, and the advent of new image modalities.[96]

New or old, I think that the modal quality of images is clearly an issue for *The Pencil of Nature*, in which the act of drawing is depicted as part of a wider range, a plurality, of image modalities. In addition to drawing, we see a high-relief medallion, a statue, and ephemeral traces of bodies and objects in the reflections that appear on a black floor

that functions as a mirror—not to mention the pronounced presence of the shadow (or rather, a series of shadows of which only one is being traced). We know that the act of drawing being depicted at center stage is bound to produce an image, but that image is not (yet) a *fait accompli*; it cannot be seen in the artwork. It lacks materiality, but, being congruent with a perspicuous shadow, its potentiality as an image is abundantly clear. The foregrounding of this modality of becoming-an-image is, in my view, of central importance to Knorr's picture. And it ascribes to drawing an axial position on a spectrum leading from prototypes to well-determined images, from "natural," intangible appearances to plastic renditions of images that function as artifacts.

Knorr's *The Pencil of Nature* invites us to ponder the relationship between these different procedural modalities of the image, reminding us (through its title) of the presence of the photographic image that represents all these modalities without leaving a trace of its own medial identity. What's more, just as Talbot's *The Pencil of Nature* conveyed what the author understood to be photography's natural condition of representationality, a more general question arises here: How should we understand the relationship between the ontological conditions of the photographic image and the historical space in which it singularizes itself?

SEPARATION 2

- Didn't you say that this book is about separation?

- Yes, it deals with that moment.

- But, how is this connected to photography? What does photography have to do with separating?

- The question, for me, is about how to part ways or how to say goodbye properly.

- Separating from whom or from what? Do you mean to say, as Barthes does, that photography is itself a way of saying goodbye?

- Photography has its ways of welcoming and bidding farewell.

- Are you thinking of separation in a different sense?

- Yes and no. I am primarily thinking of the act of saying goodbye to photography itself. **115**

- So, Barthes is not relevant here?

- Barthes *is* relevant. He is someone to whom I definitely want to say goodbye. But, what's important is how to part ways *comme il faut*.

- What do you mean by "*comme il faut*"?

- I use the term in its literal sense, not in the customary formal sense of complying with etiquette, but rather in the sense of doing what needs to be done.

- Needs?

- An opportunity arises in the event of a separation, and the question is how one attends to and responds to that opportunity. I often think of this as acting with a precision within the moment—for example, when looking someone in the eye and saying (for the last time) "adieu" or just "see you later."

- Are you thinking of this act as a work of art?

- No . . . well, sometimes . . .

PHOTOGRAPHY AND THE DEATH OF GOD

1. TALBOT'S SHADOWS

The isomorphic relationship between the conditions of photography's birth and Pliny's imagery of the Corinthian maid has consistently been a popular theme in both art and theory. Under the sign of the shadow, this isomorphism is typically articulated in terms of the basic features shared by photography and the mythic paradigm of the first image: the copy, the trace, the index, and the positive/negative relation as well as the more general or transcendental themes, such as the triangular structure of presence, absence, re-presentation, or in a more psychoanalytic guise, of a desired object, loss, and memory. Yet Talbot's famous description of his invention, the "art of fixing shadows," not only affirms photography's rootedness in both nature and in the drama of human transience, it also provides an unintended commentary on the ambivalent relation between photography and the shadow.

Photography may have been born amid the shadows, but its relationship to them was complicated from the start. The first working title that Talbot chose for his early pioneering experimentations was *skiagraphy*, a term he borrowed from ancient Greek writings on art and that literally means "shadow drawing" or "shadow writing." By the time he introduced his invention to the public in January 1839, shadows were still central

117

to its imagery, but Talbot had already redubbed his method "photogenic drawing." The name change represented a move away from the shadow and the positing of light (the Greek *phos, photos*) as the invention's foundation—an assumption that became the trademark of "photo-graphy." In addition to "photogenic drawing," Talbot nevertheless continued to speak of the "art of fixing shadows" alongside the invention's formal titles, suggesting a duality despite what the new names for his invention seemed to efface: Before light there was the shadow.

Talbot's rhetorical move from shadow to light was only the first step in a gradual transformation by which the shadow was slowly erased from photographic terminology. This had to do with a contradiction that the shadow revealed within the photographic, and that, as such, needed to be obscured. Photography's inner logic required that it hide its dark birthmark in order to come into its own and materialize as a coherent pictorial medium. In this context, the idea of the shadow as "the first negative," a reaffirmation of photography's rootedness in an origin myth, in nature, was only part of a wider campaign that allowed photography to conceal the equivocality that can still be heard in the invention's early epithet.

The first lesson to be gleaned from the "art of fixing shadows" is that photography's shadow is far from a transient phenomenon of nature. Photography is a "fixed," morphed shadow that is at odds with the intrinsically evanescent presence in the Butades paradigm. Photography's shadow could only assimilate the form of Pliny's shadow on the condition that its oxymoronic identity be suppressed. What makes the art of fixing shadows oxymoronic is that it ensues from a conflation of two antithetical configurations of the visible: the vision of an embodied, temporally and historically situated human eye that is deeply sensitive to nature and a then-new—and ultimately more dominant—form of instrumental vision (a machine vision) that aims to overcome transience, reify the instant, and consume the delicate offerings of nature's silhouette. The shadow could only continue to be part of photography's self-image provided that photography contain this contradiction. In Talbot's writing, the shadow's equivocality is upheld by a rhetorical strategy that separates—and blocks any negotiation between—a romantic sensibility

based on a phenomenological insight and a "cost-effective" determination to instrumentalize nature. This separation could hardly be maintained for very long. The rhetorical turn from the shadow was a necessary purge to ensure that there be no reminder of how Talbot's unique sensitivity toward the gift of nature had instrumentally reappropriated that gift. This dialectic, through which the shadow sustained its equivocality and ultimately lost its place in photography's primal scene, is crucial to understanding what was new in photographic visuality. In what follows, I show what was unique in Talbot's philosophy of the shadow and then explain how, despite its deep, sensitive insight into the ontological significance of shadows, this understanding was turned on its head.

2. THE MOMENT OF THE SHADOW (BEFORE THE IMAGE)

Talbot's unwritten philosophy of the shadow develops in relation to two practical concerns that are crucial to his invention: the fleeting character of the images that appear on "sensitive paper" and the negative form of these appearances. Whereas these two issues primarily preoccupy him on a technical level, they also open up the question of the meaning of the term "shadow." The shadow is closely related to and, at times, even seems interchangeable with the "image," but the two terms are not identical. This is a crucial but easily overlooked point, for Talbot never explicitly distinguishes between these entities. At the same time, as can be gleaned from his use of the term, shadows are most typically evoked to denote an aspect of the image's appearance. The shadow is associated with the "how" of becoming a photographic image. It is an adverbial dimension of that appearance, a dimension that tends to go unnoticed when the image is regarded as a fully formed object.

Hence, in the famous fourth section of the invention's announcement, "On the Art of Fixing the Shadow," Talbot presents the event of photography in the following way:

The phenomenon which I have now briefly mentioned appears to me to partake of the character of the *marvellous*, almost as much as any fact which physical investigation has yet brought to our knowledge. The most transitory of things, a shadow,

the proverbial emblem of all that is fleeting and momentary, may be fettered by the spells of our *"natural magic,"* and may be fixed for ever in the position which it seemed only destined for a single instant to occupy. . . . Such is the fact, that we may receive on paper the fleeting shadow, arrest it there, and in the space of a single minute fix it there so firmly as to be no more capable of change, even if thrown back into the sunbeam from which it derived its origin.[1]

Photography is described as a marvelous phenomenon that unfolds, as a drama whose protagonist is the shadow. The operators of this shadow theater are the "methods of modern science, which by noticing the occurrence of unusual circumstances . . . and by following them up with experiments," lead us "to consequences altogether unexpected, remote from usual experience, and contrary to almost universal belief."[2] Within this theatrical space, an unfathomable event takes place. The ever fleeting shadow, "the most transitory of things," falls prey to an act of natural magic (experimental science). The living emblem of ephemerality is captured and stripped of its protean powers so that it is "no more capable of change."

Talbot speaks of the shadow in a language that, as he knew well, reverberated with literary and metaphysical overtones. As "the proverbial emblem of all that is fleeting and momentary," the shadow turns time into a fundamental theme for photography and specifically alludes to human temporality and transience. *Tempus Fugit,* "time flies," was a phrase commonly used by Talbot's mother, Lady Elizabeth Fielding, in the letters she wrote to her son; and Talbot, who knew large parts of Virgil's *Eclogues* by heart (in Latin)—-including the lines he uses as the motto for *The Pencil of Nature*—was of course familiar with her allusion, just as he was familiar with the proverbial words of the psalmic poet: "My days are like a shadow that declineth; and I am withered like grass" or "Man is like to vanity: his days are as a shadow that passeth away."[3]

Against the background of these "proverbial emblems," Talbot boasts of an invention that enables natural appearances to resist and overcome time. The shadow is a feature of the image that momentarily shows itself on the sensitive paper and that must

be captured before it disappears. Talbot was not alone in his pursuit of a solution that would address these concerns. His invention was part of a larger, mainly unsuccessful, effort to produce pictures by harnessing light. These attempts were based on the understanding that in the production of images, light is not only the image's efficient cause but also (together with the surface) its unique material cause. This understanding predates Talbot's invention and was already used in the eighteenth century as the foundation of experiments that allowed light to leave its mark on surfaces in the form of images. And yet, as Talbot knew, these proto-photographers faced a weighty problem for which they had no solution: Once an image registered itself chemically on the sensitive surface, viewing it as an autonomous picture (for example, independently of its appearance in the *camera obscura*) became a problem because light continued to darken the sensitive surface, ultimately leading to the loss of that image altogether.

As he announces the invention, Talbot presents this problem in a distinctively personal manner: "At the very commencement of my experiments upon this subject," he writes, "when I saw how beautiful were the images which were thus produced by the action of light, I regretted the more that they were destined to have such a brief existence, and I resolved to attempt to find out if possible, some method of preventing this, or retarding it as much as possible."[4] Talbot speaks here retrospectively. His experiments relied on procedures that were already available together with a set of, until then, unresolved technological problems that he managed to solve. The most acute of these problems was the inability to secure the permanence of these image-appearances. It is here that Talbot's contribution became so crucial: Talbot was able to successfully fix the shadow, and in the process, he created what became known as "fixer."[5]

Yet a technical understanding of what a fixer is should not obscure the metaphysical resonance of the words Talbot uses to describe the imminent loss of these beautiful images that he wants to preserve. Marveling at the beauty of these shadows and knowing that they are bound to disappear forever, Talbot is determined to prevent such beauty from fading away. Temporality is experienced by him as a disturbing problem, one that cannot be negotiated but only done away with. His vision of beauty does not allow for

the constraints of time. For Talbot, temporality is an external circumstance and not an inherent condition of beauty's appearance. In his determination to overcome beauty's ephemerality, Talbot is thus unable even to entertain the notion that transience might not necessarily be an obstacle to experiencing beauty, that it might be the very condition of that experience. This is a point to which I'll return. At this stage, it's sufficient to recognize that whereas Talbot's fixation with fixing the shadow is triggered by an experience in which beauty and transience are intertwined, his reaction to that primary experience is to try to eliminate transience by objectifying the shadow.

It's worth taking a look at the anecdote that just precedes Talbot's discussion of these issues:

> Upon one occasion, having made an image of a piece of lace of an elaborate pattern, I showed it to some persons at the distance of a few feet, with the inquiry, whether it was a good representation? When the reply was, "That they were not to be so easily deceived, for that it was evidently no picture, but the piece of lace itself."[6]

Is it coincidental that Talbot chooses to exemplify his attachment to the beauty of images by referring to a photograph of a piece of lace? The decision to use an image from the human, and specifically the feminine, world is revealing. The delicate handmade decorative fabric not only evokes the existence of a parallel visual medium—inviting reflections on its imagistic qualities and their relation to photography—but also suggests a parallel act of visual creation, a making that implicitly involves the presence of a lacemaker, a woman's hand. Is this the hand of Butades?

Talbot's philosophy of the shadow is developed in yet another context: the discussion of the negative. Here, too, we see evidence of his dual attitude toward the shadow. On the one hand, he embraces the shadow's unique presence and, on the other, he seeks to subdue, objectify, and even profit from that presence. The shadow as a negative first appears in the opening of Talbot's announcement of his invention where he recounts his first experiments with the discoloration of sensitive paper. "Some Account of the Art of Photogenic Drawing" begins as follows:

In the spring of 1834 I began to practice a method which I had devised some time previously. . . . I proposed to spread on a sheet of paper a sufficient quantity of the nitrate of silver, and then to set the paper in the sunshine, having first placed before it some object casting a well-defined shadow. The light, acting on the rest of the paper, would naturally blacken it, while the parts in shadow would retain their whiteness. Thus I expected that a kind of image or picture would be produced, resembling to a certain degree the object from which it was derived.[7]

The primary underpinnings of Talbot's shadows are his early direct-contact photograms, which, like shadows, consisted of two-dimensional projections of objects. Shadows there are understood as that "dark" hidden side of the object whose potential image—a white imprint—is realized only once the object is removed from the sensitized paper on which it was placed. The shadow in this case is presented as distinct from the image. Whereas the image is thought of in terms of a picture that is already produced, the shadow is described in terms of the process that leads to its production. And whereas the image is a separate, self-contained object, the shadow is relational; it appears as a presence that connects different elements of the photographic constellation—the object, light, the sensitive surface—as well as the temporal duration of the process, the before and after.

This idea continued to reverberate in Talbot's writing, but it took on new forms that corresponded to the developing scope of his photographic enterprise. Five years later, in *The Pencil of Nature,* the shadow appears in the short text accompanying Plate XX, titled "Lace," in which Talbot explains to his readers what is meant by the term "*negative* image":

The ordinary effect of light upon white sensitive paper is to *blacken* it. If therefore any object, as a leaf for instance, be laid upon the paper, this, by intercepting the action of the light, preserves the whiteness of the paper beneath it, and accordingly when it is removed there appears the form or shadow of the leaf marked out in white upon the blackened paper; and since shadows are usually dark, and this the reverse, it is called in the language of photography a *negative* image.[8]

In the language of photography, the shadow is called a negative image. The use of the shadow *as* negative evokes the traditional figuration of the shadow as a double or copy but, unlike natural shadows, which are dark, the photographic shadow-negative is bright: It designates the resemblance-through-reversal associated with an imprint or a contact impression.

In this context, Talbot is happy to reveal to his readers that the white piece of lace that they see in Plate XX is really a negative image "taken directly" from a black piece of lace. Could this be the same piece of lace that Talbot had mentioned a few years earlier in his first account of the invention? Is lace, once again, serving as an example of a visual practice

FIGURE 17. W. H. F. Talbot, *Lace*, 1845. Courtesy of the National Gallery of Art, Washington, D.C.

that, like photography, works around negative spaces? Would it be right to hear in Talbot's remarks on black and white lace—"black lace being as familiar to the eye as white lace"—an evocation of two kinds of dresses, a wedding dress and a mourning dress?

What makes the photographic negative philosophically interesting is that it embodies an intermediate domain between the natural object and its representation, between the visible and the visual. The negative possesses a potential and undetermined visuality, and the shadow is the placeholder for this potentiality to be realized as an image. In other words, the shadow-negative speaks to the presence of a spectrum of evolving image gradations that make up the photographic image even while it establishes its continuity with nature. It is a figure of the continuum that upholds the possibility of nature's visualization. This in-between zone of a living potentiality is no longer part of today's photography, which has internalized the logic of digital technologies. Photography can depict shadows, but, in Talbot's sense, it has grown indifferent, perhaps even blind, to the indeterminate spectrum—a dimension of being—that the shadow-as-negative held open between world and image.

And yet, in spite of Talbot's unique phenomenology of the in-between, he later abandoned his preoccupation with the shadow's temporality, relationality, indeterminacy, and even invisibility.[9] In fact, the above discussion of the negative is one of the rare instances in which Talbot mentions the shadow in *The Pencil of Nature*. Unlike the early account of the invention, in which "shadow" is a key term, in *The Pencil of Nature* it disappears almost entirely from the text and, as I'll show, can significantly be found only on a visual plane. This disappearance of the shadow converges with Talbot's developing interest in how to reproduce his process on a wider scale, which required internalizing economic values and embracing the instrumental logic of the market.

In the text accompanying Plate XX of *The Pencil of Nature*, we get an inkling of how the negative image might itself be further copied using the same process to obtain "a *positive* image of the lace: that is to say, the lace would be represented *black* upon a *white* ground." In *The Pencil of Nature*, the shadow thus makes way for a more general understanding of the negative and its projective essence. The shadow-negative is made

to submit to the logic of a reproductive process that reverses the object's dark and bright areas while retaining the object's form. This is the underlying image principle beyond Talbot's first contact imprints, of course. It applies to pictures or "views"—as Talbot calls them—taken from a distance, but it also becomes the trademark of the reproductive process itself by which a negative image is turned into a positive. The figure of the shadow, which was first used to flag the image's continuity with nature, thus becomes a sign of a specific kind of an instrumental operator within the visual field, one that—through inversion and repetition—can produce infinite chains of images.[10] Whereas daguerreotypes were singular objects, Talbot's negative became a functional principle that transformed photography into a medium for consumption in the global marketplace and, in so doing, changed nature's shadow into an economic principle of production based on an internal mechanism of reproducibility.

3. SHADOW ONTOLOGY

Talbot effaces and then forgets the shadow. But in the short moment before he chains the shadow to the *telos* of reproducibility, as he contemplates the visual essence of this natural phenomenon, he arrives at a few penetrating insights. The philosophical significance of these insights lies in the untraditional way they illuminate—and open up—a non-binary understanding of the relationship between nature and image, between the visible and the visual. The idea that the photograph comes into being by harnessing the power of the shadow introduces a new element into the traditional opposition between images and what they represent, between the kind of beings that are ontologically solid and their insubstantial copies. In responding to the shadow's distinctive presence, Talbot proposes a tripartite understanding of the photographic that consists of a triangular relationship among nature, shadow, and image. The shadow, for him, is neither object nor image, though it always appears in the proximity of either objects or images.

Talbot recognizes that the shadow is an intermediate phenomenon. And, in so doing, he breaks away from a traditional tendency to ignore the shadow's ontological distinctiveness. In the deeply rooted Platonic framework, for example, the ontological significance

of shadows is typically determined by the opposition between being and appearance. This opposition usually imposes a sense of uniformity on the field of appearances, which is treated *en bloc* as the antithesis of the real, thereby relegating shadows—immediately and all too quickly—to the general category of the image-as-copy. This category is generally a domain of ontologically secondary, non-essential entities, which are conceived of as distinct from more basic entities or objects that have a substantial presence in the world. On this view, shadows are but ethereal appearances that, under certain conditions of sight, seem to bear certain re-presentational qualities.

The fact that shadows are dark two-dimensional projections of objects that block rays of light from reaching certain surfaces only enhances their ontological inferiority. Unlike the reality ascribed to a tree, for example, its shadow is understood to be a natural copy: Like an image, it can only assimilate the identity of the real object that it re-presents. For Talbot, who ultimately "fixes" the shadow as a positive, the shadow's wavering appearance is nevertheless acknowledged as nature's primary visual unfolding. In itself, the shadow is distinct from the image, and, in being distinct, it resists the binary logic of object and copy.

Talbot's attentive reflections on the shadow's unique mode of appearance and his preoccupation with its intermediate presence invite us to understand his thinking as proto-phenomenological. His phenomenology is largely intuitive and, unlike professed phenomenologists, he develops no explicit critique of the binarism from which he attempts to release the shadow. But the very manner in which he contemplates the shadow's evasive presence is couched in a multilayered experience of looking that foreshadows a central phenomenological dictum that would be succinctly articulated by Wittgenstein: "Don't think. But, look!"[11]

Talbot begins by looking, and it is in looking that he discovers the unique life of shadows that transpires in between nature and image, the visible and the visual. Looking is the condition for recognizing the shadow's intermediate presence. In phenomenological terms, this means "to let what shows itself be seen from itself, just as it shows itself from itself,"[12] something that can only be done on the condition that we free our gaze

from its dominant tendency to focus on objects. The shadow, as Talbot knew, calls for an attentiveness that suspends the objectal framing to which the eye is so accustomed. In bracketing the kind of perception that can only see in a shadow the copied form of a given object, vision opens up to the intricate actuality of the dynamics that are at play among shadow, object, and surrounding.

The shadow then shows itself as a vital player in the multilayered, intrinsically relational, and ever-evolving drama of the visible. The appearance of a tree's shadow, for example, is clearly different from the appearance of the tree's wooden materiality; it is their combined presence that creates the dynamic matrix of the visible. Together with a tree's branches, its shadows inhabit the visible and do so through changing modes of intertwining. The shadow, in this respect, is not a mere second-order manifestation of the object; instead, it belongs—as we've seen in discussing Merleau-Ponty—to the core of an object's visibility. Photography has intuitively known how to manifest this point, and it has consistently done so in ways that challenge Merleau-Ponty's bias against the art form.

Consider for example, the shadow of a tree in Lee Friedlander's *Central Park, New York City* (1992); or the shadow cast by driving automobiles on a highway in Stephen Shore's *Amarillo, Texas, August 1973*; or the shadow of a chair next to a running child in *The Tuileries Gardens* by André Kertész (1980). These different photographs make clear that shadows actively participate in the space of appearance within which and through which an object's visibility unfolds—an occurrence that is always already dependent on concrete viewing conditions.

In Friedlander's *Central Park,* the tree's shadow is integral to the manner in which the tree shows itself, just as the spaces between its branches are integral to what we see. We may even say that, on that bright winter day in which the tree was photographed, it displayed its array of shadows on the ground just as it spread its leafless branches out toward the sky.

The shadows cast by the driving Buick and Ford Mustang on Route 66 (in Amarillo) are not representations or copies of these automobiles but an inseparable part of their appearance as viewed from behind at a specific time of day and at the specific moment

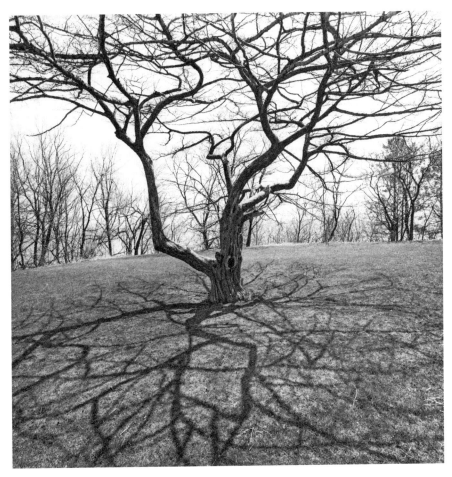

FIGURE 18. Lee Friedlander, *Central Park, New York City,* 1992.
© Lee Friedlander, courtesy Fraenkel Gallery, San Francisco.

they stopped for a red light. Similarly, the shadow of a chair in the Tuileries Gardens is inseparable from the constellation—the chair's relation to the round stone pedestal, its stillness in contrast to the child's movement—that comes into view from a particular angle.

Object and shadow are interdependent. On a physical level, the shadow's form and place is indeed determined by the specific constitution of the object; but, at the same time, the object's appearance is constituted by the shadow that operates, to cite Merleau-Ponty, as a premise of the visible or a threshold, a liminal grid that enables the object (tree, chair, etc.) to appear as it does.

For Talbot, the shadow is not only one of the devices through which nature makes itself visible (or sustains the cohesion of its visibility); it also functions as an emblem of nature's projective essence and, more significantly, its expressive structure. This can be gleaned from Talbot's description of his invention as "The Process by Which Natural

FIGURE 19. Stephen Shore, *Amarillo, Texas, August 1973.*
© Stephen Shore. Courtesy 303 Gallery, New York.

Objects May Be Made to Delineate Themselves Without the Aid of the Artist's Pencil" or from his insistence that his photographs "are impressed by Nature's hand." Nature is not only the sum of natural objects or natural facts that—to use a later phrase by Bertrand Russell—"are simply what they are" but consists in a movement of self-presentation. Nature shows itself beyond the fact that it is simply visible. It is not self-enclosed, self-sufficient, or self-identical but consists of a relational structure, always moving beyond itself toward its modalities of appearance.

For Talbot, photography avails itself of—and appropriates—this natural movement; as a result, it needs neither the "artist's pencil" nor "the aid of anyone acquainted with the art of drawing." Its ability to create pictures depends solely on knowing how to enable nature's self-presentation to resonate properly. Talbot's shadow blurs the traditional distinction between "natural objects" and the sphere in which these objects are represented, between nature and the human world of culture. Rather than remain within the bounds of nature, the shadow writes itself into culture in a way that allows nature to serve as the foundation of culture. Photography, then, is a medium that, while appearing within the bounds of culture, allows nature to show itself—to use Heideggerian phrasing—from within. We could also use Deleuzian terms to say that, instead of offering a view of nature, the photograph forms a rhizome with it: Photography is never outside the real as much as it is an integral part of the dynamics of the ongoing movement, of the effects and interactions of the real. In creating an image, the photograph always already consists of a deterriorialization of nature.[13]

Looking for a conceptual articulation of these themes in Talbot's writing will not yield satisfying results. But, once we recall that in *The Pencil of Nature* the photos themselves form the book's central trajectory, we can recognize that they make interesting phenomenological statements.[14] In this photographic series, the recurring depiction of shadows is self-aware and attests to the influence that they had on Talbot's imagination and his understanding of photography.

Consider, for instance, Plate X of *The Pencil of Nature*, *The Haystack*. If we let the plate's title direct our gaze, what we first encounter in the photograph is indeed a large

house-shaped haystack that dominates the pictorial field. The relatively close distance from which the photograph is taken does not allow Talbot to completely frame it. The haystack's uncontainable presence beckons the viewer to ponder the relationship between the pictorial field and the actual—"agricultural"—field in which it is located, between the visual and the visible. Thematically, the haystack, like the photograph, is a hybrid phenomenon, one that is at once "natural" yet inscribed within culture, a modality of cultured nature. As we tarry with the photograph, however, we realize that the haystack is not, in itself, the pictorial center of the picture as much as it is a backdrop for the presentation of the photograph's pictorial drama. What's at the center of this photograph is, in fact, an event, something that takes place among the static elements that are all part of its staging. This event is the appearance of the shadow.[15] The shadow makes for a doubling of the ladder, but at the same time, its verticality with respect to the diagonally positioned ladder accentuates its autonomy as a player or force in the visual field.

FIGURE 20. W. H. F. Talbot, *The Haystack*, 1844.
Courtesy of the National Gallery of Art, Washington, D.C.

In Plate XIV, *The Ladder*, the shadow makes a similarly strong appearance by showing a diagonal version of the centrally positioned vertical ladder. And the autonomy of the shadow's inner life manifests itself in the shadow's divergence from the unified linear form of the ladder: Unlike the ladder, which is simply set against a building, the shadow "crawls" on the floor before "climbing" the wall to meet the ladder's top. While the texts accompanying these plates ignore the presence of the shadows they depict, I see the photographs as pictorial meditations on the epiphany of the shadow, which together say something about photography's rootedness in nature's projective essence.

The idea that photography is anchored in nature's inner doubling takes on different forms in *The Pencil of Nature*. In Plate XV, *Lacock Abbey in Wiltshire*, its extension includes, in addition to strictly defined shadows, a similar natural phenomenon: reflections in water. In *Lacock Abbey*, there is a symmetrical relationship between the picture's upper

FIGURE 21. W. H. F. Talbot, *Lacock Abbey in Wiltshire*, 1844.
Courtesy of the Met's Public Access Initiative.

and lower halves. Whereas the picture's upper half presents a distant view of the abbey, the lower half shows the abbey's inverted form as it appears in the waters. Talbot's accompanying text is, in its own indirect way, revealing:

> One of a series of views representing the Author's country seat in Wiltshire. It is a religious structure of great antiquity, erected early in the thirteenth century, many parts of which are still remaining in excellent preservation. This plate gives a distant view of the Abbey, which is seen reflected in the waters of the river Avon. The spectator is looking to the North West.[16]

Talbot is attentive to the abbey's double appearance. But rather than draw an analogy between two elements (the abbey and its reflection) that appear in the picture or landscape, he compares the photograph's "distant view of the Abbey" and the abbey as "seen reflected in the waters of the river." Though he says nothing more of this natural reflection or of the significance he ascribes to it, after a further description of the building, the text itself becomes reflective, unexpectedly looking back at Talbot's own early attempts to photograph the abbey:

> In my first account of "The Art of Photogenic Drawing," read to the Royal Society in January, 1839, I mentioned this building as being the first "that was ever known to have drawn its own picture." It was in the summer of 1835 that these curious self-representations were first obtained. Their size was very small: indeed, they were but miniatures, though very distinct: and the shortest time of making them was nine or ten minutes.[17]

Having mentioned the photograph of the abbey, Talbot recalls the pivotal moment when he announced his invention of photography. He then slides back further in time to his first experiments with the cameras—the "mousetraps"—that he spread across the grounds of his estate.[18]

Pertinent to both these "memories" is an understanding of the photograph as the outcome of a process in which objects re-present themselves on paper: The building

has "drawn its own picture," the first photographs of it are "self-representations." This is the key to the double presentation of the abbey in Plate XV: The photograph itself is the result of the abbey's self-delineation. But it also addresses its own movement of self-presentation. While allowing the abbey to be seen, the photograph reflects on how the abbey's visuality has been made possible. Talbot achieves this by showing the abbey's relation to its reflected image in the river's water. He underscores that the abbey appears in the photograph just as it is "seen reflected in the waters of the river Avon." In both cases, what allows the visibly present to become re-presented—what allows the visible to become visual—is nature's projective essence, its shadow structure.

The shadow is an instance of nature's ability to represent itself, of its movement toward a "second" appearance. Its presence within the natural order is indicative of a movement that reveals nature's expressive character. Things get more complicated and interesting here, though, because the shadow, while belonging to both the visible and the object's space of appearance, also harbors a form that resembles the object, a kernel of iconicity. It's not yet a fully formed image, but it can be understood as providing grounds for a potential image or as a proto-image. As a form of natural likeness, the shadow manifests a doubling of nature that belongs to the very order of nature itself: Nature is pregnant with the seed of the image.

The shadow allows us to recognize nature's innate ability to reproduce. First, nature (or being) is never self-identical; it is always transcending its materiality while remaining (and this is important) within the realm of the sensible. Second, re-presentation is not opposed to a natural kind of presence; the seed of virtuality already resides within nature itself. The grounds of the possibility of representation is thus being's inner doubling, an ontological condition of which the shadow is a trace. To understand the shadow in this way is to recognize its presence as a manifestation of the ontological structure that enables nature to open itself to the possibility of representation (of being represented).

The shadow links—it embodies the continuity between—the visible and the visual. Indeed, the possibility of the image (of having, making, and experiencing images) is dependent on an ontological structure, yet this structure is not an immutable given but a reciprocal relation that develops in concert with human vision. Nature is never there, in and of itself, but is always in relation to us, developing its resistances in relation to our capacities as viewers and appropriators of being. This is also how I understand Talbot's ultimate move: He turns his back on the shadow, though he'd initially been so intimate with it and so responsive to its inner life. The point, I take it, is that photography's "betrayal" of the shadow is not simply a failure in embracing the continuum between the visible and the visual. In disowning the shadow, photography clearly is not blind to the possibility of grounding culture and technology in nature's giving. Nor is the photograph merely driven by an economic determination to use up nature. Photography's duplicitous relation to the shadow primarily reflects the difficulty of upholding the promise of a continuum—of a world order that is an expression of the great chain of being—of which the shadow is an emblem. The inability to respect the shadow—which in Kantian terms means to treat it as an end in itself—is a sign of this grave difficulty, a symptom of a fundamental crisis—one we learn about thanks to the emergence of photography and its new visuality.

True, in Talbot's accounts, the reification of the shadow remains unacknowledged and is at times even concealed by a rhetoric that seems to embrace the shadow's ontological significance. But, interestingly, in the developing history of photography, shadows will become an important visual theme; they become popular in the photographic imagination, particularly within contexts of medial and personal self-reflection. What is the connection between the widespread appearance of shadows *in* photographs and the shadow as a transcendental principle, a condition of the possibility of image-ness? And, more specifically, what is the relationship between the consistent attraction to and representation of shadows in the history of photography and the killing or fixing of the shadow in photography's primal birth scene? Is photography's ongoing display of shadows a symbolic repetition of repressed killing of nature's offspring, of nature's gift to humans: the seed or kernel of the image?

4. UNABLE TO SAY GOODBYE

Talbot's story begins in a beautiful setting—a cultivated landscape on the shores of Lake Como—in Italy, a *locus amoenus* that is particularly meaningful, given his classical education and interests.

> One of the first days of the month of October 1833, I was amusing myself on the lovely shores of the Lake of Como, in Italy, taking sketches with Wollaston's Camera Lucida, or rather I should say, attempting to take them: but with the smallest possible amount of success. For when the eye was removed from the prism—in which all looked beautiful—I found that the faithless pencil had left only traces on the paper melancholy to behold.[19]

In this apparently relaxed ambience, Talbot (who does not mention the fact that he was on his honeymoon) makes a few unsuccessful attempts to sketch the surrounding landscape using a relatively popular technological aid: Wollaston's *camera lucida* (invented in 1807). And, although his attempts at drawing are initially described as a form of amusement, the ultimate failure seems to disrupt the harmony promised by the beauty of the place. A sense of estrangement from the hand (from the body?) is apparent in Talbot's reference to the workings of "the faithless pencil" that bars him from capturing the beauty of things, leaving only "traces on the paper melancholy to behold."

The word "melancholy," which is here employed against the more formulaic phrasing of "a wonder to behold," may carry a range of meanings, but, judging from Talbot's letters, this is not a word that he uses inadvertently.[20] Without psychologizing Talbot, let's just mark the seemingly unexpected way in which his limited satisfaction with the hand's abilities turns his amusement into melancholy. If Talbot was only "amusing himself" by drawing, why does his inadequate success bring on such melancholy? Can his existing sketches of the shores of Lake Como teach us something about his disappointment?

Looking at his sketches of the view of the lake taken from Villa Melzi on October 5, 1833, we see that while on a rudimentary technical level—the precision of outlines, the perspectival schematization of the different elements—the drawing is adequate, its schematic form nevertheless lacks expressivity, animation, or even aesthetic value beyond the mere mechanical tracing produced by the *camera lucida*'s apparatus. One way to describe the sketch—and here I owe the observation to my young daughter Renana—is to say that "there are no shadows in it." Unlike the women in his family who were experienced amateur painters, Talbot presents himself as lacking the basic skills needed to draw or paint. However, if drawing—apropos the Corinthian maid—is an act of visually being in touch and negotiating a sense of ephemerality in the presence of things, what we have in the Villa Melzi sketch is not so much an attempt to draw as an attempt to follow certain rules for tracing dictated by the apparatus. If there is a kind

FIGURE 22. W. H. F. Talbot, *Sketch of Lake Como*, 1833. Public domain.

of failure in this sketch, it cuts deeper than the hand's limitations and pertains to an intentionality that refuses to attach itself to nature's beauty whose transience seems to affect Talbot so strongly.

As Talbot's story continues, however, we see that this initial "failure" and the decision to overcome it are key to the narrative that undergirds his invention. As in a fairytale or a foundational myth, Talbot's story is structured as a success that unfolds over three acts. The failed attempt to draw with a *camera lucida* is followed by a second failed attempt to draw with another technological aid, the *camera obscura*, which then paves the way for success with the invention of photography.

> I then thought of trying again a method which I had tried many years before. This method was, to take a Camera Obscura, and to throw the image of the objects on a piece of transparent tracing paper laid on a pane of glass in the focus of the instrument. On this paper the objects are distinctly seen, and can be traced on it with a pencil with some degree of accuracy, though not without much time and trouble.[21]

Turning to the aid of the *camera obscura*, Talbot continues to think of his drawing endeavor in terms of the possibilities and problems that ensue from the method of tracing.

> I had tried this simple method during former visits to Italy in 1823 and 1824, but found it in practice somewhat difficult to manage, because the pressure of the hand and pencil upon the paper tends to shake and displace the instrument (insecurely fixed, in all probability, while taking a hasty sketch by a roadside, or out of an inn window); and if the instrument is once deranged, it is most difficult to get it back again, so as to point truly in its former direction.

> Besides which, there is another objection, namely, that it baffles the skill and patience of the amateur to trace all the minute details visible on the paper; so that, in fact, he carries away with him little beyond a mere souvenir of the scene—which, however, certainly has its value when looked back to, in long after years.

Such, then, was the method which I proposed to try again, and to endeavour, as before, to trace with my pencil the outlines of the scenery depicted on the paper. And this led me to reflect on the inimitable beauty of the pictures of nature's painting which the glass lens of the Camera throws upon the paper in its focus—fairy pictures, creations of a moment, and destined as rapidly to fade away.

It was during these thoughts that the idea occurred to me . . . how charming it would be if it were possible to cause these natural images to imprint themselves durably, and remain fixed upon the paper!

And why should it not be possible? I asked myself.[22]

Talbot comes up with the idea of photography after two failed attempts to trace with a pencil the images that he sees. His failure only accentuates his feeling of unavoidable loss in the face of beauty. Once again, Talbot is preoccupied with and disconcerted by the tension between the beauty of images and their ephemerality. But unlike Odysseus, whose three attempts to embrace the shadow (*eidolon*) of his dead beloved mother all result in failure, Talbot's two failures lead to a third successful attempt to capture the shadow.

Talbot's words reveal that this new invention was not only born in response to a loss, but it was also the kind of response that allowed him to shift away from his consuming preoccupation with transience. Photography offers the promise of durability, of overcoming the fragility of desire in the face of time. Talbot is not concerned with accommodating or accepting temporality but with finding a technique for fixing the transient. The problem that engrosses him also frees him from the burden of coming to terms with the fading beauty of the moment.

In other words, what leads to the invention of photography is a shift in attitude: Though it was full and beautiful, Talbot relinquishes his previous—personal, emotional, corporeal—engagement with transient nature in order to devise a mechanism that will "cause these natural images to imprint themselves durably." Giving up on improving his

own drawing skills—on developing ways for further articulating his being in the visible—Talbot opts instead for an ingenious causal conception of nature within which nature itself is manipulated so as to produce sought-after results. "And why should it not be possible?" he asks.

> The picture divested of the ideas which accompany it, and considered only in its ultimate nature, is but a succession or variety of stronger lights thrown upon one part of the paper, and of deeper shadows on another.

> Now Light, where it exists, can exert an action, and, in certain circumstances, does exert one sufficient to cause changes in material bodies. Suppose, then, such an action could be exerted on the paper; and suppose the paper could be visibly changed by it. In that case surely some effect must result having a general resemblance to the cause which produced it: so that the variegated scene of light and shade might leave its image or impression behind, stronger or weaker on different parts of the paper according to the strength or weakness of the light which had acted there. Such was the idea that came into my mind.[23]

What makes possible the idea of photography is the new attitude Talbot assumes. This attitude releases him from the allure of images to the extent that he can regard them as "divested" of their pictorial meaning, illusion, and any reference—beyond themselves—to the world or nature. The invention of the photographic is anchored in the shift that neutralized the captivating power of images by bracketing their pictorial effect. This shift in gestalt allows the physical character of fleeting images to come to the fore: "The picture, divested of the ideas which accompany it, and considered only in its ultimate nature, is but a succession or variety of stronger lights thrown upon one part of the paper, and of deeper shadows on another." Once the image is stripped of its imageness, Talbot sees in it (sees it *as*) the mere distribution of lit and shaded areas.

Seeing images as mere patches of light and shade relegates them to nature's strictly causal—rather than expressive or visual—order. Talbot can thus envision a solution

to the problem of the image's transience in the form of a physical-chemical condition. The possibility of a new image-making technology is a shift in the act of "seeing-as" that equates the image with the material and chemical properties of the paper's surface. This kind of seeing-as is fundamentally different from the kind of seeing-as that grounds Butades's primordial act of drawing. Butades's mythical drawing is based on her ability to understand the imagistic potential of natural phenomena, to see the shadow *as* bearing the form of her lover's profile. Talbot's seeing-as is the inversion of her vision. Unlike the ability to see the shadow *as* an image, the invention of photography depends on the inverse—the ability to see the image *as* a shadow, a shaded pattern whose essence is not visual but chemically codified and that, as such, lends itself to chemical manipulation.

Talbot was initially inspired by nature's self-expressivity, but his own ambition leads him to turn his back on the image's rootedness in the visible. And in reframing the image's presence in terms of a codified understanding of workings of light, he turns the image's visuality into an epiphenomenon. This is a significant moment in the development of the photographic: Unknowingly, it heralds the advent of a new phase in the life of images, one that is crucial for understanding the visuality of the contemporary world.

This breach between the image and the visible extends to Talbot's incorporation of the term "photography," a term that not only supersedes the shadow and replaces it with light (*phos/photos*), but that almost imperceptibly modifies the original meaning of the invention's first moniker, "photogenic drawing." While "photography" may at first seem to be a literal equivalent of "photogenic drawing," it changes, in fact, the early determination of the term by introducing a certain ambiguity. The Greek *graphein* that appears in "photography" has a double sense; it means drawing but also writing. The term "photography" suggests that the new image-making technique operates somewhere between drawing and writing, between visual depiction and the codified signs of language. These two interconnected aspects of *graphein* are both at play in Talbot, according to whom the shadows that indeed appear as pictures are essentially the written

inscriptions of nature's pencil. In this sense, Talbot not only announces the birth of the photographic image but also presages the birth of what Vilém Flusser would term the "post-historic technical image."[24]

Hence, photography's reification of the shadow is not just about turning shadows into durable artifacts. What's unique about photography's supersession of the shadow is not the durable materiality of the image it produces, but the transmutation of the image's visual constitution. The birth of the photographic lies in the ability to see the shadow as a code and, consequently, to create a new visually uprooted image whose self-sufficiency is no longer indebted to vision. Talbot shows us that the in(ter)vention of photography was made possible by a vision that withdrew itself from the life—and the lure—of the visible. It's a vision that grew out of a frustrated desire to embrace the beauty of the visible, a failure to embrace the possibility of loss and transience that are part and parcel of beauty and desire. The flip side of Talbot's desire to possess the shadow-image is a completely instrumental attitude toward the unfolding of the visible that refuses to engage with its inherent temporality.

There is a duality to the way that Talbot operates. He acknowledges nature's "generosity" in giving itself to the human eye, but he remains indifferent to—even disrespectful of—the very structure of nature's giving. For Talbot, nature's gifts are reducible to what we extract from it and fully possess. Nature's visual gifts are resources to be mined and consumed. Though he is clearly moved by the images given by nature's pencil, he refuses to accept that what he desires—nature's beautiful appearances or, more generally, the beauty of things—cannot be fully owned precisely because it is fleeting. The only way that Talbot can fulfill his desire to possess the living images he sees in the *camera obscura* is by depriving them of life. Talbot satisfies his desire for that which appears by creating a mechanism that extinguishes that desire. For him, photographic satisfaction is not the fulfilment but the evacuation of desire. Unlike Butades, who uses drawing to come to terms with the end of love, Talbot invents photography in an attempt to deny and overcome the condition of finitude and transience. Photography is born from the refusal to say goodbye.

5. SEPARATED FROM THE BODY: THE GAP

In the history of photography, connectedness has functioned as a consistently popular photographic value. For Henri Cartier-Bresson, the foundational myth of photography is "the Greek myth of Antaeus who had to touch earth to regain his strength."[25] Son of Mother Earth, Antaeus possesses incredible strength that derives from his physical rootedness. According to the myth—which saw a revival in the nineteenth century—as long as Antaeus is in touch with the ground, he remains invincible.[26] It is only when Hercules realizes the source of Antaeus's strength that he is able to detach him from the earth and thus overcome him.

For Cartier-Bresson, the position of Antaeus is illuminatingly analogous to that of the photographer in the world. A true photographer has both feet on the ground and is ever in touch with the concrete grounding of his existence, the changing location of his feet. "A photographer must not run but walk, tirelessly. Then he can seize what is on offer on the pavement, at the street corner, in life."[27] The specific ground on which the photographer treads may be constantly shifting, but the photographer attaches himself to it by living horizontally: "You always find yourself on the crest of a wave, like a surfer."[28] Being in touch with the palpability of Mother Earth is an imperative that requires the photographer to attentively embrace her embodied situatedness.

Embodiment is the enabling condition of the photographic act, which Cartier-Bresson compares to a hunter's shot:

> We are passive when confronted with a world in movement; and our only creative moment is this 1/125th of a second when we press the button, this shifting instant when the blade falls. We can be compared to the shooters who "fire" their rifle shot.[29]

But the specific moment in which "a whole visual organization clicks into place" is only the end point of a slow process of immersing oneself in—of allowing one's body to become part of—a surrounding. The silent openness to the unexpected, the waiting, the endurance have become a trademark of the photographer's ethos.[30]

The composition is born of chance. I never calculate. . . . I wait for something to happen within. There is no rule. You should not try to explain the mystery too much. It is better to be available, with a Leica close at hand. It is the ideal camera body.[31]

Indeed, for Cartier-Bresson, "[T]here is no standard plan, no pattern from which to work. You must be on the alert with the brain, the eye, the heart and the suppleness of body."[32] And the camera, in this context, is an inseparable part of the photographer's body and movement. "I had just discovered the Leica. It became the extension of my eye, and I've never been separated from it since I found it."[33]

Cartier-Bresson's photography grows from and develops a kind of vision of the world whose gravitational center is the lived body. His understanding of photography's ways of seeing is not very different from the kind of embodied vision that Merleau-Ponty

FIGURE 23. Henri Cartier-Bresson, *Pilgrimage: India, Tamil Nadu, Madras,* 1950. Magnum Photos.

FIGURE 24. Henri Cartier-Bresson, *Sicily, Palermo*, 1971. Magnum Photos.

ascribes to painters alone. It is a vision that is never just "a view upon the *outside*, a merely 'physical-optical' relation with the world,"[34] but one that opens from the human condition of being "caught within the fabric of the world."[35] The visuality of Cartier-Bresson's photographs is intrinsically corporeal.

The photographic stance of which Cartier-Bresson is an important representative has been central to photography's trajectory and ethos since the invention of the hand camera. It finds its clearest manifestations in photojournalism, street photography, and, more generally, in the rich, multi-leveled matrix of photography's exploration of the everyday. And, yet, photography's umbilical relation to the human body is not given as it seems. The machine's apparent rootedness in embodied intentionality is a construction that cannot be taken for granted and needs to be rethought. Antaeus's connectedness to the ground becomes meaningful only against the backdrop of detachment and separation.

To illuminate this complex relationship, we do well to recall how the question of the body figures in photography's beginnings. Talbot's accounts of the new picture-making process generally underplay the role of the body, which appears only metonymically through references to the human hand—often connected to a pencil—and the human eye. These bodily parts are typically mentioned as negative examples that allow Talbot to highlight the finesse of the photographic apparatus. The body's presence is only insinuated in a fragmented and somewhat alienated, perhaps even antagonistic, way.

Talbot makes dual use of the terms "hand" and "pencil." There are two sets of hands and pencils at issue in his accounts: One set belongs to humans, the other to nature. "The Art of Photogenic Drawing" *is* "The Process by Which Natural Objects May Be Made to Delineate Themselves Without the Aid of the Artist's Pencil." Similarly, *The Pencil of Nature* is a pencil that liberates image production from the constraints of the artist's hand. The text opens with the statement that photography forms its images "by the mere action of Light upon sensitive paper" and therefore has no need for "the aid of any one acquainted with the art of drawing." Photographs "differ in all respects, and

as widely as possible" from pictures of "the ordinary kind, which owe their existence to the united skill of the Artist and the Engraver" since they "are impressed by Nature's hand." This distinction is, of course, preferential. In contrast to the imperfect human hand and its pencil, which Talbot treats with a degree of suspicion, the photographic process can produce images with an unparalleled degree of fidelity. "The hand is liable to err . . . [a] manual process cannot be compared with the truth and fidelity" that is obtained "by means of solar light."[36] The hand and pencil that are "liable to err" remind us of Talbot's complaint about "the faithless pencil" that had failed him on his honeymoon, when he attempted to draw from nature, leaving only "traces on the paper, melancholy to behold."[37]

Talbot's opposition between nature's hand and the artist's hand articulates the autonomy of photography from what he sees as the overbearing presence of the traditional visual arts. Photography's pictures exhibit a representational precision that cannot be matched by the human hand, and they are liberated from the requirements of skill and enculturation that tradition imposes on the artist. In Talbot's endorsement of photography, there is an implicit endorsement of democratization, of the right to make pictures. This sentiment is, again, not neutral; underlying it is a sense of *ressentiment* against the select few who possess the unique artistic skill to produce images by hand.

While he pairs the human hand with the hand of nature, he compares the working of the human eye to the *camera obscura*. In his discussion of Plate III, *Articles of China*, in the *The Pencil of Nature*, we read:

> The articles represented on this plate are numerous: but, however numerous the objects—however complicated the arrangement—the Camera depicts them all at once. It may be said to make a picture of whatever *it sees*. The object glass is the *eye* of the instrument—the sensitive paper may be compared to the *retina*. And, the eye should not have too large a *pupil*: that is to say, the glass should be diminished by placing a screen or diaphragm before it, having a small circular hole, through which alone the rays of light may pass. When the eye of the instrument is made to

look at the objects through this contracted aperture, the resulting image is much more sharp and correct.[38]

For Talbot, who returns time and again to the analogy between eye and camera, the gist of the difference between these two "viewing mechanisms" is that "the eye of the camera would see plainly where the human eye would find nothing but darkness."[39] The visuality of the camera excludes the human eye, just as the drawings of nature's pencil supersede in their "truth and fidelity" any drawing done by hand. Talbot's strong preference for mechanical picture-making—one antagonistic to the claims of the body and the artistic potential of the human hand—is interesting in itself. But it becomes more pertinent here once we understand that it is part of an actual dramatic change that the invention of photography introduced into the historical relationship between the image and the human body.

The birth of photography radically transfigured the relationship between hand and image. In its dependence on an autonomous mechanical apparatus—the depicting device—photography drove a wedge between the hand (intrinsically connected to the living eye) and the produced image, creating an unprecedented split between the two.[40] Photography allowed the photographer to be corporeally involved in the act of taking photographs, but, on a structural level, its images do not grow out of the intertwining of world and embodied vision. This is interestingly exemplified by Talbot's very first cameras, the "mousetraps," which he placed throughout the grounds of his estate in Lacock to capture "views" of the abbey and its surroundings. What was innovative about these views was that they were not anchored in the vision of an embodied living subject; they were "neutral" (nonhuman) viewpoints and represented a homogenously expanded field of options for visual representation.

From its inception, photography opened up a rift between its modes of vision and those of the living eye of the everyday. And with time, it gradually established an unassuming split between visual experiences that develop within the horizons of an embodied subjectivity and a new kind of image that has *nothing* to do with lending one's body to the

world, the very condition from which, according to Merleau-Ponty, painting emerges. The term "nothing" is not used here as a mere turn of phrase. "Nothing" is precisely what photography contributed to the reciprocal overlapping of image and embodied vision.

If in drawing or painting the making of a picture depends on an active, imaginative eye that is involved in the gradual formation of the image, the output of the photographic apparatus is always a surprise for the image-maker (or at least, it has been for most of photography's history). The surprise is not necessarily psychological but, primarily structural, as indicated by the etymology of the word: to "sur-prise" is to over-take. Unlike images that yield to the guidance of the creative eye, photography, at some point, always turns the tables. It suddenly confronts the eye with an autonomous image that evolves independently of—and creates a gap in—the photographer's experience. For the active eye, the photographic image springs out of nowhere insofar as it loses its continuity with bodily perception.

Photography turned its back on the process by which the artist's eye had traditionally upheld the coming into being of an image. Photography is born out of an imperceptible caesura, imperceptible because discontinuity is not something that can be experienced directly. This caesura can only be experienced retrospectively: The photographer's eye suddenly experiences itself as passive in relation to what, only a moment earlier, it seemed to be in control of. The previously active eye becomes passive with regard to the new image. When the photographer looks at a photograph, the eye's forward gaze flips backward: Its temporal horizon switches from present to past. The very shift from a future-oriented present to a past-oriented intentionality, from the visible to the visual, creates a blind spot.

In Talbot, we already find an intuitive understanding of this caesura, which he describes as silently resonating in his photographs and whose exploration he regards as, "one of the charms of photography." In the text accompanying a photograph of the *Entrance Gateway, Queen's College, Oxford,* Plate XIII in *The Pencil of Nature,* he writes:

> In examining photographic pictures of a certain degree of perfection, the use of a large lens is recommended, such as elderly persons frequently employ in reading.

This magnifies the object two or three times, and often discloses a multitude of minute details, which were previously unobserved and unsuspected. It frequently happens, moreover—and this is one of the charms of photography—that the operator himself discovers on examination, perhaps long afterwards, that he has depicted many things he had no notion of at the time. Sometimes inscriptions and dates are found upon the buildings, or printed placards most irrelevant, are discovered upon their walls: sometimes a distant dial-plate is seen, and upon it—unconsciously recorded—the hour of the day at which the view was taken.[41]

According to Talbot, good photographs require thorough observation. Although the photograph is all surface, a cursory, synoptic gaze is not sufficient to uncover its contents. Rather, both time and adequate technical aids (such as a magnifying glass) are necessary in order to allow the image to unfold in its entirety. A hiddenness is integral to the photograph and seems to ensue from its temporal form. This can be seen most clearly when the photographer, or the "operator" as Talbot calls him, reviews his own depictions. In reviewing the image, the operator returns to the "view" that appeared to him at the time the photo was "taken."

The phrase "the view taken" is commonly used by Talbot to introduce the photographs he describes. For example, when describing yet another photograph of Queen's College—the *Pencil*'s Plate I—Talbot writes: "The view is taken from the other side of the High Street—looking North. The time is morning." A view, in other words, has spatial and temporal coordinates that can typically be shared by the operator. When a "view is taken," however, it becomes detached—it is taken away—from these coordinates and ultimately finds itself in new spatio-temporal coordinates that correspond with the location where the photograph is viewed. Unlike the tradition of perspectival painting, which is based on an essential isomorphism between the points of view of the painter and the painting's viewer (who both face the frame of the same imaginary "window"), photography assumes a clear separation between the "view taken" *by* the camera and the viewing *of* the photograph.

In photography these two "views" remain incongruent. And the operator is the only one capable of connecting what he sees in the photograph to the particular experience of viewing the world, of framing the visible, that belongs to the past action of taking the photograph. Yet, despite his ability to connect the two "views," he, too, cannot bridge the gap that photography creates between the visible and the visual. The operator lacks a privileged position, for the "view taken" was never identical with any viewing experience enabling the taking of the photo. All he can do is try to discover what was "unconsciously recorded." In his references to "inscriptions . . . dates . . . printed placards" as examples of those "minute details" that hide themselves from the eye—as well as his assertion that the viewer of the photograph needs a magnifying lens like those used for reading—Talbot again speaks of photography in terms of writing (*graphein*). The photograph is a surface bearing layers of inscriptions—a palimpsest, perhaps—in which certain signs are no longer legible and others are difficult to see or decipher. Talbot describes the photograph's surface in much the same way that Freud would later speak of "the Mystic Writing-Pad."[42] And in his allusion to the unconscious recording of the photographic apparatus, he pre-figures Walter Benjamin's notion of the "optical unconscious."

For Talbot, photography's unconscious is not a theoretical construct but a matter of fact, a fact with which he is familiar from his personal work and experience. This un-conscious dimension of the invention's workings is not just technical: It is a byproduct of photography's detachment from the artist's intentionality, a detachment that is the prevalent mood underlying the invention. With such unconscious processes woven into its being, the photograph triggers in the viewer, according to Talbot, the need to explore undiscovered aspects of the picture's surface.

As Benjamin would later point out, one of the (sociological) manifestations of photography's optical unconscious is our urge, when we look at photographs, to discover retro-spectively dimensions of the photographed event that escaped the eye of the photographer.

No matter how artful the photographer, no matter how carefully posed his sub-ject, the beholder feels an irresistible urge to search such a picture for the tiny

spark of contingency, of the here and now, with which reality has (so to speak) seared the subject, to find the inconspicuous spot where in the immediacy of that long-forgotten moment the future nests so eloquently that we, looking back, may rediscover it.[43]

Talbot presents the discovery of "unobserved and unsuspected" details as "one of the charms of photography." For Benjamin, whose notion of the "optical unconscious" stems from his dialogue with psychoanalysis, the fact that what's in plain view includes a dimension of hiddenness is less charming than uncanny.[44] And, as such, it also calls for a more complicated interpretation of the dialectics of photographic technology. But, even on a less theoretical level, photography's intrinsic gap is an experience shared by anyone who has taken photographs.[45]

In an autobiographical description of the events surrounding the creation of his famous *Steerage*, Alfred Stieglitz describes the immense tension between seeing a scene whose depiction would create "a milestone in photography" and his anxiety about the lack of control he had over what the camera would record and what the developing process would bring about: "I had but one plate-holder with one unexposed plate. Would I get what I saw, what I felt? Finally, I released the shutter. My heart was thumping. I had never heard my heart thump before. Had I gotten my picture?" When he arrived in Paris, he immediately looked for a darkroom, and there, his concerns continued to multiply: "What intense minutes! Had I succeeded, had I failed?.... Had I moved while exposing?.... The minutes seemed like hours." Interestingly, when Stieglitz returns to New York, his anxiety bars him from finding out: "When I got to New York finally four months later I was too nervous to make a proof of the negative."[46]

This gap opened by the independence of the apparatus has been integral to the narration of the experience of photography from the earliest literary accounts to cinematic reflections on the medium—from Hitchcock's *Rear Window* and Antonioni's *Blow-Up* to more conventional TV detective series in which a familiar photograph, examined anew, reveals a previously overlooked key to solving a mystery.

6. PERSPECTIVISM

The question to be asked here is how the divide between the photographic apparatus and the human body affects the visual field and, specifically, the relationship between the visual and the visible. What are the consequences of introducing into the visible an essentially independent photographic device? In what ways is the possibility of releasing representation from human corporeality philosophically significant?

The first implication of this possibility is that photography's visualization of the visible becomes, in principle, limitless. Detached from the body, the apparatus can essentially access anything that appears in the "flickering light of the universe's countless solar systems,"[47] and every point in that space now becomes a potential point of view for taking a photograph.

The logic of the photographic is imperialistic. Photography's all-encompassing vision of the universe implies a full domination of the visible by the visual. Every visibility is a potential photograph that can be taken from an infinite variety of perspectives. In such a limitless photographic space, nothing is too close or too far, too small or too large for assuming a photographic form. And each view captured in a photograph is always one among an indefinite number of other perspectives. Within this vast visibility, far and near, small and large—but also "important" and "trivial"—become meaningless, as do most of the coordinates that make our world human. In this space, the visible is no longer attuned to an anthropomorphic measure: It loses its uniquely human resonance. Among the many potential "views" of the visible opened by photography, the human constellation is of negligible significance. Although the history of photography is replete with photographs that are sensitive to our unique human condition, photography's inner logic has no sense of the contingent values, practices, or forms of meaningful involvement that constitute the human world.

The visuality that photography offers is uprooted at its core. On a conceptual level, Talbot's first photographs already hint at future photographic developments. A century later, there would be uncanny—yet beautiful—depictions of the earth as it appears from outer space. *Blue Marble*, the famous 1972 photograph taken from Apollo 17 or *Pale Blue*

Dot taken by Voyager 1 from a distance of about 6 billion kilometers—and in which the earth's apparent size is less than a pixel—are photographic possibilities that were intrinsic to Talbot's invention. In the history of photography, the fundamental separation between the embodied eye and the apparatus was typically either ignored or explicitly used to explore—as in surrealism or New Vision—"external" and surprising perspectives on our everyday that reveal extraordinary and uncanny aspects hidden within the ordinary.

FIGURE 25. Apollo 17, *The Blue Marble*, December 7, 1972. Public domain.

Yet despite such explorations—and perhaps just because these experimentations typically led back to a reconciliation of the uncanny with the ordinary—the ethos of photography remained, as a whole, untouched in its commitment to the immediate visibility of our human-embodied, temporal situatedness. In the attempt to ratify this commitment, photography interestingly developed compelling strategies for inhabiting the space of vision with a camera at hand so that the consequences of its uprootedness—the perspectival fragmentation it brought about—typically remained inconspicuous.

What photography, in spite of itself, has consistently testified to were the very consequences of the conceptual revolution that Alexander Koyré identified in the scientific thinking of the seventeenth century, describing them as a shift "from a closed world to an infinite universe."[48] In the course of this fundamental shift, "man lost the very world in

FIGURE 26. Barbara Probst, *Exposure #39. NYC, 545 8th Avenue. 03.23.06. 1:17 p.m.*
Courtesy of the artist.

which he was living and about which he was thinking." And, the idea of a hierarchically ordered, value-laden cosmos was replaced by a scientific vision of infinite spatial expansion "bound together by the identity of its fundamental components and laws, and in which all these components are placed on the same level of being." This, in turn, implied, according to Koyré, "the discarding by scientific thought of all considerations based upon value-concepts, such as perfection, harmony, meaning and aim, and finally the utter devalorization of being, the divorce of the world of value and the world of facts."[49]

At issue here is not only photography's ability to conjure views that are indifferent to man's being-in-the-world. More radically, lacking a gravitational center—and thus an organizing principle or hierarchy—photography's space consists of an indefinite multitude, a plurality of viewpoints that refuse to coalesce. Photography offers us hypervisual access to the real. But rather than make the visible more coherent, it multiplies perspectives and produces a counter-effect of utter fragmentation. The idea of an infinite plurality of perspectives is part of its inner logic. According to this logic, the photographic appearance of a human face, for example, is indiscriminately attached and equally indifferent to what is seen from the eye of another person, an insect, or a satellite. The "same" photographed face can take the form of a traditional, frontal, "humanistic" portrait, but with a slight perspectival change, it can also appear as an instance of undeliberate facial or bodily expressivity; it may even lose its human character altogether when viewed upside-down or from an oblique angle; it may appear as an alien creature or, in an extreme close-up, as a field of pores and bumps, as mere organic matter.

For photography, from the start, all of these "views" were equally valid and equally meaningful or meaningless. Talbot's bust of Patroclus, insect wings, or Parisian boulevards are all on a par, just as are the very different "views" of Lacock Abbey. This inherently photographic idea coincides with a radical philosophical vision that was articulated in the second half of the nineteenth century by Friedrich Nietzsche as photography was coming into its own. This position, known as Nietzsche's *perspectivism*, is the idea that there is no "view from nowhere" with respect to how things really are and that perspective is, therefore, central to the constitution of meaning, truth, and knowledge.

The perspectival nature of the real dates back to Nietzsche's early writings. In "On Truth and Lying in a Non-Moral Sense," the young Nietzsche began to develop his criticism of traditional conceptions of truth that are governed by the idea of an "a-perspectival" objectivity and, specifically, of the predominant theoretical tendency to read the multifaceted and ever-wavering character of phenomena as the mere expression of an underlying, stable, and self-identical ontological structure.

Nietzsche is concerned with what he terms "the need for truth," which, as he argues, always has an ulterior motive, such as the need "to live with some degree of peace, security, and consistency." The belief that knowledge can reflect the real independently of any point of view is a clear manifestation of "the *hyperbolic naiveté* of man," who chooses to live in bad faith or self-denial. Only the "artistically creative subject" is willing to recognize the perspectival structure of the real and ultimately experience "the vast confusion of contradictory valuations and . . . contradictory drives." For the ordinary person, perspectivism appears as a threat that must be eliminated or at the very least concealed. This is exemplified by the common refusal to confront the obvious fact "that insects or birds perceive a quite different world from that of human beings, and that the question as to which of these two perceptions of the world is the more correct is quite meaningless, since this would require them to be measured by the criterion of the *correct perception*, i.e. by a *non-existent* criterion."[50]

Nietzsche's later writings continue to develop these themes beyond the epistemic. Facts, value, and meaning are not only shown to be intrinsically dependent on particular optics, but the very idea of an optics is explicitly tied to the Nietzschean principle of the will to power. Perspective is never neutral. It is an expression of particular economies of needs and *teloi* that are grounded in "power-centers." In the human world, such "perspectives of utility" typically take the form of values and evaluative judgments that serve "the individual, a community, a race, a state, a church, a faith, a culture"[51] and are "designed to maintain and increase human constructs of domination."[52]

What's most significant for our discussion, however, is that for Nietzsche, the notion of perspective is not a contingent aspect of the way in which reality shows itself;

rather, it is at the very heart of the real. Being cannot but open itself in a perspectival manner. To be is always already—as Jean-Luc Nancy says—"being singular plural." Consequently, the idea of

> A "thing-in-itself" [is] just as perverse as a "sense-in-itself," a "meaning-in-itself." There are no "facts-in-themselves," for a sense must always be projected into them before there can be "facts." The question "what is that?" is an imposition of meaning from some other viewpoint. "Essence," the "essential nature," is something perspective and already presupposes a multiplicity.[53]

In other words, "In so far as the word 'knowledge' has any meaning, the world is knowable; but it is *interpretable* otherwise, it has no meaning behind it, but countless meanings." Nietzsche's affirmation of multiplicity is indicative of the absence of a unifying frame in which the world's meaning can cohesively show itself. Perspectivism is primarily a way of acknowledging the disintegration of an all-encompassing structure of legibility, the loss of coordinates to orient man's place in the universe. The collapse of an overarching, super-sensible principle that upholds human meaning and value is what Nietzsche understands as the "death of God."

The proclamation of God's death by Nietzsche's madman was the point of departure for our study of photography. Photography emerges with the death of God, a condition that calls for a new way of orienting humans within an indifferent (homogeneous, meaningless, nihilistic) space. Nietzsche's madman describes the difficult and horrifying experience of trying to ground oneself in such a godless, coordinate-less space:

> But, how did we do this? How were we able to drink up the sea? Who gave us the sponge to wipe away an entire horizon? What were we doing when we unchained this earth from its sun? Where is it moving to now? Where are we moving to? Away from all suns? Are we not continually falling? And backwards, sidewards, forwards, in all directions? Is there still an up and down? Aren't we straying as though through an infinite nothing? Isn't empty space breathing at us? Hasn't it got colder?

Isn't night and more night coming again and again? Don't lanterns have to be lit in the morning? Do we still hear nothing of the noise of the gravediggers who are burying God? Do we still smell nothing of the divine decomposition?—Gods, too, decompose. God is dead. God remains dead and we have killed him.[54]

7. NO GOD

In 1887, Nietzsche published an expanded edition of *The Gay Science* that included a newly added fifth book, "We Fearless Ones." It opens as follows: "The greatest recent event—that 'God is dead,' is already starting to cast its first shadow over Europe." For most people, though, "the event itself is far too great, distant, and out of the way even for its tidings to be thought of as having arrived yet." The shadow cast by the dead God is not immediately apparent; it reveals itself only "to those few . . . whose eyes—or the suspicion in whose eyes is strong and subtle enough for this spectacle."[55]

Those few "free spirits," whom Nietzsche describes in the first person plural, are "on the lookout on the top of the mountain, posted between today and tomorrow and stretched in the contradiction between today and tomorrow." They are the "firstlings and premature births of the next century."[56] Gazing ahead into the twentieth century, what they see is how, in being enveloped by the shadow, Europe surrenders itself to a "long dense succession of demolition, destruction, downfall, upheaval that now stands ahead."[57]

The death of God signifies the collapse of the European value system. It is an event that forces humans to reevaluate their standing in a world that reveals itself to be intrinsically meaninglessness. The challenge this event poses is nihilism. But the majority of people flee this challenge and respond with denial. This explains why the proclamation of the death of God by a madman running through the marketplace only "caused great laughter" in the crowd.[58] The madman seems incoherent, but the audience's inability to understand him is not the result of their firm belief in the old God. On the contrary, it is their self-regard as advanced non-believers who cling to new secular value systems that bars them from recognizing the condition of "being held out into the nothing."

Something similar can be said of blindness to the shadow's presence. It is not an ordinary form of sightlessness in which the eye is denied access to visual information. Quite the contrary. It is a situation in which the eye cannot open up to the void because it is flooded with information. What is hidden from the multitude is not any positive content, but that which cannot be framed as a positive. Not a positive content that eludes the eye but the opposite—a positive content that overwhelms the eye and forces it to forget the nothing.

This unique model of visual concealment preoccupied Nietzsche throughout his writing life. It first appears in his early writings on the dialectic of the image in Greek tragedy where it appears with respect to the perpetual struggle between the Apollonian and the Dionysian. There, Nietzsche argues that the possibility of a clear and distinct image depends on the image's ability to obscure the condition of its emergence. The logic of the image is that of Apollo, the god of light and image-maker, possessor of "the wisdom and beauty of semblance." But the apparent coherence and clarity of the Apollonian image cannot be understood, according to Nietzsche, without the dark, formless gravity of Dionysus whose intoxication, transgression, and hybridity all point to the chaotic, fragmented, and meaningless grounds that underlie the image's lucidity. In the context of tragedy, Apollonian meaning is most clearly embodied, for Nietzsche, by the figure of the hero. The hero presents the viewer with a determined positive meaning that at first seems autonomous. But, this autonomy is a mere appearance.

The language of Sophocles's heroes surprises us by its Apollonian definiteness and clarity, such that we feel as if we are looking straight into the innermost ground of their being and are somewhat astonished that the road to this ground is so short. But if we divert our gaze from the character of the hero as it rises to the surface and becomes visible, it turns out to be no more than an image of light (*Lichtbild*) projected onto a dark wall. It is an appearance through and through. If we instead penetrate down to the myth that projects itself in these bright reflections, we experience the inversion of a familiar optical phenomenon. When we turn away, blinded, after a strenuous attempt to look directly at the sun, we see dark colored patches before our eyes, as if the dark were trying to heal us.

Conversely, the appearance of those Sophoclean heroes in images of light, their Apollonian masks, are the necessary consequence of gazing into the terrible inner depths of nature—radiant patches, as it were, to heal a gaze seared by gruesome night.[59]

This topsy-turvy inversion of the customary relationship between light and dark, positive and negative, continues to be central to later discussions of the shadow cast by the death of God. Nietzsche locates the cause of this event in an acute crisis, a colossal loss unfolding in the historical moment of the present. The majority cannot yet see the shadow cast over Europe. The multitude, he says, is blind to the predicament of nihilism, which all too quickly finds refuge in new and alternative paradigms of sense-making, such as science, economics, social justice, or art. In visual terms, the crowd's blindness results from the inverted logic of the shadow cast by the death of God. Unlike ordinary shadows, this shadow is no dark projection of a lit object. It is not the negative of an object illuminated by the sun but the bright projection of "a deep darkness and an eclipse of the sun the likeness of which has probably never before existed on the earth."[60] The shadow of the void appears to the multitude as all positivity, a new world-picture whose clarity and attractive content, like that of the photograph, is to be embraced. Like the photograph, the shadow of the dead God appears to the multitude as a positive light-image that bears no trace of its rootedness in the abyss.

In articulating the response to God's death in terms that evoke photography's visual logic, Nietzsche echoes an earlier text by Charles Baudelaire in which the French writer—whom Nietzsche read—presents the public response to the invention of photography in similar terms. Baudelaire's harsh critique of what he terms "the invasion of photography" conveys why, in his opinion, the new invention threatens the future of art and the life of the imaginative mind while giving voice to anxieties about the deep cultural crisis that was transforming mid-century Europe and that continued to preoccupy Nietzsche twenty-five years later.

> In the domain of painting and statuary, the present-day credo of the worldly wise … is this: "I believe in nature, and I believe only in nature. … I believe that art is, and

can only be, the exact reproduction of nature. . . . Thus if an industrial process could give us a result identical to nature, that would be absolute art." An avenging God has heard the prayers of this multitude; Daguerre was his messiah. And then they said to themselves: "Since photography provides us with every desirable guarantee of exactitude" (they believe that, poor madmen!), "art is photography."[61]

For Baudelaire, photography arrives at a transformative moment in French history in which, as Nietzsche will later note, the dominant value system based on faith in God is on the brink of collapse. Photography is but a symptom of these "deplorable times," yet because it functions as an addictive, fraudulent *pharmakon,* he expects it will destroy whatever "vestige of the divine might still have remained in the French mind." Photography invades European culture, which Baudelaire presents as crucially affected by the absence of the divine. And this invasion is possible because God—or the old gods—have evacuated, leaving a vacuum in the space of human meaning and value. "From that moment onwards," Baudelaire continues,

Our loathsome society rushed, like Narcissus, to contemplate its trivial image on the metallic plate. A form of lunacy, an extraordinary fanaticism, took hold of these new sun-worshippers. Strange abominations manifested themselves. By bringing together and posing a pack of rascals, male and female, dressed up like carnival-time butchers and washerwomen, and in persuading these "heroes" to "hold" their improvised grimaces for as long as the photographic process required, people really believed they could represent the tragic and the charming scenes of ancient history. . . . It was not long before thousands of pairs of greedy eyes were glued to the peepholes of the stereoscope, as though they were the skylights of the infinite. . . . Will the honest observer declare that the invasion of photography and the great industrial madness of today are wholly innocent of this deplorable result? Can it legitimately be supposed that a people whose eyes get used to accepting the results of a material science as products of the beautiful will not, within a given time, have singularly diminished its capacity for judging and feeling those things that are most ethereal and immaterial?[62]

As the multitude frantically searches for immediate solutions, its prayers are heard by an "avenging God." Daguerre, his messiah, knows how to captivate the minds of people. His invention enslaves them, making them devotees of a narcissistic mirror and determining the parameters of their vision in terms of their "trivial image on the metallic plate." Photography severs any connection they might have had with the transcendent and, in leveling all sensibility to "those things that are most ethereal and immaterial," turns the multitude into a possessed crowd of "new sun-worshippers." Baudelaire's eschatological language—his allusion to the Antichrist—again foreshadows Nietzschean themes. As in Nietzsche, photography is a symptom of the "present age" that offers nothing more than an illusionary substitution for the transcendent. It is a mere distraction that results in, "[t]housands of pairs of greedy eyes . . . glued to the peepholes of the stereoscope, as though they were the skylights of the infinite."[63]

The structure of Nietzsche's pessimism is different however from that of Baudelaire, and a Nietzschean understanding of photography would differ from Baudelaire's daguerreophobia. Despite his lengthy explanation of the radical existential and cultural crisis—the incurable anxieties—plaguing Europe, Nietzsche sees in God's death an opportunity that calls for affirmation and exploration.

> The *consequences* of this event . . . [are] not at all sad and gloomy. . . . In hearing the news that "the old god is dead" . . . our heart flows with gratitude, amazement, forebodings, expectations—finally the horizon seems clear again, even if not bright; finally our ships can set out again, set out to face any danger . . . the sea, *our* sea lies open again, maybe there has never been such an "open sea."[64]

For Nietzsche, the new condition is an open question. It can be answered in a creative—or, as he says, an "active"—manner, but it also paves the way for a whole spectrum of common "re-active" positions. The same fate awaited photography from the get-go. The non-place of its birth lacked coordinates. In the beginning, there was *no* Word, no *logos*. Photography's meaning is grounded in meaninglessness. But the

nothing, the nowhere, the caesura from which the new mechanical image confronted the human eye is—like the death of God—a condition that opens up a new horizon in the search for meaning.

Baudelaire's "modern public," and on this point Nietzsche would agree, cannot see that; and as it rushes to find formulaic solutions, substitutions, and distractions, it conceals the void. Indeed, photography needed to deny the emptiness from which it came into being in order to allow the light-image to assert itself as meaningful. But the nothing from which photography emerged—and which it incessantly strove to overcome—does not determine its identity. That nothing is not what photography is but only the point of departure for what photography would become: Photography's identity has evolved from its constant preoccupation with—and reactions to—the sense of its own groundlessness. The sequence of interrelated reactions comprise the grid of photography's history such that photography *is* the history of photography: a relatively short—and passing—episode in the long history of humanity's attachment to images.

8. NEW GODS?

How is photography's current visuality illuminated by Nietzsche? The short answer is that the history of photography is entangled with the aftermath, the dialectical unfolding, of the death of God. It has been characterized by reactions to and reactivations of its gaping nothingness, by strategies of denial and modalities of reorientation with respect to the perspectival fragmentation of the meaningful. Historically, this dialectic has been essential to photography's self-presentation as a medium that translates the possibilities opened by changing technologies into distinctive modalities of visual meaning.

By way of illustration, consider the relation of contemporary photography to yet another moment in its dialectical history: In 1922, the great modernist and socially committed photographer Paul Strand published his manifesto, "Photography and the New God" in which he developed a vision of photography's task and potentialities in the age of God's death.[65] Nietzsche is nowhere mentioned therein, but his influence is unmistakable. According to Strand, "The disintegration of the power of the Christian

Church" left a vacuum that was immediately filled by the presence of a rising deity: "God the Machine" appeared as part of "a new Trinity" that included "materialist empiricism the Son, and science the Holy Ghost."[66] Under the reign of the new god, a new order of meaning and values is established. By internalizing a strictly instrumental logic of production, the industrial-capitalist order does not allow for the unique value of the human and, relatedly, holds the artist in contempt "as a waster and non-producer."[67]

Yet for Strand, this grim new reality opens up a unique opportunity for the photographer. Since the rule of the machine is too strong to be directly opposed, the possibility of change depends on covert resistance and subversion of the system from within. Photographers are well suited for the task. Intimately familiar with technology, they can take "creative control of one form of the machine, the camera." The task of the photographer is to humanize the machine. "Not only the new God but the whole Trinity must be humanized lest it dehumanize us." The mission entails a creative overtaking of "a dead thing unwittingly contributed by the scientist" and a re-appropriation that reveals "a new and living act of vision."[68]

For Strand, photography can make a difference only if it breaks with a nostalgic disposition—the longing for the providence of the old god—and roots itself in the technological culture of its time. Twentieth-century modernism encourages photography to embrace its own material-technological underpinnings as essential to its identity and in this way to separate itself clearly and distinctly from the pictorial tradition that haunted its visuality. Intersecting with central themes of the New Vision, Strand not only recognizes the distinctiveness of the photographic apparatus, but is specifically intrigued by the encounter between the mechanical and the human eye, in which he finds the key to the revolutionary transformation of the machine. Strand's machine photographs elucidate his vision.

As his manifesto comes to a close, its tone seems to change, however, and the radical politically committed rhetoric is gradually nuanced. What began as a call to humanize the machine through photography turns into a description of a future in which photography will enrich human experience through the machine. The photographer "may

FIGURE 27. Paul Strand, *Double Akeley, New York*, 1922.
© Aperture Foundation, Inc., Paul Strand Archives.

do with a machine what the brain and hand, through the act of memory, cannot do."[69] Here, the idea of taking "spiritual control over a machine" no longer entails resistance to and subversion of the power of the new god as much as it does the securing of a *modus vivendi*, one that circumvents the "wall of antagonism" and alleviates the "reciprocal hostility" between scientifically based technology and human expression. "Must not these two forms of energy converge," Strand asks in conclusion, "before a living future can be born of both?"[70]

The modernist exploration of photography's machine structure was an exciting moment, as the encounter with "the eye of the machine" was yielding new and surprising results. "We have only to recall the manner in which we used to look at landscapes," László Moholy-Nagy wrote in 1932,

> and compare it with the way we perceive them now! Think, too, of the incisive sharpness of those camera portraits of our contemporaries, pitted with pores and furrowed by lines . . . or the enlargement of a woven tissue, or the chiseled delicacy of an ordinary sawn block of wood. . . . Thanks to the photographer humanity has acquired the power of perceiving its surroundings, and its very existence, with new eyes.[71]

Photography's machine-based visuality was celebrated as opening up new vistas on the world. "The eye of the machine"[72] challenges, stimulates, and changes ordinary vision, by bringing into view and articulating dimensions of the visible that have previously remained invisible:

> Bird's-eye views, simultaneous interceptions, reflections, elliptical penetrations . . . open up a new field of visual presentation in which still further progress becomes possible. . . . Indeed, this advance of technique almost amounts to a psychological transformation of our eyesight.[73]

In a sense, this modernist vision brought photography closer to itself, as it allowed the medium to overcome its primary alienation from the machine and uncover the technological as the foundation of its condition. At the same time, however, in

embracing the technological as its essence, modernist photography reproduced the prevalent tendency—analyzed by Nietzsche—to efface God's death by all too quickly finding refuge in alternative paradigms of sense-making. The seemingly radical move of taking root in a machine structure ultimately serves as a traditionalist strategy of preserving the illusion of a grounding principle. The machine becomes a new way of hiding the caesura, the nothing that is photography's identity.

The modernist gesture of grounding photography's visuality in the facticity of the machine not only conceals photography's groundlessness, it also hides from photography one of the most crucial features of its machine logic: the virtual. Strand and Moholy-Nagy are, in some ways, close to recognizing the virtual's immanent presence in photography, but in the end they remain riveted to a paradigm of which they themselves have grown weary. Unlike photography's more traditional self-understanding, they take the disjunction between the machine and man's embodied subjectivity to be the key to photography's new visuality.[74] Although they also recognize the rupture that photography creates in the relationship between the visible and the visual, they nevertheless continue to speak of this relationship in the traditional terms of its continuity: Photography visualizes the visible, and the results of this visualization are photographs that create a "new vision" allowing its viewers to encounter the visible in new ways. The drama of photography unfolds on the stage where the visible and the visual meet as two domains—two forms of vision—that, despite their reciprocity, remain ontologically the same.

Photography was born into a world in which the distribution of vision between the visible and the visual was clear. The visible was vision's primary field of reference—the natural abode of an embodied eye—and the visual was a derivative, more limited, region to which, under special circumstances, vision could attend by looking at images. The visible is traditionally understood as the essential correlate of an embodied, active, vision immersed in the world whereas visuality is considered a secondary, more peripheral experience, one ascribed to the narrower position of being a spectator.

Photography's inner logic refuses this hierarchy. The detachment of the photographic apparatus from the human body grants photography access, as we've seen, to anything

that appears. Photography is imperialistic from the start. The eye of the machine knows no boundaries and respects nothing. It absorbs and frames everything; there is nothing, in principle, that it cannot own. But in becoming compatible with the photographic—in turning into photography's potential content—the visible undergoes a critical transformation. It can no longer sustain its primacy for vision. Photography inverts the traditional relation between the visible and the visual: It allows the visual to dominate—to serve as the measure of the visible. When Strand and Moholy-Nagy speak of a future in which photography will continue to articulate new dimensions of the visible, they fail to see that photography may irreparably transfigure the space of the visible as they have known it. They remain indifferent to the dangers of a new period in which the visible would prove vulnerable to a visual exploitation that exhausts its potential and forces it to comply with the inner *telos* of the machine.

Subordination of the visible to the visual is only the first stage, however, in the dialectic charted by photography's logic. Once the visible is packaged as visual content, it ineluctably lends itself to expanding the rule of the visual. For its part, with no resistance from the visible, the visual only wants to multiply itself, and it does so by turning the map of the visible that it has conquered into a map of active points of view. As we saw, the points that make up the field of the visible are not only points of visibility that can, in principle, be photographed. What photography's perspectivism implies is that these are always already potential points of view from which photographs of all kinds might be taken.

The visible thereby becomes a homogeneous expanded space of inhuman eyes, identical units, each of which can record an indefinite number of views that are all equally set to provide sequences of representation. In such a space (the term "world" no longer applies here) each and every point is a place mark for potential views.

This is where the virtual transmutation of the visible begins. The "visual value" of a falling leaf not only lies in the way it appears to a viewer, but primarily in the potential it carries as a visual recording device. Likewise, the red spot on a seagull's beak, a particle of food processed in the digestive system, a cookie crumb on the desk of an administrator, the tip of an iceberg melting in the Arctic, a dead fish in an oil spill in

the ocean, the bronze hand of an ancient god at the bottom of the sea, your smile—are all potential racks for photographs or visual depictions. In our age of satellites, drones, Google Glass, and GoPro, this kind of vision is becoming a reality. And in becoming a reality, it strives to achieve an all-encompassing view that would unify the fragmented perspectival multiplicity as if God had never died. Is photography's internalization of the virtual the final crowning of the new god, a god that photography has been consistently, if inadvertently, serving since its inception?

FIGURE 28. Jennifer Abessira, *The New Order, #Elastique Project*, 2015.
Courtesy of the artist.

SEPARATION 3

At the local café, Jennifer Abessira asks me how my book is coming along. Jennifer is a photographer who works in both Tel Aviv and Paris, but the actual site of her art is her Instagram account. When I tell her that I'm writing about the end of photography, I'm surprised to see that she's completely indifferent to the topic. "Today," she says, "there's no such thing as photography—there are only images."

When we say goodbye, she hands me a business card. It reads "Image Creator."

PART IV
PHOTOGRAPHY'S GOODBYES

1. BUTADES, AGAIN

In the beginning, there was *no* Word, no *logos* for photography. And yet, photography needed to find ways to enable the light-image to assert itself as meaningful. In its struggle for self-assertion, it was compelled to deny the nowhere, to hide the caesura, from which its new mechanical images sur-prised, overtook, the human eye. Erasing from its biography any trace, any shadow, of vacuity or discontinuity, the photograph installed itself as an integral part of the great—uninterrupted—chain of Being. Photography pictured itself as an embodiment of a natural principle of continuity that confirmed its rootedness in nature and validated its uniqueness as a method of visualization that promised an image that is an imprint of the world itself.

Whereas the role of nature as origin ultimately lost its efficacy under high modernism (concurrent with the demolition of nature), the idea of a causal-material continuity remained integral to the status of photography during the twentieth century and received a pronounced theoretical confirmation within the influential photographic discourse that emerged in the late 1970s to early 1980s. As we've seen, photography has articulated its continuum concept in terms of a physicality that typically remains indifferent to the human condition of corporeality, ignoring not only the sense of touch but the

175

very presence of the body as an original site for the unfolding of the visible. (Whereas in Talbot the analogy between the human and the mechanical eye is taken for granted, in the modernism of the 1920s the disjunction between the two "eyes" becomes a theme in and of itself.) But even as it excluded human embodiment from the core of its visual equation, photography generally continued to embrace the human—body, temporality, loss, longing, pain—as the essential measure of its visuality.

One of the most prevalent and consistently effective strategies for asserting photography's *continuum concept* is what this book terms the "Butades picture." According to this picture-myth, a photograph is a faithful mode of memorialization, one that succeeds in holding onto the visible presence of a bygone moment, despite the passing of time. Photography's essence lies in its ability to present the now to the future as a direct imprint of the past. This ability stems from the participation of the photographic act in the now that it represents. Be it an event, person, or place—the Butades photograph is born of an encounter that shares the temporal and spatial horizons of its object: There is a mutual involvement, a being-together in the present. The photographic act takes place in the present, but while the present ineluctably recedes into the past, the photograph functions as a bridge to the future in which that "primary" bygone present is retrospectively viewed as a past (a past-present that is also a present-past).

Roland Barthes has served here to exemplify a conception of photography that complies with this logic. In explicating photography's essence in terms of the "'That-has-been,' or . . . the Intractable,"[1] he embraces the primacy of the lost present as that which grounds the photographic image. But can a foundation ever be found for photography, can the imperative of the Butades tale relieve photography of the void that haunts it, the plight of perspectivism? The "that-has-been"? The "intractable"? Are these apparent certainties anything but perspectival constructions? If all photography can offer are perspectives—if perspectives are all there is to offer—how can photography uphold the meaning of an event, especially a "primary" or "originary" event? What event? Whose love? Can there be anything for photography to remember in a fragmented space of infinitely conflicting perspectives?

Butades is not only a conceptual scheme. It is also a figurative and affective framework by which photography is able to cope with its groundlessness and to assert itself as a coherent form of sense-giving within modern life. Butades creates a conceptual and emotional rationale that enables photography to repress the destructive implications of its inherent perspectivism. It furnishes photography with a nativity scene that takes place around the hearth of the human home: In this setting, at the intersection of Eros and Thanatos, the photographic emerges as an event that carries a regulative significance in the drama of a human life. It becomes meaningful as the embodiment of the human response to finitude, the transience of the now, and, in a corollary sense, to the imperative of memory. This grounding strategy has remained central to photography's life for at least one hundred and fifty years, and it continues to echo clearly in formulations that, even when contested, hover over contemporary photographic discourse.

Butades offers a narrative, but, more importantly, it offers a meta-narrative (a picture of pictures) that sets the standard for photography's meaningfulness. When Barthes asserts the primacy of the "that-has-been," his claim does not only pertain to the epistemic value of a photograph. It is, unwittingly, a normative claim about the photograph's entitlement to meaning, a claim that is ultimately not descriptive but regulative. The insistence on the intractable status of what we see in photographs is a way of constructing a foundation for photography, a foundation that is marked by the sign, the imperative, of remembering and that concomitantly hides photography's need to forget.

This dialectic of hiding by showing is what allows for the thematization of loss. "Photography," as Eduardo Cadava says, "is a mode of bereavement."[2] Indeed, photography has often understood itself in terms of the lost moments—or lost presences—that it captures and memorializes (a moment in a life, in the everyday, a historical event, a person's youth, the beauty of a face, a falling leaf). What this preoccupation with such bygone presences concomitantly suppresses is a categorically different kind of loss, one that cannot be framed as photographic content. This kind of colossal, structural loss— the erasure of an underlying grid for meaning and value—is what we called, following Nietzsche, the death of God. Photography's attachment to what is ultimately lost—to

the varieties of death in a human world—is always already an expression of its effort to negotiate, to deny, and to overcome the technological void into which it can easily collapse. It is this non-human death, the ultimate breakdown of human meaning, that photography sublimates when it internalizes the Butades picture and turns memory and bereavement into its human trademark.

2. NAN AND BRIAN IN BED, NEW YORK CITY

It might be the effect of the unique yellow, evoking a day's last rays of sunlight, that determines the mood of this picture. The artist, lying in bed, her head on the pillow, looks at her seated lover, whom we see only in profile. Is this what the dissipation of love looks like? On the wall above the bed, we see another Goldin photograph of Brian

FIGURE 29. Nan Goldin, *Nan and Brian in Bed, New York City*, 1983. © Nan Goldin.
Courtesy of Marian Goodman Gallery.

(*Brian with the Flintstones,* 1981), once again in bed, again without a shirt, a cigarette in his mouth; this time he faces the camera. *Nan and Brian in Bed* is emblematic of Goldin's work. It is part of Goldin's influential photographic series *The Ballad of Sexual Dependency,* which depicts moments in the life of her friends, lovers, and family and which was initially presented in public as a slideshow accompanied by a sound track. It also serves as the cover image for the book version of the *Ballad* and is a key image within the book's internal sequencing, as it serves to open the book's last section, "Memories Are Made of This."

Goldin describes the *Ballad* as "the diary I let people read." Unlike the written journals that she keeps private (and that "form a closed document of my world"), her "visual diary is public," allowing her to articulate and come to terms with the unfolding of her life in the open. "These pictures" she writes "were taken so I can see the people in them. I sometimes don't know how I feel about someone until I take his or her picture."[3] Life as immanence is not only the subject matter but also the enabling condition of her photography. And photography is her way of viewing life from within. Goldin's photographic eye is never external to the situations depicted in her photographs; it is always already entangled in them. Perhaps this is what she means when she writes that "these pictures come out of relationships, not observation." She is never in the position of a voyeur or a mere spectator; she is always already involved with and affected by the specific people and concrete dramas that shaped her life from the late 1970s to the mid-1980s.[4] And Brian, who appears frequently in the *Ballad,* is one of the people with whom she is entangled.

Whereas *Nan and Brian in Bed* is a key—perhaps final "moment"—in the sequence, it acquires significance through its relation to other moments in the *Ballad* and, in particular, to earlier depictions of Brian and Nan, such as *Nan on Brian's Lap, Nan's Birthday, New York City* (1981), which opens the book, to Brian appearing alone or with others, and ultimately to an image that Goldin regards as her visual diary's centerpiece, *Nan One Month After Being Battered* (1984). In the introduction to the *Ballad,* Goldin describes her relationship with Brian as follows:

> For a number of years, I was deeply involved with a man. . . . We were addicted to the amount of love the relationship supplied. We were a couple. Things between us started to break down, but neither of us could make the break. The desire was constantly re-inspired at the same time that the dissatisfaction became undeniable. Our sexual obsession remained one of the hooks.
>
> One night he battered me severely, almost blinding me. He burned a number of my diaries. I found out later that he had read them. Confronting my normal ambivalence had betrayed his absolute notion of romance. His conflict between his desire for independence and his addiction to the relationship had become unbearable.[5]

While the *Ballad* documents "moments" in her ongoing relationship with Brian, the introduction was written a few years after the relationship had ended, so the perspective it offers is retrospective.

> After two years of anger and mourning, I was face to face with him on the street for the first time since that night. We said hello. I looked into his eyes. Later I was able for the first time to remember my real desire for this man and I understood how intense that bond was. Despite all the destruction, I could still crave that love. I had to face the irreconcilable loss.[6]

In her introduction, Goldin looks back at images that she made in the past and that were once integral to her present. The present is the root of her photographic act. "Photography is as much a part of my everyday life as talking or eating or sex." It is intrinsic to Goldin's everyday experience, but this is not to imply that, for her, the everyday is ever ordinary, average, or mechanical. On the contrary, Goldin lives the everyday through the changing intensities of its moments, and photography is her way of negotiating, of orientating herself in, and with respect to, those intensities. "The instance of photographing, instead of creating distance, is a moment of clarity and emotional connection."[7]

Her images are rooted in and continuous with an embodied vision that both finds itself in time and is responsive to the moment's imminent transience. They grow and

develop out of the intersection of desire and loss that upholds our being-in-the-moment, a being-in that inevitably surrenders itself to the passing of time, which is always also the passing of one's life. It is precisely in negotiating a moment's changing horizons that the image presents itself as never containable within the confines of any specific "now." Rather, it always addresses itself to an impending future whose arrival in the form of a present turns the image into a memory.

> My desire is to preserve the sense of people's lives, to endow them with the strength and beauty I see in them. I want the people in my pictures to stare back. . . . Real memory, which these pictures trigger, is an invocation of the color, smell, sound, and physical presence, the density and flavor of life. . . . It enables me to remember.[8]

Goldin wants to be able to remember, and photography is her way to preserve real memories. Whereas *Nan and Brian in Bed* is imbued with the singularity of her intimacy with Brian, of her desire and pain, the image also displays a more general photographic structure. It is the mythical structure that enables photography to become meaningful in the pose—to be a mode, for instance, of saying goodbye to the now. The grammar of *Nan and Brian in Bed*, its elaboration of the intensity of a transient moment that is on its way to becoming part of the retroactive workings of remembering and mourning, positions Goldin's work within the horizons of Roland Barthes's vision of photography. Goldin's photograph resonates with the thematics of the photographic image that Barthes so forcefully articulated through his triangulation of desire, loss, and memory. For Barthes, this understanding of the photographic is intertwined with personal grief, his mourning of the death of his beloved mother; and yet, in his investment in his mother's photographs, he ends up reproducing, as we've seen, a phantasm that in the nineteenth century allowed photography to *hide its nothingness from itself*, the Butades picture.

Goldin, too, unsuspectingly shares this with Butades. Her radical, cutting-edge photography—her harsh, personally exposed, and feminine visual statements of the 1980s—reproduces an already established strategy of responding photographically to

photography's old originary complex—its "black hole." Like Barthes's *Camera Lucida*, Goldin's *Nan and Brian in Bed* presents the photograph as an embodiment of a loss, a space in which the density of a bygone presence can live on. For both Barthes and Goldin, the meaning of photography's visuality lies in the obsessions of the body and the pains of the soul that together attest to the human predicament of having to let go, to say goodbye, and to live with the unpreventable evanescence of what we want and love and care about.

3. THE DIVORCE

Sophie Calle's *The Divorce* (1992) brings the Butades picture into the postmodern era. The photograph and accompanying text are part of her *True Stories* series, which, as its title suggests, seeks to complicate the standard opposition between truth and fiction. Taken in black and white, the photograph presents a man in frontal view. His head is not included in the picture's frame,[9] but the head of his penis is front and center, pissing toward the camera and held from behind by a woman's hand. In the text, Calle tells the story of a ritual she used to perform with her ex-husband:

> In my fantasies, I am a man. Greg was quick to notice this. Perhaps that's why he invited me one day to piss for him. It became a ritual: I would come up behind him, blindly undo his pants, take out his penis, and do my best to aim well. Then, after the customary shake, I would nonchalantly put it back and close his fly. Shortly after our separation I asked Greg for a photo-souvenir of this ritual. He accepted. So, in a Brooklyn studio, I had him pee into a plastic bucket in front of a camera. This photograph was an excuse to put my hand on his sex one last time. That evening, I agreed to the divorce.[10]

On a literal level, Calle's photograph emerges from her need to have "a photo-souvenir" of her relationship with Greg that has just come to an end. The setting—the story she conjures up—is one that involves, like the Butades tale, a separation and the need to remember, to memorialize, an intimate dimension of her beloved. But unlike

FIGURE 30. Sophie Calle, *The Divorce*, 1992. © Sophie Calle. ADAGP.

the Butades tale, Calle's story is told with ironic distance. The "true story," we are called upon to see in *The Divorce*, is a hybrid of fact and fiction—not only because Calle's representation may be, on some level, inaccurate but because her memory-image does not at all present the actuality of the situation she wants to remember.

Unlike Nan Goldin, who photographs directly from life and for whom the ability to view life from within is the key to creating "real memories," Sophie Calle is a constructivist. The making of her memory-image is not part of a now in which she faces the nearing separation from her lover but a retrospective response to a separation that has already happened. Calle's photo-souvenir derives not from her personal past but is a concocted image of a scene staged for a photo shoot that takes place in her studio. Although she creates the image after the fact of separation, it functions as a "true" memory of the life she and Greg once had. Calle clearly resists the sentimental when she speaks of her photographic gesture, but the gist of that gesture challenges photography's myth of original presence. Calle refuses to accept the necessity of the Barthesian "that-has-been." For her, photographic truth no longer depends on (what Merleau-Ponty terms) "the primacy of perception." This turning from the Barthesian picture—and its way of appropriating Butades—is manifest in the image itself.

Importantly, *The Divorce* is devoid of shadows. Unlike the tenebrous space of Goldin's *Nan and Brian in Bed*, the faceless bodies of Sophie and Greg appear in a bright, homogenous light against a white background. Shadows have no place in this kind of setting, which is distant, in terms of both structure and atmosphere, from the room in which the pronounced shadow of Brian's finger flickers on his face in profile. This absence of shadows marks Calle's understanding of the photographic moment, her indifference to the kind of authenticity that is often associated with the painful, transient, singularity of being-in-the-present. The absence of shadows marks her refusal to acknowledge photography's rootedness in the fullness of a self-contained now, an originary event whose past presence continues to inhabit the image and uphold its meaning. Another aspect of Calle's (de)constructive attitude toward presence is her doctoring of the original camera-image: the elimination of the rest of her body from the picture. Whereas a

responsiveness, a sensitivity, to the shadow attests to photography's manner of rooting itself in the singularity of the passing moment, photography can equally turn its back on the claims of the "that-has-been," an option that has become more attractive with the vast horizon of possibilities opened by the digitalization of the image. Photoshop means an acceptance of the uprootedness of images, the death of the shadow that is, perhaps, the ultimate meaning of the idea of "fixing shadows." This does not mean that shadows do not appear in photoshopped images. On the contrary, in the domain of photoshopping, shadows come in high demand, as they upgrade the apparent veracity of images. Fixing shadows has become a requisite for making images look real.

Nevertheless, despite Calle's ironic distance, we see that her work continues to orbit the Butades model. While her photographic image does not commit itself to the actuality of a singular here and now, it does grow out of a sense of loss and the need to remember. In the image itself, Calle is present through her hands—the hands of the artist, of a woman holding and handling a pencil-like, even if organic, device with which she draws a line. While she erases from her photograph all typical traces of an immediate presence, her picture does retain the strong presence of the now. The singularity of the now shows itself in the actual event of Greg's pissing: a urine flow—reconstructed but real—"that-has-been."

In *The Giraffe*, another of Calle's *True Stories*, there is a similar duality; it depicts, from below, the long neck and head of a taxidermied giraffe mounted on a wall. The accompanying text reads as follows:

> When my mother died I bought a taxidermied giraffe. I named it after my mother and hung it up in my studio. Monique looks down at me with sadness and irony.[11]

The Giraffe is one of several works in which Calle deals with her mother's death, which she addresses, like the giraffe itself, "with sadness and irony." What Calle shows us is an image of an image, one that in itself has nothing in common with the being of the person whose memory it is supposed to evoke. Nothing seems to link the image and the lost beloved apart from the contingent, if not arbitrary, fact that Calle named

the giraffe after her dead mother. Monique is only present in the image because of her daughter's artistic act. Thanks to Calle's retrospective construction of the meaning of this otherwise displaced image, however, the Butades triangulation of love, loss, and memory remains the infrastructure of this work in which the long shadow of a giraffe's upper body unassumingly takes its position on a white painted wall.

FIGURE 31. Sophie Calle, *The Giraffe*, 2012. © Sophie Calle. ADAGP.

4. NOW, PHOTOGRAPHY

Before takeoff, on the plane from Berlin to Tel Aviv, I think of the sections of this book that still need to be written. I spent the last few weeks in a big apartment with a garden, working intensively on finishing the book, hoping to be able—after four years—to say goodbye to it. I am close to that moment, I tell myself, but not quite there yet.

Then an urge announces itself, insisting that I take a picture and capture the moment of parting. I reach for my cell phone, look around for what would make a good photo-souvenir, and decide to aim the phone's mechanical eye through the airplane's window, where I spot a few groundcrew workers standing next to the plane. I click once and after a quick look at the result on the screen, slip the phone back into my bag.

The days pass and I forget about the event until today, a month later, when I coincidentally come across that photo again. Looking at the photo on the phone's screen, I want to see what exactly was happening there outside the airplane's window, so I zoom in. I see the two men—different from each other in appearance and posture—having an on-duty conversation, parked vehicles behind them, a flight of stairs, a sleeve leading to another airplane, and above them, a cloudy sky. I am somewhat disappointed that there's nothing in what I see that specifically captures my interest or touches me emotionally. The gesture of taking this photo on the plane suddenly feels unclear, and I want to make sense of it. What exactly was I doing?

My time in Berlin was up. I was transitioning to a new phase in life. And in the liminal space of the airplane, I wanted to acknowledge something of that feeling of separation. But how is the photo I took relevant here? I just mentioned wanting to have a souvenir, but is that what it really is? Is it really an act of creating a memory, as standard photographic theory would suppose? My urge to take a photo had something to do with the transience of the moment, but what was at stake didn't feel like the need to produce, from that moment, a future platform for looking back. If I had really wanted to create a souvenir, I would have cared more about—made a greater effort to determine—the photo's content.

The role that photographic theory ascribes to memory is frequently overrated or oversimplified. The centrality of memory is typically tied, as in Barthes, to the perspective of a viewer who reflects on the experience of looking at photographs. For the viewer, it is indeed the case that what one sees in a photograph always already belongs to the past. But this all too often misses the gravitational center of the photographic *act*: the now. To take a picture is, first and foremost, a way of being in the now, even if—and perhaps just because—the now is structurally complicated, leaving all kinds of loose ends.

There are times when the now calls on us to turn it into an image. But the urge to take a picture does not necessarily arise from the need to memorialize or, rather, the

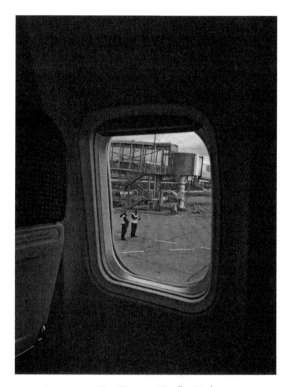

FIGURE 32. Hagi Kenaan, *Goodbye Berlin*, 2018.

need to memorialize is but one form of a more basic Existential of negotiating the presence of the now. The need for a picture is indicative of the quest to be able to frame the now—to be able to hold it in its plentitude—but, precisely as such, it also reflects the insufficiency we experience in being in the now. It's as if our being in the now cannot stand on its own, as if it requires a scaffolding, a framework, a relation to something external. The insufficiency or incompleteness of the now that is revealed by the need for an image is not a new phenomenon. It is part of the plight of being human, an open question that continues to be addressed through varying historical forms, including the Butades tale that has figured so importantly here.

In today's culture, our obsession with having an inherently photographic life does not typically involve "remembering" as its immediate *telos*. People incessantly take photos of everything they can lay their eyes on, but the main function of these photos is to serve as tokens of interaction on social media; the many billions of photographs that are uploaded daily are visual transactions, dynamic modes of self-presentation in the public sphere. In such a context, memory is no longer a value; and because, in this arena, a photo's visual presence is limited to the now of a transaction—the "sharing" and receiving of a community's instant feedback (those addictive "likes")—any complicated interlocking of the temporal aspects of existence is erased. Yet individuals connected to social media feel a constant inner demand to take pictures and share them. What drives this urge to photograph and to turn the personal stream of life into a public one?

The need to be photographic is indicative of a difficulty inherent in inhabiting the now. It is challenging to experience oneself in the now without the anchor of a public eye, which, with the exhaustive externalization of private experience, has become the validating measure of our subjectivity. It is difficult today to be inspired by the now—to love, to surf, to enjoy a meal—without knowing that one's experience feeds the anonymous gaze of the multitude.[12] Is photography providing us, in this case, with a substitute for the omnipresent, providential gaze of a no-longer-existing god?

I look again at the photo I took on the plane, thinking of what in that particular now incited me to take it. In looking, I realize that what appears through the airplane window

is, in fact, not the crux of my photograph. What the photograph shows is not the plane's outside as seen through a window but the interiority of a space that contains an opening—an aperture, a window—onto the outside. Inadvertently, this is a photo that is itself taken from within a *camera obscura*, evoking the camera's structure as an analogy to the site, the locality, the room of the subject: closed but also open, being here as a way of being there, or being there as a way of inhabiting the now. The now is itself a threshold. Its liminality reverberates with the tension between the not-yet and the no-longer; it is always in-passing, gradually losing ground to a future that is bound to take its place. Loss, in this sense, belongs to the structure of the now. But in asserting loss as the now's trademark, we are imposing, in fact, an ideal of fullness—the fullness of the present—as a measure of the now's concreteness. This means that we refuse to acknowledge the liminal as a primary condition of the now, seeing in it, instead, a deficient mode of a self-sufficient standard of presence. What would it mean to affirm the now as a moment of passing?

Being a friend of the now requires that we neither mourn nor resent, but rather see the beauty of its passing. This is a Nietzschean theme. "I want to learn more and more," he writes, "how to see what is necessary in things as what is beautiful in them."[13] Transience is the necessary structure of temporal experience.

Can we see transience as what is beautiful in the now? A photograph by William Eggleston comes to mind. Called *Glass in Airplane* (see the frontispiece of this book), its pictorial space is structurally similar to that of my own photograph: the space of a passenger's seat appears against the backdrop of the airplane's window. Is the connection coincidental? Unlike my airplane shot, Eggleston's plane is airborne, soaring above white clouds in a sunny sky. A woman's delicate hand is holding a straw set in a drink on ice (Eggleston says it's a Coke), a glass that, in refracting the light that enters through the plane's window, shows itself on the white tray through a manifold of happy colorful reflections. The moment is so joyful that the photograph might easily be mistaken for an advertisement. But this attractive spectacle of colors refracted through the glass prism is, in fact, a presentation of shadows that relate to yet another darker, almost monstrous shadow cast by the woman's hand, a distant relative of Butades. The presence of the

shadow—"the most transitory of things," as Talbot called it, "the proverbial emblem of all that is fleeting and momentary"—tells us that the photographer has recognized the now's evanescence; indeed, it is a central issue for Eggleston, who remains unruffled in the face of this harbinger of death.

The question here is about photography's ability to accept the separation that is always already part of the now. Being able to accept separation—or the caesura—as integral to life is a necessary condition for knowing how to say goodbye. As we've seen, the tendency to understand the photographic as part of a continuum typically results in a notion of goodbye that dodges the question of separation. For both Barthes and Cadava, photography's essence lies in its ability to mournfully hold onto the bygone presence of what has been loved and lost. This kind of understanding allegedly bids farewell, but it does so without accepting the nothingness of separation. Hence the recourse to the Butades paradigm, which—with its triangulation of love, loss, and memory—serves as an antidote to the nothingness that underlies photography.

But the moment of separation can also open up a different route for photography, one that both overcomes a nostalgic understanding of photography as a mode of memory and bereavement and refuses to be indifferent to the importance of the moment of separation. This route straddles two opposed photographic appropriations of the now and its goodbyes. While resisting the wordiness of a goodbye that cannot genuinely accept the passing of time, it keeps its distance from the careless, forgetful, mechanical forms of goodbye that are currently indicative of a paratactic temporality that doesn't remember why saying goodbye matters and what the claims of memory are. Both options are forms of avoidance. What do we avoid when we obscure the event of a goodbye? Is it only the pain of accepting that the condition of our attachment to what we love and care about is no longer possible? Are we merely avoiding an epistemic clarity? Or is there a deeper kind of truth that is hidden in such moments, one that calls for a photographic gesture of recognition? I would be happy to entertain a positive answer to this last question. But, the question is not a theoretical one. It calls on photography for an answer.

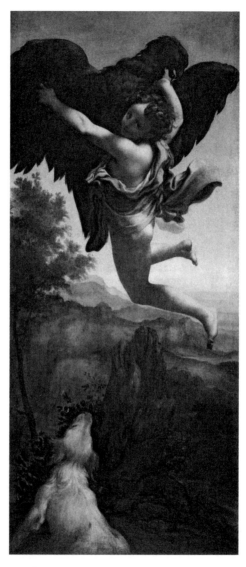

FIGURE 33. Antonio da Correggio, *The Abduction of Ganymede*,
ca. 1531–1532. Oil on canvas. Kunsthistorisches Museum, Vienna.
Lessing Culture and Fine Arts Archive.

SEPARATION 4

I tell Giancarla Periti about the book I'm writing. In parting, I ask her if any interesting farewell gestures come to mind apropos of our conversation. GC is an art historian of the Italian Renaissance. She says she'll think about it and get back to me. A few days later, she recommends I look at Correggio's *Abduction of Ganymede*. When we meet to discuss the painting, I tell her that this suggestion puzzles me. "Ganymede," I say, "was abducted by Zeus . . . does this involve a farewell?" "Listen to the barking in the painting," she replies. "The dog is the one saying goodbye."

INTRODUCTION

1. Joel Snyder, "Inventing Photography," in *On the Art of Fixing a Shadow: One Hundred and Fifty Years of Photography*, eds. Sarah Greenough et al. (Washington, DC: National Gallery of Art, 1989); Rosalind Krauss, "Photography's Discursive Spaces: Landscape/View," *Art Journal* 42, no. 4 (1982), 311–19; Allan Sekula, "On the Invention of Photographic Meaning," in *Thinking Photography*, ed. Victor Burgin (London: Palgrave Macmillan, 1982); Geoffrey Batchen, *Burning with Desire: The Conception of Photography* (Cambridge, MA: MIT Press, 1999); Kaja Silverman, *The Miracle of Analogy or the History of Photography, Part 1* (Stanford: Stanford University Press, 2015); Robin Kelsey, *Photography and the Art of Chance* (Cambridge, MA: Harvard University Press, 2015).

2. Hans Belting, *An Anthropology of Images: Picture, Medium, Body,* trans. Thomas Dunlap (Princeton: Princeton University Press, 2011), 147.

3. Friedrich Nietzsche, *Beyond Good and Evil/On the Genealogy of Morality; The Complete Works of Friedrich Nietzsche*, Vol. 8, trans. Adrian Del Caro (Stanford: Stanford University Press, 2014), 190.

4. Friedrich Nietzsche, *The Gay Science: With a Prelude in German Rhymes and an Appendix of Songs*, ed. Bernard Williams, trans. Josefine Nauckhoff (Cambridge: Cambridge University Press, 2001), 108.

5. Unlike Nietzsche's reading, the shadow in these theories is typically not understood as a figure of the concealment of an absent god, but rather an indication—a trace—of the Buddha's unique, albeit changing, presence. As such, these theories also provide, as Eugene Wang shows, a model for the visualization of the Buddha that embraces the shadow as an Ur-image—a medium or a source that grounds the possibility of a true representation of the divine. Eugene Wang, "The Shadow Image

in the Cave: Discourse on Icons," in *Early Medieval China Sourcebook*, ed. Wendy Swartz (New York: Columbia University Press, 2014).

6. They are interestingly presented through a reversal of their more typical roles in language: Substance (which underlies appearances) is that which fades here, and the shadow (the prototype of evanescence) marks an endurance in time.

7. See, for example, Hilde van Gelder and Helen Westgeest, *Photography Theory in Historical Perspective* (Hoboken: Wiley-Blackwell, 2011), 12.

8. "Branches of Being"—this is Merleau-Ponty's terminology for the facets of painting: "depth, color, form, line, movement, contour, physiognomy." Maurice Merleau-Ponty, "Eye and Mind," trans. Carleton Dallery, in *"The Primacy of Perception" and Other Essays on Phenomenological Psychology, the Philosophy of Art, History, and Politics*, ed. James M. Edie (Evanston: Northwestern University Press, 1964), 188.

9. Roland Barthes, *Camera Lucida: Reflections on Photography*, trans. Richard Howard (New York: Hill and Wang, 1981), 3, 20.

10. Ibid., 76–77.

11. Eduardo Cadava, *Words of Light: Theses on the Photography of History* (Princeton: Princeton University Press, 1997), 11.

12. Eduardo Cadava and Paola Cortés-Rocca, "Notes on Love and Photography," *October* 166 (2006), 34.

13. James Elkins, *What Photography Is* (New York, London: Routledge, 2011), xi–xii.

14. Ibid. See also, page 174: "I think that the answer is that photography gives us all kinds of things that we don't want it to give us. Things we prefer not to dwell on, things that are magnetically attractive but at the same time repulsive to our eyes. . . . Photography is at war with our attention."

15. Silverman, *The Miracle of Analogy*, 10–11.

16. Ibid., 11.

17. Soren Kierkegaard, *The Concept of Anxiety*, trans. Reidar Thomte (Princeton: Princeton University Press,

1980), 61.

PART I

1. Louis Jacques Mandé Daguerre, "Daguerreotype: Prospectus, Second Half of 1838," in *First Exposures, Writings from the Beginning of Photography*, ed. Steffen Siegel (Los Angeles: Getty Publications, J. Paul Getty Museum, 2017), 34–37.

2. φώς, φωτός [light]. "It may suffice . . . to say," Talbot succinctly explains to those who "may still

be unacquainted with the art," that photographs are pictures "obtained by the mere action of Light upon sensitive paper." William Henry Fox Talbot, *The Pencil of Nature* (London: Longman, Brown, Green, and Longmans, 1844), 1.

3. Dominique François Arago, "Report," in *Classic Essays on Photography*, ed. Alan Trachtenberg (New Haven: Leete's Island Books Inc., 1980), 18.

4. Sir David Brewster, letter to Talbot, November 13, 1847, National Museum of Photography, Film, and Television Inv. No. 1937–4963, Talbot Correspondence Project Document No. 06048.

5. Plato, *The Republic*, ed. G. R. F. Ferrari, trans. Tom Griffith (Cambridge: Cambridge University Press, 2000), 509b.

6. Ibid., 508a.

7. Ibid., 508b.

8. Ibid., 516a–516c.

9. Ibid., 532c.

10. Ibid., 509b.

11. Gaston Tissandier, *A History and Handbook of Photography* (London: Sampson, Low, Marston, Low, & Searle, 1877), iv.

12. Ibid., 3.

13. On trees and the forest in America at the time of photography's inception, see Alexander Nemerov, The Sixty-Sixth A. W. Mellon Lectures in the Fine Arts: "The Forest: America in the 1830s," in particular, Part 1: "Herodotus Among the Trees" (May 24, 2017). https://art.stanford.edu/news/sixty -sixth-w-mellon-lectures-fine-arts-forest-america-1830s-alexander-nemerov

14. Tissandier, *History and Handbook of Photography*, 3–4.

15. Daguerre, "Daguerreotype: Prospectus," 34.

16. This kind of understanding continued to rule well into the beginning of the twentieth century. A popular American guide to photography, Alexander Black's *Photography Indoors and Out: A Book for Amateurs* (Boston: Houghton, Mifflin, 1898) asserts: "In the shadow of a tree the sunlight falling through a chink between the leaves does not make a bright spot of irregular outline like the opening through which it passes, but makes a circular image—a photograph of the sun, in forming which the opening amid the leaves has, by focusing the rays of light, acted as a lens" (pp. 2–3). For Black, the origin of photography is tied to the experience of the first man: "When the first man, wandering in the wild garden of which he found himself to be the only human inhabitant, approached the brink of some quiet pool, and looking down, saw for the first time his own surprised face, how novel must have been his emotions! Adam had scanned all that nature cast about him. . . .

This first photograph must have been a sight upon which Adam gazed long and wonderingly" (p. 1). The conflation of photography with the myth of Narcissus, which was an important theme for painters, is indicative of photography's use of a "borrowed" self-image.

17. Notice a semantic difference between the earlier ad for daguerreotypes with "secure the shadow" and the Kodak ads that underline taking and possession.

18. The game laws and the conservationism of the early twentieth century is usually explained as a direct reaction to the realization that nature and the natural resources of the American west were in fact exhaustible. The camera was a perfect tool for sublimating that urge to exploit or conquer nature by offering an innovative sustainable alternative that adhered to the newly established conservationist restraints. I thank Graham Shapiro for this point. The other side of this is that the origination of photography as the alleged child of nature coincides with the disappearance of nature.

19. Immanuel Kant, *Critique of the Power of Judgment*, ed. Paul Guyer, trans. Paul Guyer and Eric Matthews (Cambridge: Cambridge University Press, 2001), 186.

20. Ibid., 185.

21. Ludwig Wittgenstein, *Philosophical Investigations*, eds. P. M. S. Hacker and Joachim Schulte, trans. G. E. M. Anscombe (Hoboken: Wiley-Blackwell, 2009), §115.

22. Ibid., §1.

23. In philosophical discourse, "image" and "essence" hardly ever intersect in this way, since they belong to fundamentally different layers of being. Essence is the *to ti esti*, "the what it is" or the intrinsic nature of a thing that traditionally stands in contrast to the realm of appearances of which images and pictures are part. Hence, when Wittgenstein speaks of a picture of an essence, his uncommon use of the phrase serves to make a point. The point is couched in a phenomenological sensibility that resists the opposition of essence and appearances. A similar kind of move is made when he claims that "the human body is the best image of the human soul." *Philosophical Investigations, Part II*, §24.

24. Gilles Deleuze, *Difference and Repetition*, trans. Paul Patton (New York: Columbia University Press, 1994), 127–67.

25. Saint Augustine, *Confessions*, trans. Henry Chadwick (Oxford: Oxford University Press, Oxford World's Classics, 2008), I.8; see Wittgenstein, *Philosophical Investigations*, §1.

26. Augustine, *Confessions*, I.8.

27. Wittgenstein, *Philosophical Investigations*, §1.

28. Photography's "legitimacy" was a central theme in the influential 1981 exhibition at the Museum of Modern Art, *Before Photography*, curated by Peter Galassi. The objective of the exhibition, Galassi explains in a statement that has become emblematic, is to "show that photography was not a

bastard left by science on the doorstep of art, but a legitimate child of the Western pictorial tradition." *Before Photography* (New York: The Museum of Modern Art, 1981), 12. The point I make here is that photography's legitimacy was never a given, but the result of a continual effort at construction and sustenance of its self-image.

29. Hal Foster, ed., *Vision and Visuality: Discussions in Contemporary Culture* (Seattle: Bay Press, 1988), ix:

> Why vision and visuality, why these terms? Although vision suggests sight as a physical opera-
> tion, and visuality sight as a social fact, the two are not opposed as nature to culture: vision is
> social and historical too, and visuality involves the body and the psyche. Yet neither are they
> identical: here, the difference between the terms signals a difference within the visual—between
> the mechanism of sight and its historical techniques, between the datum of vision and its dis-
> cursive determinations—a difference, many differences, among how we see, how we are able,
> allowed, or made to see, and how we see this seeing or the un-seen therein. With its own rhetoric
> and representations, each scopic regime seeks to close out these differences: to make of its many
> social visualities one essential vision, or to order them in a natural hierarchy of sight.

30. I thank David Heyd for referring me to Corot's painting.

31. Wallace Stevens, *The Collected Poems of Wallace Stevens* (New York: Vintage, 2011), 93–94, stanzas III and IX.

32. Aristotle, *Physics II*, trans. Robin Waterfield (Oxford: Oxford University Press, 2008), 199a.

33. Ibid.

34. See, for example, F. W. J. Schelling, *The Ages of the World*, trans. Jason M. Wirth (Albany: SUNY Press, 2000 [1815]), 31:

> That tendency . . . is even recognizable in customary expressions such as "Nature eludes the eye and
> conceals her secrets" or "Only when pressed by a higher power does she discharge . . . what will be." In
> point of fact, everything in nature becomes only through development, that is, through the constant
> contradiction of a swathing, contracting force. Left to itself, nature would still lead everything back
> into a state of utter negation. . . . Nature is like Penia showing up at Zeus' feast. From the outside,
> Penia was the picture of poverty and extreme need. On the inside, she shut away divine plenitude
> which she could not reveal until she had wed Wealth, Excess himself, that effusively and inexhaust-
> ibly garrulous being. Even then, however, the child wrested from her womb appears under the form
> and, so to speak, press, of that originary negation. It was the bastard child of Need and Excess.

35. Aristotle, *The Complete Works of Aristotle: The Revised Oxford Translation*, Vol. 1, ed. Jonathan Barnes (Princeton: Princeton University Press, 1984), 460:1.11.

36. William Shakespeare, *A Midsummer Night's Dream: The Oxford Shakespeare*, ed. Peter Holland (Oxford: Oxford University Press, 2008), Act 5, Scene 1:

> The lunatic, the lover and the poet
>
> Are of imagination all compact:
>
> One sees more devils than vast hell can hold,
>
> That is, the madman: the lover, all as frantic
>
> Sees Helen's beauty in a brow of Egypt:
>
> The poet's eye, in fine frenzy rolling,
>
> Doth glance from heaven to earth, from earth to heaven; And as imagination bodies forth
>
> The forms of things unknown, the poet's pen
>
> Turns them to shapes and gives to airy nothing
>
> A local habitation and a name.

37. In the context of natural phenomena, this typically involves the ability to see a determined form within a certain materiality. Images themselves are not material but are typically congruent with—or wedded to—some specific materiality. And, here, certain materialities are more conducive to—more suggestive of—image experiences. These are typically never blank materialities but always appearances with some degree of determination that, at the same time, are an under-determination, making potentiality part of the encounter.

38. Leon Battista Alberti, *On Painting and on Sculpture: The Latin Texts of De Pictura and De Statua*, ed. and trans. Cecil Grayson (London: Phaidon, 1972), 43.

39. Ernst Hans Gombrich, *Art and Illusion: A Study in the Psychology of Pictorial Representation* (New York: Pantheon Books, 2004), 106.

40. Ibid., 106–07.

41. Ibid., 107.

42. Ibid.

43. Daguerre's *Fossils and Shells* has been discussed repeatedly by interpreters who, in different interesting ways, articulate the analogical relation between the being of fossils and the essence of photography. See, Geoffrey Batchen, *Burning with Desire: The Conception of Photography* (Cambridge, MA: MIT Press, 1999), 133; Eugenia Parry Janis, "Fabled Bodies: Some Observations on the Photography of Sculpture," in *The Kiss of Apollo: Photography and Sculpture 1845 to the Present*,

ed. Jeffrey Fraenkel (San Francisco: Fraenkel Gallery, 1991), 20; W. J. T. Mitchell, "Romanticism and the Life of Things: Fossils, Totems, and Images," *Critical Inquiry* 28, no. 1 (2001); Walter Benn Michaels, "Photographs and Fossils," in *Photography Theory*, ed. James Elkins (Routledge, 2007).

44. Hiroshi Sugimoto, "Pre-Photography Time-Recording Device," https://www .sugimotohiroshi.com/pptrd/

45. Susan Sontag, *On Photography* (New York: Penguin Books, 1977), 158.

46. Roland Barthes, *Camera Lucida: Reflections on Photography*, trans. Richard Howard (New York: Hill and Wang, 1981), 80–81.

47. Ibid., 82.

48. Rosalind Krauss, "Notes on the Index: Seventies Art in America, Part 1," *October* 3 (Spring 1977), 75.

49. Ibid.

50. For a polyphonic debate on the index's value and validity that includes discussion by a cohort of leading scholars on the topic, see James Elkins, ed., *Photography Theory* (New York, London: Routledge, 2007). On the relation of the question of the index to Sugimoto's fossils, see that book's concluding article by Walter Benn Michaels, "Photographs and Fossils," which also provides a succinct summary of the debate and interesting insight.

51. Rosalind Krauss, "Notes on the Index: Seventies Art in America, Part 2," *October* 4 (Autumn 1977), 58–67.

52. Talbot, *The Pencil of Nature*, 28.

PART II

1. Johann Wolfgang von Goethe, *The Sorrows of Young Werther*, trans. David Constantine (Oxford: Oxford University Press, 2012), 34.

2. The first edition of Goethe's novel was published in 1774.

3. Goethe, *The Sorrows of Young Werther*, 34.

4. Ibid., 35.

5. Ibid., 7.

6. Jean Paul Sartre, *Being and Nothingness*, trans. Hazel E. Barnes (New York: Washington Square Press, 1984), 137.

7. Henry Fuseli, *The Life and Writings of Henry Fuseli, ed. John Knowles* (Amazon Digital Services, 2012), Vol. 2.

8. Pliny the Elder, *Natural History*, trans. H. Rackham (Cambridge, MA: Loeb Classical Library, Harvard University Press, 1952), Book IX, 371.

9. Ibid., Book XXXV, 373.

10. Rosenblum calls attention to the intricate iconographical matrix created by depictions of the Corinthian maid from Joachim von Sandrart's engravings in his *Teutsche Academie* (1675), to the paintings of the Scotsmen Alexander Runciman and David Allan from the 1770s, to Joseph Wright of Derby's *Corinthian Maid* famously commissioned by Josiah Wedgwood, to Jean-Baptiste Regnault's painting for Queen Marie Antoinette in the 1780s, to Joseph-Benoît Suvée in the 1790s, to Anne-Louis Girodet-Trioson in the 1820s, to Honoré Daumier's "destruction of the Greek legend" in his caricatures/lithographs of the 1840s.

11. Robert Rosenblum, "The Origin of Painting: A Problem in the Iconography of Romantic Classicism," *The Art Bulletin* 39, no. 4 (1957), 288–90.

12. See, for example, Ann Bermingham, "The Origins of Painting and the Ends of Art: Wright of Derby's *Corinthian Maid*," in *Painting and the Politics of Culture*, ed. John Barrell (Oxford: Oxford University Press, 1992), 162. See also Ann Bermingham, *Learning to Draw: Studies in the Cultural History of a Polite and Useful Art* (New Haven, London: Yale University Press for the Paul Mellon Centre for Studies in British Art, 2000), 160: "the relationship of middle-class women to certain mechanical forms of artistic production. Furthermore, it is interesting that Rosenblum does not make the connection between the artistic preoccupation with the shadow and the fermenting imagery that grounded the invention of photography."

13. Bermingham, "The Origins of Painting and the Ends of Art," 164.

14. See, for example, discussion of Rejlander in Jordan Bear, *Disillusioned: Victorian Photography and the Discerning Subject* (University Park: Pennsylvania State University Press, 2015); also, Daniel A. Novak, *Realism: Photography and Nineteenth-Century Fiction* (New York: Cambridge University Press, 2008); Lori Pauli, "The First Negative," in *Oscar Gustave Rejlander: 1813(?)–1875*, ed. Leif Wigh (Stockholm: Moderna Museet, 1998), 20.

15. Gerhard Wolf, "The Origins of Painting," *Res: Anthrolopology and Aesthetics* 39 (2009), 61. See also Jean-Pierre Vernant, "The Birth of Images," *Mortals and Immortals: Collected Essays*, ed. Froma I. Zeitlin (Princeton: Princeton University Press, 1991), 164–85.

16. Hans Belting, *An Anthropology of Images: Picture, Medium, Body*, trans. Thomas Dunlop (Princeton: Princeton University Press, 2011), 18, 20.

17. Victor I. Stoichita, *A Short History of the Shadow* (London: Reaktion Books, 1997), 20.

18. Ibid., 25.

19. Plato, *The Republic*, ed. G. R. F. Ferrari, trans. Tom Griffith (Cambridge: Cambridge University Press, 2000), VII.514a.

20. Ibid., 514b.

21. Ibid., 515a.

22. Stoichita, *A Short History of the Shadow*, 25–26. Stoichita reads the shadow's significance in Pliny as follows: "[T]he shadow represents, the stage that is furthest away from the truth" and consequently "here and later, the shadow is charged with a fundamental negativity that, in the history of Western representation, was never to be abandoned altogether." Stoichita finds it fruitful to underscore the affinities between Pliny's image and Plato's allegory of the cave. For him, Pliny's origin of painting (which "is in truth the story of the surrogate image") should be read against the backdrop of Platonic metaphysics. Pliny's image is a reflection of the Platonic oppositions that underlie the ontological inferiority ascribed to the art of painting. And furthermore, Plato's bias against visual representation is couched in the same terminology used by Pliny "to expound the story of Butades, which stems from the same archaic if not oriental mentality as the surrogate image."

23. In the act of drawing, Butades not only reorients herself in the world, but she is, more specifically, taking a new stance in relation to the person she loves. The primordial act of drawing is inseparable from her response to the other person whose presence has become elusive and that can no longer be taken for granted. In this sense, the making of the first image is an expression of an unresolved tension that is characteristic of our relationship with others. This is a tension between the other's existence as opening for us a meaningful world of things that affect us—that we want and love and care about—and, at the same time, as marking a world that remains forever elusive, unexpected, and impenetrable: a world whose strangeness is upheld by the uncontainable alterity of the other person. In this context, Butades's gesture may be understood in Levinasian terms: tracing the trace of the other, "a trace [that] obliges with regard to the infinite, to the absolutely other" and that "establishes a relationship with illeity, a relationship which is personal and ethical." On such a reading, see Hagi Kenaan, "What Makes an Image Singular-Plural: Questions to Jean-Luc Nancy," *Journal of Visual Culture* 9, no. 1 (2010), 63–76.

24. Maurice Merleau-Ponty, "Cézanne's Doubt," in *Sense and Non-Sense, eds. Hubert L. Dreyfus and Patricia Allen Dreyfus* (Evanston: Northwestern University Press, 1964), 15.

25. Maurice Merleau-Ponty, "Eye and Mind," trans. Carleton Dallery, in *"The Primacy of Perception" and Other Essays on Phenomenological Psychology, the Philosophy of Art, History, and Politics*, ed. and trans. James M. Edie (Evanston: Northwestern University Press, 1964), 162.

26. Ibid., 164.

27. For further discussion of Butades's pioneering act of tracing shadows, see Michael Newman, "The Marks, Traces and Gestures of Drawing," in *The Stage of Drawing: Gesture and Act*, ed. Catherine de Zegher (London: Tate, 2003), 93–108; W. J. T. Mitchell, "Drawing Desire," in *What Do Pictures Want: The Lives and Loves of Images* (Chicago: University of Chicago Press, 2006), 66–72; Lisa Saltzman, *Making Memory Matter: Strategies of Remembrance in Contemporary Art* (Chicago: University of Chicago Press, 2006); and Marina Warner, *Phantasmagoria: Spirit Visions, Metaphors, and Media into the Twenty-First Century* (Oxford: Oxford University Press, 2006).

28. Merleau-Ponty, "Eye and Mind," 166.

29. Ibid.

30. Ibid.

31. Ibid.

32. Maurice Merleau-Ponty, "Working Notes," in *The Visible and the Invisible*, ed. Claude Lefort, trans. Alphonso Lingis (Evanston: Northwestern University Press, 1968), 258.

33. Ibid., 229.

34. Ibid., 215.

35. Jacques Derrida, *Memoirs of the Blind: The Self-Portrait and Other Ruins*, trans. Pascale-Anne Brault and Michael Nass (Chicago: University of Chicago Press, 1993), 51.

36. Ibid., 49.

37. Merleau-Ponty "Eye and Mind," 168.

38. Ibid.

39. Ibid.

40. Giorgio de Chirico, *The Memoirs of Giorgio de Chirico*, trans. Margaret Crosland (London: Peter Owen, 1971), 46.

41. Ibid., 47–48.

42. Maurice Merleau-Ponty, "Preface," in *Phenomenology of Perception*, trans. Donald A. Landes (New York, London: Routledge, 2013 [1945]), xxxiv.

43. Interestingly, he thinks about cinema more than photography. See Mauro Carbone, *The Flesh of Images: Merleau-Ponty Between Painting and Cinema* (Albany: SUNY Press, 2011).

44. Merleau-Ponty, "Cezanne's Doubt," 14.

45. Ibid., 19.

46. Ibid.

47. Ibid.

48. Merleau-Ponty, "Eye and Mind," 166.

49. Ibid.

50. Ibid., 184.

51. Ibid., 185.

52. Ibid., 186.

53. Ibid., 181.

54. Ibid., 163.

55. Merleau-Ponty, *The Visible and the Invisible*, 255.

56. Merleau-Ponty, "Eye and Mind," 186.

57. In his eulogy on Merleau-Ponty, Sartre writes: "A Christian at twenty, he ceased to be [one].... [H]e asked that Catholicism reintegrate him in the unity of immanence and this was precisely what it couldn't do." "Merleau-Ponty Vivant," in *The Debate Between Sartre and Merleau-Ponty*, ed. Jon Stewart (Evanston: Northwestern University Press, 1998), 575.

58. Merleau-Ponty, "Eye and Mind," 162.

59. Roland Barthes, *Mourning Diary*, trans. Richard Howard (New York: Hill and Wang, 2010), 191.

60. Ibid., 4: "You have never known a woman's body!—I've known the body of my mother, sick and then dying."

61. See James Elkins, *What Photography Is*, (New York, London: Routledge, 2011), 5.

62. Roland Barthes, *A Lover's Discourse: Fragments*, trans. Richard Howard (London: Macmillan, 1978), 106–07.

63. Ibid., 108.

64. Ibid., 194.

65. Ibid.

66. Roland Barthes, *Camera Lucida: Reflections on Photography, trans. Richard Howard* (New York: Hill and Wang, 1981), 99.

67. Barthes, *A Lover's Discourse*, 13–14. The question of how this fits into Barthes's understanding of his sexuality deserves a separate discussion that is beyond our scope here.

68. Jean-Pierre Vernant, "The Birth of Images," in *Mortals and Immortals: Collected Essays*, ed. Froma I. Zeitlin (Princeton: Princeton University Press, 1991), 164–85.

69. Jean-Pierre Vernant, "From the 'Presentification' of the Invisible to the Imitation of Appearance," in *Mortals and Immortals: Collected Essays*, ed. Froma I. Zeitlin (Princeton: Princeton University Press, 1991), 152.

70. Homer, *The Odyssey*, trans. Richmond Lattimore (New York: Harper Perennial Modern Classics, 2007), 11.153–64.

71. Vernant, "The Birth of Images," 168.

72. The Greek *eidolon* bears similarities to the biblical Hebrew word *tzelem* ("image") as in Genesis 1.26–27: "And God said 'Let us make Man in our image, after our likeness . . . and God created man in His image.'" *Tanakh—The Holy Scriptures: The New JPS Translation.* The word *"tzelem"* develops into the compound word *"tzalmavet"* ("the shadow of death," "deep darkness").

73. Homer, *The Odyssey*, 11.2014–224.

74. Barthes, *Camera Lucida*, 71.

75. Ibid., 66.

76. Ibid., 67.

77. Ibid., 73.

78. Ibid., 70: "[M]y grief wanted a just image, an image which would be both justice and accuracy—justesse: just an image, but a just image. Such, for me, was the Winter Garden Photograph."

79. Ibid., 109.

80. Ibid., 71.

81. Ibid.

82. Ibid., 76.

83. The term *noeme* evokes a Husserlian language with which Barthes occasionally dabbles. In this context, he explains that the *noeme* of the photograph differs from Husserl's analysis in that it only "flows back from presentation to retention." Ibid., 90.

84. Ibid.

85. Ibid., 82.

86. Ibid., 77.

87. Emmanuel Levinas, *Ethics and Infinity: Conversations with Philippe Nemo*, trans. Richard A. Cohen (Pittsburgh: Duquesne University Press, 1985), 33.

88. Roland Barthes, "The Death of the Author," in *Image, Music, Text*, trans. Stephen Heath (New York: Hill and Wang, 1977), 142–43.

89. See, for example, *The Preparation of the Novel: Lecture Courses and Seminars at the Collège de France*, trans. Kate Briggs (New York: Columbia University Press, 2011), 156: "It can be said in a more western manner, that . . . radical, ontological *Idleness* is *Natural*. Here's a quotation from Heidegger (*Essays*, XXVII, "Overcoming Metaphysics"):"

90. Barthes, *Camera Lucida*, 3.

91. Jean-Paul Sartre, *The Imaginary: A Phenomenological Psychology of the Imagination* (London, New York: Routledge, 2010), 11–14.

92. See, for example, Hilde van Gelder and Helen Westgeest, *Photography Theory in Historical Perspective* (Hoboken: Wiley-Blackwell, 2011), 12.

93. For Lisa Saltzman, for example, "Pliny's tale presents that mythic moment when imminent loss drives the impulse to record and remember." It is, according to her, "a story in which anticipated absence inspires and grounds the birth of [the] pictorial" and could thus be applied—cross-historically—also to the analysis of contemporary art. Saltzman, *Making Memory Matter*. A clear example of the oscillation between the two aforementioned tendencies can be found in a conversation between Victor Burgin and Geoffrey Batchen discussing a theme that was central to both theorists: the relationship between image and desire. Whereas Burgin, like Barthes, tends to conceptualize the photographic in terms of the general economy of the image, Batchen puts forward a view that historicizes the particular condition of photography's emergence. According to Burgin,

> [V]iewed in terms of desire, the origin of photography is identical to the origins of painting, with the origin of any desire for the image.... The origin of the graphic image is ... in the desire for protection against the loss of the object and the loss of identity.... So to introduce considerations of desire into the story of the invention of photography is necessarily to construct a definition of "apparatus" that pushes the invention of photography back beyond the nineteenth century.

Batchen who is unsatisfied with this paradigm, looks instead at reframing the question as one that relates to photography's uniquely historical desire:

> Could we ... articulate the "desire to photograph" not as one instance of general desire common to all cultures and times, but rather a desire quite specific to the historical period beginning in the late eighteenth and early nineteenth centuries?

From Geoffrey Batchen, "For an Impossible Realism: Interview with Victor Burgin," *Afterimage* 16, no. 7 (1989), 4–5. When Batchen returns to reflect on this interview in his seminal *Burning with Desire* (Cambridge, MA: MIT Press, 1999), his criticism is more direct:

> This makes the desire to photograph but one instance of a more general desiring economy common to all times and places and therefore transcending historical and cultural difference.... This psychoanalytical version of photography's origin still does not account for the specificity of the timing, the morphology or the cultural focus of the desire to photograph as represented in the efforts of Wedgwood, Davy and all other early nineteenth century experimenters. (p. 113)

94. Again, a lesson can be gleaned from Barthes on this point because he exemplifies a prevalent methodological tendency of subsuming the photographic under the more general category of the image. Interestingly, this is something we find even in Derrida who, in *Copy, Archive, Signature: A Conversation on Photography* (Stanford: Stanford University Press, 2010), for example, explicitly returns to the Butades story as grounds for understanding the photographic:

> When Dibutade traces, she begins to re-trace. . . . But the possibility of this repetition, this iterability, marks in advance the very threshold of perception. . . . Activity and passivity touch together or are articulated along a differential border. This is the very movement of the trace: a movement that is a priori photographic. The fact that it did not wait for the invention of what for more than a century we have called photography does not mean that this technique is not an irreducible event and a transformation. But it is necessary also to think [of] this irreducibility against the background of what made it possible. (p. 17)

On page 18, Derrida continues to develop the idea of the photographic trace, which become applicable as a general principle of the arts. This is, then, tied by him to Barthes's understanding of loss as photography's main emotion. Derrida writes:

> The "great art" of this double re-treat or withdrawal, no less for photography than for literature, for painting and for drawing, is to grasp this line or this instant, certainly, but in grasping it to let it be lost, to mark the fact that "this took place, it is lost," and that everything that one sees, keeps, and looks at [*garde et re-garde*] now is the being-lost of what must be lost, what is first of all bound to be lost. And the signature of the loss would be marked in what keeps and does not lose, what keeps (from) loss. It is necessary to keep loss as loss, if I can put it this way. This is perhaps the photographic emotion, the poignancy of which Barthes speaks.

95. Karen Knorr, "Natural Histories: Karen Knorr in Conversation with Rebecca Comay, 2002," in *Genii Loci: The Photographic Work of Karen Knorr*, eds. David Campany et al. (London: Black Dog, 2002), 66: "Photography shares with the shadow its indexical nature. The indexical sign is after all the cornerstone of the photographic image"; for further readings on Knorr's *The Pencil of Nature*, see David Campany, "Museum and Medium: The Time of Karen Knorr's Imagery," in *Genii Loci*, 114–23. See also Gen Doy, *Picturing the Self: Changing Views of the Subject in Visual Culture* (London: I. B. Tauris & Co., 2005): 101–02. David Campany reads Knorr's *The Pencil of Nature* as a reflection on cultural heritage, photography of artworks, and museum culture. Gen

Doy follows Campany's metacultural reading while underscoring the significance of Knorr's feminized retelling of Pliny's tale.

96. This is also how I tend to read Knorr's technical description of her image. *"The Pencil of Nature,"* she explains in an email, "is neither digital nor retouched. It is analogue shot on 50 ISO Velvia Fujichrome positive film and printed on Cibachrome. . . . It comes in one size 105cm X 105cm, framed. The frame is part of the work and it comes with a brass plaque attached with the title: *The Pencil of Nature.*" Would it be right to hear in Knorr's detailed specifications an indirect commentary on the continuing need to negotiate photography's vanishing materiality twenty years after the making of the work?

PART III

1. William Henry Fox Talbot, "Some Account of the Art of Photogenic Drawing, or the Process by Which Natural Objects May Be Made to Delineate Themselves Without the Aid of the Artist's Pencil" (London: R. and J. E. Taylor, 1839), 6–7.

2. Ibid.

3. Psalm 102:11, 144:4 (King James Version), in the New KJV: "Man is like a breath; his days *are* like a passing shadow."

4. Talbot, "Some Account of the Art of Photogenic Drawing," 6.

5. Despite different attempts to create darkened viewing conditions, the burden of this structural difficulty was not lifted prior to Talbot, whose fame as an inventor rests largely on his success in fixing the image. In both of his accounts of the invention, Talbot pays homage to the proto-photographers Thomas Wedgwood and Sir Humphry Davy who were able to produce light-images but whose "numerous series of experiments . . . ended in failure." In this context, Talbot makes it a point to underscore how fortunate he was to have made his own discovery previous to his reading of Davy's report, which could have gravely discouraged him:

> the circumstance . . . announced by Davy, that the paper upon which these images were depicted was liable to become entirely dark, and that nothing hitherto tried would prevent it, would perhaps have induced me to consider the attempt as hopeless, if I had not (fortunately) before I read it, already discovered a method of overcoming this difficulty, and of *fixing* the image in such a manner, that it is no more liable to injury or destruction.

Talbot, "Some Account of the Art of Photogenic Drawing," 4.

6. Ibid., 5.

7. Ibid., 3.

8. William Henry Fox Talbot, *The Pencil of Nature* (London: Longman, Brown, Green, and Longmans, 1844), 55–56.

9. This indeterminate zone of potentiality will eventually become tied, for Talbot, to the discovery of the latent image. In September 1840, he discovers that very short exposures of the sensitive paper to light create chemical transformations that embody latent images that have no visible trace on paper, but these images could be brought out—"developed"—with the application of a proper chemical solution. "The Calotype," as Talbot patented it, is a photographic image whose making depends on an explicit dimension of invisibility, a dormant potentiality for the visual, that the photographer develops out of the chemically transformed surface.

10. On the affinities between early photography and printmaking, see Stephen Bann, "'When I Was a Photographer': Nadar and History," *History and Theory* 48, no. 4 (2009), 95–111.

11. Ludwig Wittgenstein, *Philosophical Investigations*, eds. P. M. S. Hacker and Joachim Schulte, trans. G. E. M. Anscombe (Hoboken: Wiley-Blackwell, 2009), §66.

12. Martin Heidegger, *Being and Time*, trans. Joan Stambaugh (Albany: SUNY Press, 1996), 30.

13. In *A Thousand Plateaus: Capitalism and Schizophrenia* (Minneapolis: University of Minnesota, 1987), Gilles Deleuze and Félix Guattari propose an analogical rhizomatic analysis of the relation between the book and the world. They write:

> The same applies to the book and the world: contrary to a deeply rooted belief, the book is not an image of the world. It forms a rhizome with the world, there is an aparallel evolution of the book and the world; the book assures the deterritorialization of the world, but the world effects a reterritorialization of the book, which in turn deterritorializes itself in the world (if it is capable, if it can). Mimicry is a very bad concept, since it relies on binary logic to describe phenomena of an entirely different nature." (p. 12)

14. It was Carol Armstrong's *Scenes in a Library* (Cambridge, MA: MIT Press, 1998) that set the field for a literary and figurative reading of Talbot's *Pencil of Nature*. For Armstrong, *The Pencil of Nature* was a new kind of visual-textual complexity that called for its own unique forms of decipherment. Interestingly, despite her sophisticated hermeneutics, which is intended to allow Talbot's writing to speak in its own voice, Armstrong concomitantly embraces Roland Barthes as her theoretical framework. This ineluctably results in an interpretation that reads Barthes into Talbot in a manner that simplifies the tension that constitutes Talbot's rhetoric and that I try to describe here.

15. This was, in a way, acknowledged by viewers of Talbot's time. *The Athenaeum*, no. 904 (1845), 202: "In the Haystack we have a delightful study—the fidelity with which every projecting fibre is given, and the manner in which that part of the stack which has been cut, is shown, with the ladder which almost stands out from the picture, and its sharp and decided shadow, are wonderful . . . "

16. Talbot, *The Pencil of Nature*, 43.

17. Ibid., 44.

18. The term is ascribed to Talbot's wife, Constance. See her letter to Talbot, September 7, 1835, in "The Correspondence of Henry William Fox Talbot Project," ed. Larry J. Schaaf, http://foxtalbot. dmu.ac.uk/project/project.html

19. Talbot, *The Pencil of Nature*, 3.

20. In a personal communication with his mother, Talbot employs the notion of melancholy to describe an Italian landscape, "as I passed by the roofless walls of the unfinished hospice, on the summit of the pass, the appearance was most melancholy & forlorn"; see Talbot's letter to Elisabeth Theresa Feilding, July 24, 1821, in "The Correspondence of Henry William Fox Talbot Project," http://foxtalbot.dmu.ac.uk/project/project.html

21. Talbot, *The Pencil of Nature*, 3.

22. Ibid., 2–4.

23. Ibid., 4–5.

24. Vilém Flusser, *Towards a Philosophy of Photography*, trans. Anthony Mathews (London: Reaktion Books, 2000), 14:

> In the case of technical images one is dealing with the indirect products of scientific texts. This gives them, historically and ontologically, a position that is different from that of traditional images. Historically, traditional images precede texts by millennia and technical ones follow on after very advanced texts. Ontologically, traditional images are abstractions of the first order insofar as they abstract from the concrete world while technical images are abstractions of the third order: They abstract from texts which abstract from traditional images which themselves abstract from the concrete world. Historically, traditional images are prehistoric and technical ones "post-historic". . . . Ontologically, traditional images signify phenomena whereas technical images signify concepts. Decoding technical images consequently means to read off their actual status from them.

25. Henri Cartier-Bresson, *Interviews and Conversations 1951–1998*, eds. Clément Chéroux and Julie Jones (New York: Aperture, 2017), 32.

26. Ibid. On the significance of the figure of Antaeus to modernity, see Vered Lev Kenaan, *The Ancient Unconscious: Psychoanalysis and the Classical Text* (Oxford University Press, 2019), ch. 2.

27. Cartier-Bresson, *Interviews and Conversations 1951–1998*, 42.

28. Ibid., 109.

29. Ibid., 43.

30. As an example for this common attitude, consider Stieglitz's description of the patient waiting that led to the making of his *Fifth Avenue, Winter*: "Fifth Avenue is the result of a three hours' stand during a fierce snowstorm on February 22nd, 1893, awaiting the proper moment. My patience was duly rewarded." Alfred Stieglitz, *Stieglitz on Photography: Selected Essays and Notes*, eds. Richard Whelan and Sarah Greenough (New York: Aperture, 2000), 68.

31. Cartier-Bresson, *Interviews and Conversations 1951–1998*, 34.

32. Ibid.

33. Ibid., 22.

34. Maurice Merleau-Ponty, "Eye and Mind," trans. Carleton Dallery, in *"The Primacy of Perception" and Other Essays on Phenomenological Psychology, the Philosophy of Art, History, and Politics*, ed. James M. Edie (Evanston: Northwestern University Press, 1964), 181.

35. Ibid., 163.

36. Talbot, "Some Account of the Art of Photogenic Drawing, 8.

37. Talbot, *The Pencil of Nature*, 3.

38. Ibid., 22 (Plate III). The analogy between the human eye and the *camera obscura* goes back at least to Descartes's discussion of vision in his *Optics*.

39. Ibid., 30 (Plate VIII).

40. The common analogy between the human eye and the camera's eye often blurs the fact that photography detached the bond between the act of taking a picture and the embodied condition of vision.

41. Talbot, *The Pencil of Nature*, 39–40 (Plate XIII).

42. The metaphor of palimpsest is generally important for Freud for sorting the different layers of the dream, especially through the difference between their manifest and their latent content. In his *Interpretation of Dreams* (p. 161 note), he quotes from the essay of the nineteenth-century author James Sully, "The Dream as a Revelation," (*Fortnightly Review* 53, no. 315 (March 1893), 346):

The chaotic aggregations of our night-fancy have a significance and communicate new knowledge. Like some letter in cypher, the dream-inscription when scrutinized closely loses its first

look of balderdash and takes on the aspect of a serious, intelligible message. Or, to vary the figure slightly, we may say that, like some palimpsest, the dream discloses beneath its worthless surface-characters traces of an old and precious communication. See also, Sigmund Freud, "A Note upon 'The Mystic Writing-Pad,'" *SE* 19 (1925), 227–32.

43. Walter Benjamin, *Selected Writings, Volume 2: 1927–1934*, eds. Marcus Bullock and Michael W. Jennings, trans. Rodney Livingstone (Cambridge, MA: Harvard University Press, 2004), 510. On Benjamin's "optical unconscious," see Eduardo Cadava, *Words of Light: Theses on the Photography of History* (Princeton: Princeton University Press, 1997). See also Rosalind Krauss, *The Optical Unconscious* (Cambridge, MA: MIT Press, 1994); Shawn Michelle Smith and Sharon Sliwinski, eds., *Photography and the Optical Unconscious* (Durham: Duke University Press, 2017.)

44. On Benjamin's "optical unconscious" as a key to photography's technological imagination, see my "The Photographic Imagination: The Visible and the Invisible," in *Photography and Imagination,* eds. Amos Morris-Reich and Margaret Olin (Routledge History of Photography, Routledge, 2019).

45. This experience was more prominent before the age of digital-screen cameras, but photographers continue to experience it today when using the most ubiquitous photographic device, the cell phone.

46. Alfred Stieglitz, "How *The Steerage* Happened," in *Stieglitz on Photography: His Selected Essays and Notes,* eds. Richard Whelan and Sarah Greenough (New York: Aperture, 2000), 195–96.

47. Friedrich Nietzsche, "On Truth and Lying in a Non-Moral Sense," in *The Birth of Tragedy and Other Writings,* eds. Raymond Geuss and Ronald Speirs, trans. Ronald Speirs (Cambridge: Cambridge University Press, 1999), as in footnote 49, p. 141.

48. Alexandre Koyré, *From the Closed World to the Infinite Universe* (Baltimore: Johns Hopkins University Press, 1957), 2.

49. Ibid.

50. Nietzsche, "On Truth and Lying in a Non-Moral Sense," 148.

51. Friedrich Nietzsche, *The Will to Power*, ed. Walter Kaufmann, trans. Walter Kaufmann and R. J. Hollingdale (New York: Vintage Books, 1968), 259.

52. Ibid., 12.

53. Ibid., 556.

54. Friedrich Nietzsche, *The Gay Science: With a Prelude in German Rhymes and an Appendix of Songs*, ed. Bernard Williams, trans. Josefine Nauckhoff (Cambridge: Cambridge University Press, 2001), 125.

55. Ibid., §343.

56. Ibid.

57. Ibid.

58. Ibid., §125.

59. Nietzsche, *The Birth of Tragedy and Other Writings*, §9.

60. Nietzsche, *The Gay Science*, §343.

61. Charles Baudelaire, "The Modern Public and Photography," in *The Painter of Modern Life*, trans. P. E. Charvet (London: Penguin Books, 2010), 108–09.

62. Ibid., 109–12.

63. Ibid.

64. Nietzsche, *The Gay Science*, §343; see also, §346:

> No! No longer with the bitterness of the one who has torn himself away, and must turn his un-belief into another faith, a goal, a martyrdom! We have become hard-boiled, cold, and tough in the realization that the way of the world is not at all divine—even by human standards it is not merciful, rational or just. We know it: the world we live in is ungodly, immoral, "inhuman". . . . [But] we take care not to claim that the world is worth *less*; indeed, it would seem laughable to us today if man were to aim at inventing values that were supposed to *surpass* the value of the real world.

65. Paul Strand, "Photography and the New God," *Broom: An International Magazine of the Arts* 3, no. 4 (November 1922), 252–58.

66. Ibid., 252.

66. Ibid., 253.

67. Ibid., 257.

68. Ibid., 253–54.

69. Ibid., 256.

70. Ibid., 258.

71. László Moholy-Nagy, "A New Instrument of Vision," in *Moholy-Nagy: An Anthology*, ed. R. Kostelantez (New York: Da Capo Press, 1970), 53–54.

72. Strand, "Photography and the New God," 256.

73. Moholy-Nagy, "A New Instrument of Vision," 51.

74. Benjamin, *Selected Writings, Volume 2: 1927–1934*, 510: "For it is another nature that speaks to the camera rather than to the eye; 'other' above all in the sense that a space informed by human consciousness gives way to one informed by the unconscious."

PART IV

1. Roland Barthes, *Camera Lucida: Reflections on Photography*, trans. Richard Howard (New York: Hill and Wang, 1981), 77.

2. Eduardo Cadava, *Words of Light: Theses on the Photography of History* (Princeton: Princeton University Press, 1997), 11.

3. Nan Goldin, *The Ballad of Sexual Dependency* (New York: Aperture, 1986), 6.

4. Ibid.: "There is a popular notion that the photographer is by nature a voyeur, the last one invited to the party. But I'm not crashing. This is my party."

5. Ibid., 8.

6. Ibid.

7. Ibid.

8. Ibid., 6.

9. In exhibition display, image and text are framed separately. Appearing in a square frame (50 x 50 cm) that hangs above the framed life-size image, the text takes the place of the image's absent head. In the book format of *True Stories*, image and text are presented on adjoining pages. Sophie Calle, *True Stories: 50 Short Stories*, 5th ed. (Arles, France: Actes Sud, 2016), 72–73.

10. Ibid., 107.

11. Ibid.

12. On the logic of the selfie, see Hagi Kenaan, "The Selfie and the Face," in *Exploring the Selfie: Historical, Theoretical, and Analytical Approaches to Digital Self-Photography*, eds. Julia Eckel, Jens Ruchats, and Sabine Wirth (New York: Palgrave Macmillan, 2018).

13. Friedrich Nietzsche, *The Gay Science: With a Prelude in German Rhymes and an Appendix of Songs*, ed. Bernard Williams, trans. Josefine Nauckhoff (Cambridge: Cambridge University Press, 2001), §276.

BIBLIOGRAPHY

Alberti, Leon Battista. *On Painting and on Sculpture: The Latin Texts of De Pictura and De Statua*, edited and translated by Cecil Grayson. London: Phaidon, 1972.

Arago, Dominique François. "Report." In *Classic Essays on Photography*, edited by Alan Trachtenberg (15–26). New Haven: Leete's Island Books Inc., 1980.

Aristotle. *Physics II*, translated by Robin Waterfield. Oxford: Oxford University Press, 2008.

———. "On Dreams." In *The Complete Works of Aristotle: The Revised Oxford Translation*, edited by Jonathan Barnes. Princeton: Princeton University Press, 1984.

Armstrong, Carol. *Scenes in a Library*. Cambridge, MA: MIT Press, 1998.

Augustine, Saint. *Confessions*, translated by Henry Chadwick. Oxford: Oxford University Press, Oxford World's Classics, 2008.

Bann, Stephen. "'When I Was a Photographer': Nadar and History." *History and Theory* 48, no. 4 (2009), 95–111.

Barthes, Roland. *Camera Lucida: Reflections on Photography*, translated by Richard Howard. New York: Hill and Wang, 1981.

———. "The Death of the Author." In *Image, Music, Text*, translated by Stephen Heath (142–48). New York: Hill and Wang, 1977.

———. *A Lover's Discourse: Fragments*, translated by Richard Howard. London: Macmillan, 1978.

———. *Mourning Diary*, translated by Richard Howard. New York: Hill and Wang, 2010.

———. *The Preparation of the Novel: Lecture Courses and Seminars at the Collège de France,* translated by Kate Briggs. New York: Columbia University Press, 2011.

Batchen, Geoffrey. *Burning with Desire: The Conception of Photography.* Cambridge, MA: MIT Press, 1999.

————. "For an Impossible Realism: Interview with Victor Burgin." *Afterimage* 16, no. 7 (1989).

Baudelaire, Charles. "The Modern Public and Photography." In *The Painter of Modern Life,* translated by P. E. Charvet. London: Penguin Books, 2010.

Bear, Jordan. *Disillusioned: Victorian Photography and the Discerning Subject.* University Park: Pennsylvania State University Press, 2015.

Belting, Hans. *An Anthropology of Images: Picture, Medium, Body,* translated by Thomas Dunlap. Princeton: Princeton University Press, 2011.

Bermingham, Ann. *Learning to Draw: Studies in the Cultural History of a Polite and Useful Art.* New Haven, London: Yale University Press for the Paul Mellon Centre for Studies in British Art, 2000.

————. "The Origins of Painting and the Ends of Art: Wright of Derby's *Corinthian Maid.*" In *Painting and the Politics of Culture,* edited by John Barrell (135–66). Oxford: Oxford University Press, 1992.

Benjamin, Walter. *Selected Writings, Volume 2: 1927–1934,* edited by Marcus Bullock and Michael W. Jennings, translated by Rodney Livingstone. Cambridge, MA: Harvard University Press, 2004.

Black, Cecil Frances Alexander. *Photography Indoors and Out: A Book for Amateurs.* Boston: Houghton, Mifflin, 1898.

Cadava, Eduardo. *Words of Light: Theses on the Photography of History.* Princeton: Princeton University Press, 1997.

Cadava, Eduardo, and Paola Cortés-Rocca. "Notes on Love and Photography." *October* 166 (2006), 3–34.

Calle, Sophie. *True Stories: 50 Short Stories, 5th edition.* Arles, France: Actes Sud, 2016.

Campany, David. "Museum and Medium: The Time of Karen Knorr's Imagery." In *Genii Loci: The Photographic Work of Karen Knorr,* edited by David Campany et al. London: Black Dog, 2002.

Carbone, Mauro. *The Flesh of Images: Merleau-Ponty Between Painting and Cinema.* Albany: SUNY Press, 2011.

Cartier-Bresson, Henri. *Interviews and Conversations 1951–1998,* edited by Clément Chéroux and Julie Jones. New York: Aperture, 2017.

Daguerre, Louis Jacques Mandé. "Daguerreotype: Prospectus, Second Half of 1838." In *First Exposures, Writings from the Beginning of Photography,* edited by Steffen Siegel (34–37). Los Angeles: Getty Publications, J. Paul Getty Museum, 2017.

Davis, Whitney. *A General Theory of Visual Culture.* Princeton: Princeton University Press, 2011.

de Chirico, Giorgio. *The Memoirs of Giorgio de Chirico,* translated by Margaret Crosland. London: Peter Owen, 1971.

Deleuze, Gilles. *Difference and Repetition,* translated by Paul Patton. New York: Columbia University Press, 1994.

Deleuze, Gilles, and Félix Guattari. *A Thousand Plateaus: Capitalism and Schizophrenia,* translated by Brian Massumi. Minneapolis: University of Minnesota, 1987.

Derrida, Jacques. *Copy, Archive, Signature: A Conversation on Photography.* Stanford: Stanford University Press, 2010.

———. *Memoirs of the Blind: The Self-Portrait and Other Ruins,* translated by Pascale-Anne Brault and Michael Naas. Chicago: University of Chicago Press, 1993.

Descartes, René. *The Philosophical Writings of Descartes: Optics,* translated by John G. Cottingham, Robert Stoothof, Dugald Murdoch, and Anthony Kenny. Cambridge: Cambridge University Press, 1984.

Doy, Gen. *Picturing the Self: Changing Views of the Subject in Visual Culture.* London: I. B. Tauris & Co., 2005.

Elkins, James, Ed. *Photography Theory.* New York, London: Routledge, 2007.

———. *What Photography Is.* New York, London: Routledge, 2011.

Flusser, Vilém. *Towards a Philosophy of Photography,* translated by Anthony Mathews. London: Reaktion Books, 2000.

Foster, Hal, Ed. *Vision and Visuality: Discussions in Contemporary Culture.* Seattle: Bay Press, 1988.

Freud, Sigmund. *The Interpretation of Dreams: The Complete and Definitive Text,* translated and edited by James Strachey. New York: Basic Books, 2010.

———. "A Note upon 'The Mystic Writing Pad.'" *SE* 19 (1925), 227–32.

Fuseli, Henry. *The Life and Writings of Henry Fuseli* (three volumes), edited by John Knowles. Amazon Digital Services, 2012.

Goethe, Johann Wolfgang von. *The Sorrows of Young Werther,* translated by David Constantine. Oxford: Oxford University Press, 2012.

Goldin Nan. *The Ballad of Sexual Dependency.* New York: Aperture, 1986.

Gombrich, Ernst Hans. *Art and Illusion: A Study in the Psychology of Pictorial Representation.* New York: Pantheon Books, 2004.

Heidegger, Martin. *Being and Time,* translated by Joan Stambaugh. Albany: SUNY Press, 1996).

Homer. *The Odyssey*, translated by Richmond Lattimore. New York: Harper Perennial Modern Classics, 2007.

Janis, Eugenia Parry. "Fabled Bodies: Some Observations on the Photography of Sculpture." In *The Kiss of Apollo: Photography and Sculpture 1845 to the Present*, edited by Jeffrey Fraenkel (9–23). San Francisco: Fraenkel Gallery, 1991.

Kant, Immanuel. *Critique of the Power of Judgment*, edited by Paul Guyer, translated by Paul Guyer and Eric Matthews. Cambridge: Cambridge University Press, 2001.

Kelsey, Robin. *Photography and the Art of Chance*. Cambridge, MA: Harvard University Press, 2015.

Kenaan, Hagi. *The Ethics of Visuality: Levinas and the Contemporary Gaze*. London: I. B. Tauris & Co., 2013.

———. "The Photographic Imagination: The Visible and the Invisible." In *Photography and Imagination*, edited by Amos Morris-Reich and Margaret Olin. Routledge History of Photography, Routledge, 2019 (forthcoming).

———. "The Selfie and the Face." In *Exploring the Selfie: Historical, Theoretical, and Analytical Approaches to Digital Self-Photography*, edited by Julia Eckel, Jens Ruchats, and Sabine Wirth. Basingstoke: Palgrave Macmillan, 2018.

———. "What Makes an Image Singular-Plural: Questions to Jean-Luc Nancy." *Journal of Visual Culture* 9, no. 1 (2010), 63–76.

Kenaan, Vered Lev. *The Ancient Unconscious: Psychoanalysis and the Classical Text*. Oxford University Press, 2019.

Knorr, Karen. "Natural Histories: Karen Knorr in Conversation with Rebecca Comay, 2002." In *Genii Loci: The Photographic Work of Karen Knorr*, edited by David Campany et al. London: Black Dog, 2002.

Koyré, Alexandre. *From the Closed World to the Infinite Universe*. Baltimore: Johns Hopkins University Press, 1957.

Krauss, Rosalind. *L'Amour Fou: Photography and Surrealism*. New York: Abbeville Press, 1985.

———. "Notes on the Index: Seventies Art in America, Part 1." *October* 3 (Spring 1977), 68–81.

———. "Notes on the Index: Seventies Art in America, Part 2." *October* 4 (Autumn 1977), 58–67.

———. *The Optical Unconscious*. Cambridge, MA: MIT Press, 1994.

———. "Photography's Discursive Spaces: Landscape/View." *Art Journal* 42, no. 4 (1982), 311–19.

———. *A Voyage on the North Sea: Art in the Age of the Post-Medium Condition*. London: Thames & Hudson, 2000.

Levinas, Emmanuel. *Ethics and Infinity: Conversations with Philippe Nemo*, translated by Richard A. Cohen. Pittsburgh: Duquesne University Press, 1985.

Merleau-Ponty, Maurice. "Cezanne's Doubt." In *Sense and Non-Sense*, translated by Hubert L. Dreyfus and Patricia Allen Dreyfus (9–25). Evanston: Northwestern University Press, 1964.

———. "Eye and Mind." In *"The Primacy of Perception" and Other Essays on Phenomenological Psychology, the Philosophy of Art, History, and Politics*, edited and translated by James M. Edie. Evanston: Northwestern University Press, 1964.

———. *Phenomenology of Perception*, translated by Donald A. Landes. New York, London: Routledge, 2013 [1945].

———. "Working Notes." In *The Visible and the Invisible*, edited by Claude Lefort, translated by Alphonso Lingis (165–276). Evanston: Northwestern University Press, 1968.

Mitchell, W. J. T. "Drawing Desire." In *What Do Pictures Want: The Lives and Loves of Images*. Chicago: University of Chicago Press, 2006.

Moholy-Nagy, László. "A New Instrument of Vision." In *Moholy-Nagy: An Anthology*, edited by R. Kostelantez. New York: Da Capo Press, 1970.

Moxey, Keith. *Visual Time: The Image in History*. Durham: Duke University Press, 2013.

Nemerov, Alexander. The Sixty-Sixth A. W. Mellon Lectures in the Fine Arts: "The Forest: America in the 1830s," Part 1: "Herodotus Among the Trees" (May 24, 2017). https://art.stanford.edu/news/sixty-sixth-w-mellon-lectures-fine-arts-forest-america-1830s-alexander-nemerov

———. *Soulmaker: The Times of Lewis Hine*. Princeton: Princeton University Press, 2016.

———. "This Pretty World: William Eggelston's Photographs." In *William Eggelston: The Democratic Forest, Selected Works*. David Zwirner Books/Steidl, 2016.

Nietzsche, Friedrich. *Beyond Good and Evil/On the Genealogy of Morality; The Complete Works of Friedrich Nietzsche*, Vol. 8, translated by Adrian Del Caro (Stanford: Stanford University Press, 2014).

———. *The Birth of Tragedy and Other Writings*, edited by Raymond Geuss and Ronald Speirs, translated by Ronald Speirs. Cambridge: Cambridge University Press, 1999.

———. *The Gay Science: With a Prelude in German Rhymes and an Appendix of Songs*, edited by Bernard Williams, translated by Josefine Nauckhoff. Cambridge: Cambridge University Press, 2001.

———. *The Will to Power*, edited by Walter Kaufmann, translated by Walter Kaufmann and R. J. Hollingdale. New York: Vintage Books, 1968.

Novak, Daniel A. *Realism: Photography and Nineteenth-Century Fiction*. New York: Cambridge University Press, 2008.

Pauli, Lori. "The First Negative." In *Oscar Gustave Rejlander: 1813(?)–1875*, edited by Leif Wigh (20–28). Stockholm: Moderna Museet, 1998 (exhibition catalog).

Philostratus. *The Life of Apollonius of Tyana,* translated by F. C. Conybeare. Cambridge, MA: Loeb Classical Library, Harvard University Press, 1927.

Plato. *The Republic,* edited by G. R. F. Ferrari, translated by Tom Griffith. Cambridge: Cambridge University Press, 2000.

Platt, Verity. "Virtual Visions: Phantasia and the Perception of the Divine in The Life of Apollonius of Tyana." In *Philostratus,* edited by E. Bowie, J. Ewen Bowie, and Jaś Elsner (131–54). Cambridge: Cambridge University Press, 2009.

Pliny the Elder, *Natural History,* translated by H. Rackham. Cambridge, MA: Loeb Classical Library Harvard University Press, 1952.

Pollitt, J. J. *The Ancient View of Greek Art: Criticism, History, and Terminology.* New Haven: Yale University Press, 1974.

Rosenblum, Robert. "The Origin of Painting: A Problem in the Iconography of Romantic Classicism." *The Art Bulletin* 39, no. 4 (1957), 279–90.

Rousseau, Jean-Jacques, and Johann Gottfried Herder. *Two Essays on the Origin of Language.* Chicago: University of Chicago Press, 1986.

Saltzman, Lisa. *Making Memory Matter: Strategies of Remembrance in Contemporary Art.* Chicago: University of Chicago Press, 2006.

Sartre, Jean-Paul. *Being and Nothingness,* translated by Hazel E. Barnes. New York: Washington Square Press, 1984.

———. *The Imaginary: A Phenomenological Psychology of the Imagination.* New York, London: Routledge, 2010.

———. "Merleau-Ponty Vivant." In *The Debate Between Sartre and Merleau-Ponty,* edited by Jon Stewart. Evanston: Northwestern University Press, 1998.

Sekula, Allan. "On the Invention of Photographic Meaning." In *Thinking Photography,* edited by Victor Burgin. London: Palgrave Macmillan, 1982.

Shakespeare, William. *A Midsummer Night's Dream: The Oxford Shakespeare,* edited by Peter Holland. Oxford: Oxford University Press, 2008.

Siegel, Steffen, Ed. *First Exposures: Writings from the Beginning of Photography. Los Angeles: Getty Publications,* J. Paul Getty Museum, 2017.

Silverman, Kaja. *The Miracle of Analogy or the History of Photography, Part 1.* Stanford: Stanford University Press, 2015.

Smith, Shawn Michelle, and Sharon Sliwinski, Eds. *Photography and the Optical Unconscious.* Durham: Duke University Press, 2017.

Snyder, Joel. "Inventing Photography." In *On the Art of Fixing a Shadow: One Hundred and Fifty Years of Photography*, edited by Sarah Greenough et al. Washington, DC: National Gallery of Art, 1989.

———. "Res Ipsa Loquitur." In *Things That Talk: Object Lessons from Art and Science,* edited by Lorraine Daston. New York: Zone Books, 2004.

Sontag, Susan. *On Photography*. New York: Penguin Books, 1977.

Stevens, Wallace. *The Collected Poems of Wallace Stevens*. New York: Vintage, 2011.

Stieglitz, Alfred. *Stieglitz on Photography: Selected Essays and Notes,* edited by Richard Whelan and Sarah Greenough. New York: Aperture, 2000.

Stoichita, Victor I. *A Short History of the Shadow*. London: Reaktion Books, 1997.

Strand, Paul. "Photography and the New God." *Broom: An International Magazine of the Arts* 3, no. 4. (November 1922), 252–58.

Sugimoto, Hiroshi. "Pre-Photography Time-Recording Device." https://www.sugimoto hiroshi. com/pptrd/

Talbot, William Henry Fox. "The Correspondence of Henry William Fox Talbot Project," edited by Larry J. Schaaf. http://foxtalbot.dmu.ac.uk/project/project.html

———. *The Pencil of Nature*. London: Longman, Brown, Green, and Longmans, 1844.

———. "Some Account of the Art of Photogenic Drawing, or the Process by Which Natural Objects May Be Made to Delineate Themselves Without the Aid of the Artist's Pencil." London: R. and J. E. Taylor, 1839.

Tissandier, Gaston. *A History and Handbook of Photography*. London: Sampson, Low, Marston, Low, & Searle, 1877.

Tucker, Jennifer. *Nature Exposed: Photography as Eyewitness in Victorian Science*. Baltimore: Johns Hopkins University Press, 2013.

van Gelder, Hilde, and Helen Westgeest. *Photography Theory in Historical Perspective*. Hoboken: Wiley-Blackwell, 2011.

Vernant, Jean-Pierre. "The Birth of Images." In *Mortals and Immortals: Collected Essays,* edited by Froma I. Zeitlin (151–63). Princeton: Princeton University Press, 1991.

———. "From the 'Presentification' of the Invisible to the Imitation of Appearance." In *Mortals and Immortals: Collected Essays,* edited by Froma I. Zeitlin. Princeton: Princeton University Press, 1991.

Virgil. *The Aeneid*, translated by Robert Fitzgerald. New York: Vintage Classics, 1990.

Wang, Eugene. "The Shadow Image in the Cave: Discourse on Icons." In *Early Medieval China Sourcebook*, edited by Wendy Swartz. New York: Columbia University Press, 2014.

Warner, Marina. *Phantasmagoria: Spirit Visions, Metaphors, and Media into the Twenty-First Century.* Oxford: Oxford University Press, 2006.

Wittgenstein, Ludwig. *Philosophical Investigations*, edited by P. M. S. Hacker and Joachim Schulte, translated by G. E. M. Anscombe. Hoboken: Wiley-Blackwell, 2009.

Wolf, Gerhard. "The Origins of Painting." *RES: Anthropology and Aesthetics* 39 (2009), 60–78.

ILLUSTRATION CREDITS

Frontispiece William Eggleston, *Glass in Airplane*, c. 1971–1974.
Dye transfer print. 30 × 20 1/2 inches. 76.2 × 52.1 cm.
© William Eggleston. Courtesy of David Zwirner Gallery.

Figure 1 Gustave Le Gray, *Forest Scene, Forest of Fontainebleau*, ca. 1855.
Courtesy of the Getty's Open Content Program.

Figure 2 Eastman Kodak Company, advertisement, *If You Want It—Take It—With a Kodak. If It Isn't an Eastman, It Isn't a Kodak*, 1900.
Courtesy of the George Eastman Museum.

Figure 3 Frederick W. Barnes, advertisement for Kodak photography, 1905.
Courtesy of the George Eastman Museum.

Figure 4 Camille Corot, *The Meadow, Souvenir of Ville d'Avray*, 1869–1872.
Oil on canvas. Musée d'Orsay, Paris. Art Resource.

Figure 5 Hagi Kenaan, *Face in a Tree*, Pennsylvania 2017.

Figure 6 Eugène Atget, *Saint-Cloud,* 1915–1919.
Courtesy of the Getty's Open Content Program.

Figure 7 Louis Daguerre, *Fossils and Shells*, ca. 1839. Musée des Arts et Métiers, Paris.

Figure 8 Hiroshi Sugimoto, *PPTRD 028*, 2008. © Hiroshi Sugimoto,
 courtesy Fraenkel Gallery, San Francisco.

Figure 9 W. H. F. Talbot, *A Peony Leaf Above Leaves of a Species of Chestnut*.
 Courtesy of the Met's Public Access Initiative.

Figure 10 W. H. F. Talbot, *Photomicrograph of Insect Wings*, ca. 1840.
 Public domain. Courtesy of the National Science and Media Museum,
 Bradford.

Figure 11 Joseph-Benoît Suvée, *The Invention of Drawing*, 1791. Black and white
 chalk on brown paper. Courtesy of the Getty's Open Content Program.

Figure 12 Jean Raoux, *The Origin of Painting*, 1714–1717. Oil on canvas.
 Private collection, Paris.

Figure 13 Joseph Wright of Derby, *The Corinthian Maid*, 1782–1785. Oil on
 canvas. Courtesy of the National Gallery of Art, Washington, D.C.

Figure 14 Giorgio de Chirico, *Nostalgia of the Infinite*, 1911. Oil on canvas.
 The Museum of Modern Art, New York. Art Resource and Artists
 Rights Society.

Figure 15 Oscar Gustav Rejlander, *The First Negative*, 1857. Musée d'Orsay,
 Paris. Art Resource.

Figure 16 Karen Knorr, *The Pencil of Nature*, 1994.
 Courtesy of the artist.

Figure 17 W. H. F. Talbot, *Lace*, 1845. Courtesy of the National Gallery of Art,
 Washington, D.C.

Figure 18 Lee Friedlander, *Central Park, New York City*, 1992.
 © Lee Friedlander, courtesy Fraenkel Gallery, San Francisco.

Figure 19 Stephen Shore, *Amarillo, Texas, August 1973*. © Stephen Shore.
 Courtesy 303 Gallery, New York.

Figure 20 W. H. F. Talbot, *The Haystack*, 1844. Courtesy of the National Gallery of Art, Washington, D.C.

Figure 21 W. H. F. Talbot, *Lacock Abbey in Wiltshire*, 1844. Courtesy of the Met's Public Access Initiative.

Figure 22 W. H. F. Talbot, *Sketch of Lake Como*, 1833. Public domain.

Figure 23 Henri Cartier-Bresson, *Pilgrimage: India, Tamil Nadu, Madras*, 1950. Magnum Photos.

Figure 24 Henri Cartier-Bresson, *Sicily, Palermo*, 1971. Magnum Photos.

Figure 25 Apollo 17, *The Blue Marble*, December 7, 1972. Public domain.

Figure 26 Barbara Probst, *Exposure #39. NYC, 545 8th Avenue. 03.23.06. 1:17 p.m.* Courtesy of the artist.

Figure 27 Paul Strand, *Double Akeley, New York*, 1922. © Aperture Foundation, Inc., Paul Strand Archives.

Figure 28 Jennifer Abessira, *The New Order, #Elastique Project*, 2015. Courtesy of the artist.

Figure 29 Nan Goldin, *Nan and Brian in Bed, New York City*, 1983. © Nan Goldin, Courtesy of Marian Goodman Gallery.

Figure 30 Sophie Calle, *The Divorce*, 1992. © Sophie Calle. ADAGP.

Figure 31 Sophie Calle, *The Giraffe*, 2012. © Sophie Calle. ADAGP.

Figure 32 Hagi Kenaan, *Goodbye Berlin*, 2018.

Figure 33 Antonio da Correggio, *The Abduction of Ganymede*, ca. 1531–1532. Oil on canvas. Kunsthistorisches Museum, Vienna. Lessing Culture and Fine Arts Archive.

INDEX

Alberti, Leon Battista, 39–41, 61

Aristotle, 33–35

Augustine, 25–26

Barthes, Roland, 8–10, 46, 70, 89–105, 115–116, 176–177, 181–182, 184, 188, 191, 205n67, 206n83, 207n94, 208n95

Batchen, Geoffrey, 207n94

Baudelaire, Charles, 162–165

Belting, Hans, 3, 62, 102

Benjamin, Walter, 152–153

Burgin, Victor, 8, 207n94

Cadava, Eduardo, 10, 177, 191

Calle, Sophie, 182–186

Cartier-Bresson, Henri, 144–147

Caves, 5–6, 17, 41, 63–64, 73, 77

Continuum/Continuum Concept, 39, 44, 47, 49, 125, 136, 175–176, 191

Correggio, Antonio, 192–193

Corot, Camille, 30

Daguerre, Louis Jacques Mandé, 15–16, 19, 42–44, 53, 163–164

Daguerreotype, 7–8, 16, 20, 42–44, 126

de Chirico, Giorgio, 79–83

Deleuze, Gilles, 25, 102, 210n13

Derrida, Jacques, 77–79, 208n95

Elkins, James, 9–11, 90

Eggleston, William, 190–191

Eidolon: image as, 62, 92–98, 100, 140

Eikon: image as, 92, 96, 100

Existential, 1, 9, 70, 105, 189

Fixing shadows, 6–7, 41, 118–119, 122, 140, 185, 209n5

Freud, Sigmund, 68, 152, 212–213n42

Fossils/Fossilization, 42–45, 49
Friedlander, Lee, 128

Goldin, Nan, 178–182, 184

Heidegger, Martin, 1–2, 77, 99, 101–102, 131
Hokusai, Katsushika, 47–49

Imagination (Phantasia), 10, 25–26, 35, 40–42, 90, 98, 200n36; photography's imagination, 6, 16, 61, 131, 136; romantic imagination, 64, 68
Index/Indexicality, 44–47, 117

Kant, Immanuel, 3, 24, 41–42, 136
Kierkegaard, Søren, 12
Knorr, Karen, 110–113
Kodak/Eastman-Kodak, 20–24
Koyre, Alexander, 156–157
Krauss, Rosalind, 46–47, 175–176

Merleau-Ponty, Maurice, 70, 72–79, 83–89, 128, 130, 145, 150, 184
Milosz, Czeslaw, 28–30
Moholy-Nagy, Laszlow, 168–170

the Negative, 44, 109, 117–119, 122–126, 153, 162
New Vision, 155, 166, 169
Nietzsche, Friedrich, 3–6, 12, 44, 157–165, 169, 177, 190, 195n5

Odysseus, 93–94, 97, 140
Ontology, 2–3, 9, 33, 85, 89, 93–94, 99, 101–105

Perspectivism, 154–160, 170, 176–178
Plato/Platonic, 16–19, 56, 63–64, 68, 92–93, 96, 126; anti-Platonic, 100–102
Pliny the Elder: The tale of the Corinthian maid, 8, 33, 58–59, 61–68, 70–72, 77–78, 91, 106, 110–111, 117–118, 203n22, 207n94
Post-Photography, 2, 12
Photogenic Drawing, 2, 15, 34, 57, 118, 122–123, 134, 142, 147
Prehistoric art, 40–42, 73, 77, 211n24

Raoux, Jean, 66
Rejlander, Oscar Gustave, 61–62, 106–110
Romanticism, 32, 56, 61–62, 64, 68, 106, 118
Rosenblum, Robert, 59, 61

Sartre, Jean Paul, 101–103
Seeing-as, 34–42, 142
Shore, Stephen, 128–130
Silverman, Kaja, 10–11
Sontag, Susan, 12, 44–46
Stars, 4, 17, 44, 46, 86
Stevens, Wallace, 32
Stieglitz, Alfred, 153, 212n30
Stoichita, Victor, 62–64
Strand, Paul, 165–171

Sugimoto, Hiroshi, 43–45

Technology, 2, 6, 34, 44, 57, 136, 142, 153. 166, 168, 184; Digital, 2, 37, 47, 112, 185; Google Glass, Go-Pro, 170–171; Photoshop, 185; "Post-historical technical images", 142–143; *Techne*, 33–34
Tissandier, Gaston, 18–20
Talbot, William Henry Fox, 2–3, 6, 12, 15–17, 19, 46, 48–49, 53–54, 61, 110, 112–113, 117–128, 130–143, 147–155, 157, 176, 191, 209n5, 210n9, 210n14, 211n15, 211n20

Unconscious, Optical, 151–153, 212n42

Vernant, Jean Pierre, 62, 92–94
The Virtual, 135, 169–171
Visuality: Photography's Visuality, 6–8, 12, 18–20, 27, 33–35, 47, 77, 105, 119, 125–127, 132, 135–136, 142–143, 147, 149–150, 152, 154, 165, 168–170, 175, 176, 182
The Visual and the Visible/The Visualization of the Visible, 18–20, 27–33, 39–42, 64, 71–77, 84–85, 93, 125–126, 142–143

Werther (Johann Wolfgang von Goethe), 53–57
Wittgenstein, Ludwig, 24–26, 127
Wright, Joseph, of Derby, 61, 66–67, 108